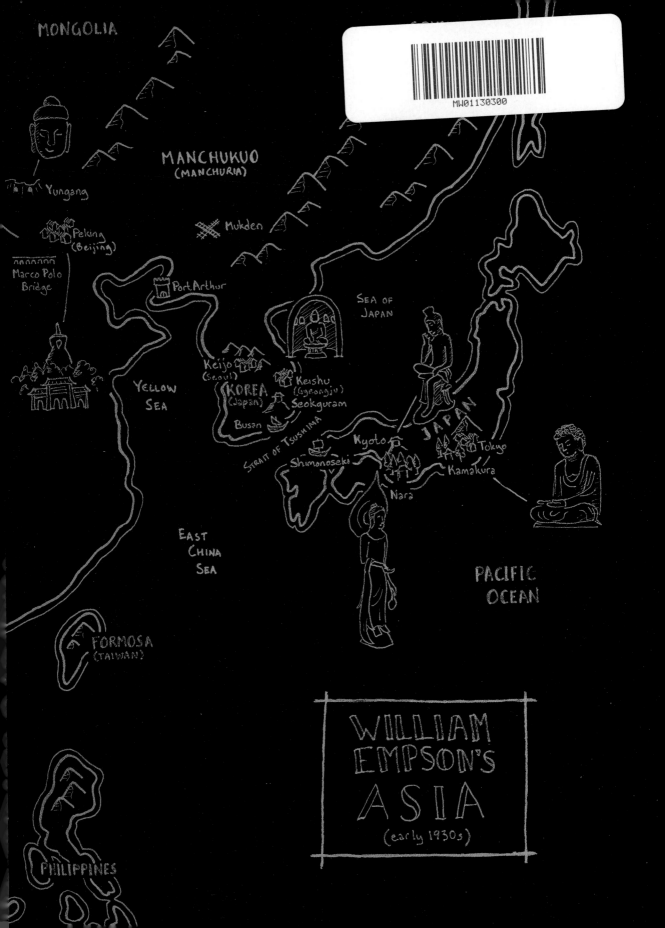

MONGOLIA

MANCHUKUO
(MANCHURIA)

Yungang

Peking
(Beijing)

Marco Polo
Bridge

Port Arthur

Mukden

SEA OF
JAPAN

YELLOW
SEA

Keijo
(Seoul)

KOREA
(Japan)

Keishu
(Gyeongju)
Seokguram

Busan

JAPAN

Kyoto

Tokyo

STRAIT OF TSUSHIMA

Shimonoseki

Kamakura

Nara

EAST
CHINA
SEA

PACIFIC
OCEAN

FORMOSA
(TAIWAN)

WILLIAM
EMPSON'S
ASIA
(early 1930s)

PHILIPPINES

THE FACE OF THE BUDDHA

WILLIAM EMPSON

THE FACE *of* THE BUDDHA

edited by

RUPERT ARROWSMITH

OXFORD
UNIVERSITY PRESS

OXFORD

UNIVERSITY PRESS

Great Clarendon Street, Oxford, OX2 6DP,
United Kingdom

Oxford University Press is a department of the University of Oxford.
It furthers the University's objective of excellence in research, scholarship,
and education by publishing worldwide. Oxford is a registered trade mark of
Oxford University Press in the UK and in certain other countries

First Edition published in 2016

Impression: 2

Published in the United States of America by Oxford University Press
198 Madison Avenue, New York, NY 10016, United States of America

British Library Cataloguing in Publication Data
Data available

Library of Congress Control Number: 2015949662

ISBN 978–0–19–965967–8

Printed in Great Britain by
Clays Ltd, St Ives plc

PREFACE

by PARTHA MITTER

Rupert Arrowsmith has rendered us a great scholarly service by his painstaking editing, copious, up-to-date informative notes, and an engaging biographical introduction, to William Empson's *The Face of the Buddha*. With exemplary devotion and scrupulous attention to detail, Arrowsmith brings to life a fascinating episode in transcultural encounters, how individuals cross cultural frontiers and develop elective affinities with societies that are not their own. In many ways, Arrowsmith himself is an ideal person to undertake the task. He too has crossed borders, living in various parts of Asia, participating in the mysteries of Buddhism as a bhikkhu, or Buddhist monk.

Arrowsmith's notes are especially useful since many of the references and the intellectual debates mentioned by Empson may not readily make sense to today's readers. However he does more; he offers us the thrilling yarn about a disappearing object and its unexpected reappearance that is worthy of a Conan Doyle or an Edgar Allan Poe. The object in question is a manuscript, its progenitor, William Empson, the celebrated author of *Seven Types of Ambiguity* (1930), which was composed by him at the precocious age of 22. Many are familiar only with this classic treatise, which has been a foundational text for the literary movement known as New Criticism. To them, *The Face of the Buddha* will come as a revelation. Empson's life, or rather several lives, is as fascinating as his various intellectual adventures. Why should a scholar of English literature concern himself with Buddhist art, which after all has been the preserve of weighty Orientalists? Therein lies the engaging story of a writer who led multiple lives, suffering vicissitudes of fortune, as well as receiving both criticism and compliment from a wide variety of people.

William Empson appears to have been a curious mixture of genius and eccentric in equal measure. Having produced *Seven Types of Ambiguity* at such an early age, which assured him a comfortable life as a don at Magdalene College, Cambridge, he had the misfortune to lose it through sheer carelessness. A minor peccadillo that today would perhaps elicit mild amusement or the slight raising of eyebrows brought down the wrath of the fellowship on the hapless scholar. Driven out of Cambridge in 1929, he eventually obtained a modest position as teacher of English in the far-flung city of Tokyo.

This in retrospect proved to be immensely fecund because it gave him an opportunity to spend a considerable amount of time in Japan and later China.

He developed a deep interest in Japanese culture, and in Buddhism in particular, which ultimately bore fruit in the form of a startling hypothesis: the asymmetry in the Buddha faces in East and South-East Asian art, namely the right and left sides, often showing two very different expressions. On his return to England, Empson completed the text of *The Face of the Buddha*, not suspecting that he would suddenly lose the manuscript, he thought for ever. In the days before the information revolution, making copies was indeed a difficult and costly affair, and it was not uncommon for authors to lose their sole manuscript copy. (At the risk of sounding autobiographical, the final manuscript copy of my first book went missing, which delayed its publication by several precious years.[1]) There is however a final twist to the Empson saga. Tragically, he never saw the book in print, but the original manuscript was unexpectedly to turn up more than twenty years after his death.

The rediscovery of *The Face of the Buddha* and its subsequent publication is of considerable interest, especially since the scholar of English literature was new to Buddhist studies. What criteria can we apply to our assessment of the treatise, not written by a specialist in the field, but by a literary critic and rank outsider to Asian art and religion? Admittedly, at first sight, it is difficult to categorize this mixed genre of writing which combines erudition with personal reflections. But, as Arrowsmith's sensitive but objective account demonstrates, Empson manages to carry it off with considerable success. Empson applies his own theories of literature to his research into Buddhist iconography, which admittedly was an entirely new subject for him. It is a striking fact that his innovative contribution to literary criticism in turn enriched the study of Asian art, bringing a fresh perspective to a fiercely parochial and specialist study jealously guarded by its votaries. Rhetoric, semiotics, and the close reading of texts, pioneered by I. A. Richards and William Empson, stood in good stead in the latter's comparative analysis of Buddhist iconography. The balancing of competing psychological impulses, Empson was convinced, could be successfully applied to the Buddha faces in sculptures of South-East and East Asia. In *Seven Types of Ambiguity*, Empson had teased out multiple meanings in classic poems of Shakespeare and Milton, emphasizing ambiguities of meaning in poetry and offering multiple interpretations of a single text. This had an unexpected and intriguing windfall in studies of the Buddha images. Arrowsmith perceptively argues that Empson found 'dual significance in Buddhist art, in that he thought that the right and left sides of some sculpted figures' faces appeared to suggest conflicting spiritual and emotional states' (p. xiv).

William Empson's 'magnificent obsession' took him all the way from Japan, via Korea and China to Bodhgaya, ending up in the caves of Ajanta, the ultimate

[1] P. Mitter, *Much Maligned Monsters: History of European Reactions to Indian Art* (Oxford: Clarendon Press, 1977).

source of Mahayana Buddhist art. In this context, the epistolary exchanges between Empson and his mentor I. A. Richards are significant. Indeed, who would have guessed that the two major contributors to New Criticism would be engrossed in discussing the various merits of the Buddha image? But there are good reasons for their engagement. Empson's experience of the beauty of the Buddhist sculptures of Nara, an ancient seat of Japanese power, was to have an epiphanic effect on him. Western sculpture left him cold, argues Arrowsmith persuasively, whereas he found Buddhist images genuinely moving and wished to convey his new-found enthusiasm to a Western audience, not least to his mentor Richards.

The Face of the Buddha can be divided into several parts. A substantial element is Empson's enthusiastic personal account of his own impressions of the artistic and religious monuments that he visited in South, South-East, and East Asia in the course of his research. Yet, what makes it more than a travelogue and a personal memoir is the underlying scholarly and intellectual content of *The Face of the Buddha*. He always insisted on visiting the actual sites to see the sculptures in the flesh as it were, in their traditional environments, rather than relying on photographic reproductions. Empson intersperses his account of visits to these sites with his painstaking iconographic and historical analysis based on a close reading of the images *in situ*. Thus these visits gave him a chance to test his literary theories against actual sculptures, especially his hypothesis about the asymmetrical sides to the Buddha faces. But during his travels from site to site, covering a wide swathe from Japan all the way to India via China and South-East Asia, he acquires a deeper understanding of Asian philosophical and religious traditions. In one passage of the text he vehemently counters the European commonplace that the Buddha faces have no expressions at all. Nor are they monotonous, for the 'essential formula for the face allows of much variety . . .' (p. 6). Equally he rejects the idea that Buddhism was a passive pessimistic religion, arguing that it had been a civilizing force in many parts of the world.

It is the inspiring story of an elective affinity that offers William Empson a new insight into and a genuine empathy for an alien art form. Arguably, he was able to inject a much-needed freshness in his observations of Asian artistic traditions that was often absent in the authoritative tomes of many an Orientalist. Perhaps the late Edward Said was correct after all. Exercising power and authority in their mastery of textual knowledge, Orientalists could not often shed their cherished stereotypes of the societies and religions they studied. Lacking the baggage of Orientalism or of art history, Empson's account becomes part of a profound human experience partly because Buddhism deeply satisfied his spiritual quest that could not be fulfilled by Christianity.

To give a few examples of Empson's refreshingly matter-of-fact style punctuated by occasional dry humour that avoids the built-in biases of great Orientalists

such as Alfred Foucher, who for instance was convinced that the Greeks with their humanism had bequeathed the idealized Buddha image to the Indians. Conscious of being an outsider, Empson gently puts forward his own view on the Buddha image controversy by connecting the emergence of the image with doctrinal changes, rather than with any racial component or Greek intervention. Racial and nationalist explanations of the artistic styles of Indian art have been the staple of art historians and archaeologists for over sixty years, from the pioneering James Fergusson down to Vincent Smith. Empson takes a sensible view of the race question, rejecting the importance of race in Buddhism, such as whether the Buddha was either Aryan or Mongolian, gently mocking Smith's tendentious claim that the Kushan rulers, in whose empire the first Buddha images were fashioned, were 'pink-cheeked'. He intervenes again with his perceptive comment that the slit eyes of the Gupta Buddhas were not a reflection of the Kushan rulers' Mongol origins (which they were not) but of iconographic requirements (pp. 20–1).

Of course, occasionally Empson could go wrong in his identifications since now we have a lot more knowledge than he had access to. Yet until recently, racial or nationalist origins of the Buddha image controversy had continued unabated and by and large his conclusions are eminently convincing. Indeed, as I suggested before, what he does bring to bear in his analysis of Buddhist iconography is his remarkable interdisciplinary skill in the close textual reading of the images, which archaeologists and Orientalists often failed to do. (As an aside, I regret that in contrast to his genuine involvement with Buddhism, William Empson, along with many Europeans, continued to find Hindu religion and its art unappealing. His empathy for early Buddhism and Buddhist art is exemplary but he accepts European misrepresentations of Hinduism, viewing Tibetan art as grotesque and Tantra as lewd and degraded, though his own sensibility and active sexuality often break through, eliciting from him an appreciative account of the mystic union of the deity Vajrayana with his shakti as a romantic act.)

The most original, controversial, and for Empson himself the 'heart' of *The Face of the Buddha*, is his theory of asymmetry, which constitutes Chapter 5. He confides to us what he considers to be his startling discovery: 'the faces [of the Buddha] all seem to be asymmetrical in the same way, as if the artists were working on a theory' (p. 119, see also p. xiv of introduction) The theory of asymmetry is startling and curious, though in fairness Empson does not push it as an all-embracing idea that explains all Buddhist heads. To understand the phenomenon he even took drawing lessons and made experiments in the photographic darkroom. Scouring Asian traditions he found that Chinese fortunetellers used a system of reading two sides of the head differently to forecast the client's character and prospects. He also sought reassurance from authorities in Japan, some of whom

concurred with him. But Empson failed to persuade European specialists, who dismissed the occurrence of asymmetry as accidental.

Convinced of an objective basis to his hypothesis, Empson eventually turned to scientific theories to bolster his case, notably Darwin's view of the universal nature of human emotions and their outward expressions that transcended cultures. In pursuit of this, he made extensive comparisons of expressions in Asian Buddhist sculptures with those of contemporary celebrities in photographs.[2] He also considered two current psychological theories in vogue on the different functions of the right and left hemispheres of the brain: Werner Wolff's view that the left side represented the 'wish-image' of an individual while the right was how others saw him; on the other hand, Pierre Abraham claimed that the left showed social personality while the right concerned deep inner self. Finally he took the advice of Sir Cyril Burt, who suggested that the whole phenomenon of asymmetry was complicated. Empson's conclusion was that while he did not entirely agree with the different theories, he nonetheless felt vindicated regarding his analysis of Buddha heads, namely that right showed individual efforts while the left indicated inherited characteristics.[3]

How would one evaluate Empson's hypothesis of the asymmetrical head of a statistically significant number of Buddhas? There is no doubt some truth in the claim that the expressions on two sides of the human face are different. However, how one explains this is the crux. The jury will be out for some time, but as a working hypothesis it holds water though a lot more research is needed on this. All in all, Empson convinces by avoiding an all-embracing universal theory by claiming that all Buddha images demonstrate this phenomenon. With his innate honesty he confesses that Yumedono Kannon, 'perhaps the most beautiful of these early Japanese statues', does not conform to his theory of facial asymmetry, adding that he did not wish to 'appear crazy over the split-face theory; because the face seemed to me completely symmetrical on the two occasions that I saw it' (p. 121). There have been advances in neurosciences since his time and now we know a great deal more about the workings of the two sides of the brain than was possible in the 1930s–1940s. For instance, 'left' brain controls the muscles on the right and vice versa. The left tends to controls language skill and logic while the right operates face recognition, processing music, and visual imagery. But in fact both sides must act in unison for us to successfully complete a task. In conclusion, what is now needed is for scholars to take up William Empson's challenge and

[2] For a magisterial study of shared traits across cultures, see Irensäus Eibl-Eibesfeldt, *Die Biologie des menschlichen Verhaltens* (Munich: Piper Verlag, 1984).

[3] Sir Cyril Burt was a controversial figure whose work on IQ and intelligence has now been discredited after allegations that he had falsified evidence. F. Samelson, 'What to do about fraud charges in science; or, will the Burt affair ever end?', *Genetica*, 99/2–3 (1997), 145–51.

investigate with further researches into the face of the Buddha armed with advances in the field. Meanwhile *The Face of the Buddha* will remain a testament to William Empson's intellectual curiosity, originality of thought, and a remarkable ability to develop empathy for a culture that was in the first instance quite unlike his own.

CONTENTS

INTRODUCTION TO WILLIAM EMPSON'S
THE FACE OF THE BUDDHA

by RUPERT ARROWSMITH

There can be few manuscripts as well-travelled as that of William Empson's *The Face of the Buddha*. Originally begun in Japan in 1932, it was expanded, annotated, and revised during visits to Korea, Vietnam, Cambodia, Burma, India, Ceylon, the United States and diverse parts of mainland China before its completion in England more than ten years later, and with a global conflict separating its first from its final draft. There can also be few manuscripts that have disappeared and reappeared so inexplicably. 'I only gradually returned to writing,' Empson recalled much later of the years that followed the Second World War, 'doing first a book on Buddhist sculpture that got lost.'[1] He continued to believe for the rest of his life that the manuscript, along with its irreplaceable photographic illustrations, had been left in the back of a taxi by a drunken family friend. No copy of the text had ever been made, and so Empson was left to lament the ignominious fate of the new book, while his commentators could only speculate over its imagined contents on the basis of fragments and hearsay. Two decades after Empson's death, however, his eldest son Mogador and his granddaughter Rebecca were unexpectedly summoned to the British Library to examine a manuscript that had tumbled out of an obscure archive. With trembling hands in white, regulation cotton gloves, the two of them opened its dusty carton amid the sacred precinct of the Manuscripts Room, and confirmed to the world that *The Face of the Buddha* had been found.[2]

What had happened to the manuscript in the meantime is a story in itself. The family friend assumed to have lost the manuscript was the author John Davenport, with whom Empson had left it in 1947 before leaving London for an extended sojourn overseas. Davenport was too embarrassed to tell Empson what he thought had happened until his friend returned to London in 1952 and he was forced to come clean, but in fact he had been wrong about the taxi all along. Too full of alcohol at the time to be able to remember the incident later, he had actually passed *The Face of the Buddha* to the Ceylonese Tamil poet Tambimuttu, editor of *Poetry London*, in the hope that he might be able to get a publisher interested in it.

[1] William Empson to Roger Sale, n.d. (1973), John Haffenden (ed.), *Selected Letters of William Empson* (Oxford: Oxford University Press, 2009; hereafter *Letters*), 547.

[2] Mogador Empson, email to the author, 19 March 2014.

Tambimuttu, however, left the magazine shortly afterwards and went back to Ceylon, at which point he seems to have handed Empson's manuscript on to one of his fellow editors, Richard March. The next twist in the tale is that March soon afterwards became ill and died, thus consigning *The Face of the Buddha* to its long half-century of obscurity. The mass of March's papers was not acquired by the British Library until 2003, and two years later a browsing curator, Jamie Andrews, laid eyes on the manuscript and began to wonder about it, thus opening the way for the unveiling of the lost book by the poet's descendants that has been described above.[3]

Most readers who know him as a poet and as the author of difficult literary critical texts such as *Seven Types of Ambiguity* will want to ask why William Empson would have wanted to try his hand at a book on Asian art in the first place. The main thing to say is that Empson, who never showed much enthusiasm for the Graeco-Roman or Renaissance traditions in sculpture, felt genuinely moved by the examples of Buddhist art that he came across in various parts of Asia, and wanted to convey an appreciation of them to others in the West. 'The Buddhas are the only accessible Art I find myself able to care about', he once told the critic John Hayward, and he was prepared to travel long distances, and suffer considerable hardship, in order to examine particular examples in the flesh, so to speak.[4]

Another thing is that researching the book allowed Empson to expand his ideas about literature into a new area. *Seven Types of Ambiguity*, published in 1930 when Empson was just 24, had discovered double or multiple meanings in passages drawn from well-known poetic works, had suggested categories for these, and had offered strategies for their analysis. He now began to sense a similar dual significance in Buddhist art, in that he thought the right and left sides of some sculpted figures' faces appeared to suggest conflicting spiritual or emotional states. 'The point is important, I think,' he explains in his essay 'Buddhas with Double Faces', 'because the faces all seem to be asymmetrical in the same way, as if the artists were working on a theory.'[5] The book, then, was intended both as a chronological introduction to the sculptures that Empson had seen, and as a vehicle for adapting his literary theories in an effort to understand them. In contrast to Empson's chronological presentation of Buddhist artworks, this introduction will discuss them in the order he encountered them, tracking not only the development of his thinking about Asian art, but also his ever-deepening engagement with the region's philosophical and religious traditions as he flitted between such key historical sites as Nara, Seokguram, Yungang, Ajanta, Anuradhapura, and Angkor.

[3] Jake Empson, email to the author, 28 April 2015.
[4] William Empson to I. A. Richards, 2 April 1933. *Letters*, 61. [5] p. 119 (Appendix).

Of course we would not have *The Face of the Buddha* at all if Empson had not been thrown out of Magdalene College, Cambridge, in 1929. Having been awarded a good junior fellowship, he was well on his way towards the privileged, if pedestrian, life of an elite professor, until one of the college porters found a pack of condoms in the drawer of his room. Unceremoniously stripped of his fellowship for possessing items that in those days connoted desperate moral depravity, Empson found himself barred even from setting foot inside the city of Cambridge. He was suddenly forced to consider all sorts of alternative career options, even at one point contemplating journalism or a civil service appointment.[6] Fortunately for the future production of *The Face of the Buddha*, Empson's intellectual mentor, the literary critic I. A. Richards, had a lot of connections in East Asia, and was able to help him instead to apply for a lecturing post in Tokyo that commenced in 1931.

The year after Empson arrived, Tokyo officially became the world's second largest city, with a closely packed urban population of 4.9 million, rising fast. The city was in the grips of a simultaneous baby boom and construction boom, and Empson's first residence was in Kojimachi, right in the thick of things. 'The noise is very destructive,' he wrote to I. A. Richards, 'especially hammering, and squalling babies.'[7] In those days Kojimachi ward represented the entire area west of the Imperial *kyujo*, or 'palace-castle', including the now separate Ichibancho district where the British Embassy is still located today. Despite the noise, being close to the embassy had some upsides, including the opportunity to spend evenings discussing East Asian history and art with the diplomat George Sansom and his wife Katharine. 'I met Mrs Sansom the other night,' he wrote to Richards, 'she is very friendly and charming.'[8] Katharine's husband had just published what would become a standard reference work on Japan's most significant cultural sites,[9] and the couple undoubtedly gave Empson strong encouragement to tour these himself.

The real story of *The Face of the Buddha* begins in the ancient Japanese city of Nara, where, in the spring of 1932, the beauty of a particular set of Buddhist sculptures struck Empson with a revelatory force. Nara had been Japan's first genuine capital, but had not occupied that position since the shifting of the Imperial bureaucracy to Kyoto more than a thousand years previously. By the time Empson visited, the city was scarcely separable from its backdrop of immense, sound-devouring evergreen trees and from its celebrated park with its over-petted and junk-food-stuffed deer. The venerable stillness of the place would have been penetrated only by the clatter of wheels across stone as the city's rickshawmen carted their passengers between its many Buddhist and

[6] William Empson to I. A. Richards, n.d. (1929). *Letters*, 8–9. See also John Haffenden, *William Empson Among the Mandarins* (Oxford: Oxford University Press, 2005; hereafter Haffenden vol. 1), 243–62.

[7] William Empson to I. A. Richards, 31 March 1932. *Letters*, 40.

[8] William Empson to I. A. Richards, 23 April 1932. *Letters*, 41.

[9] George Sansom, *Japan: A Short Cultural History* (London: Cresset, 1931).

Shinto shrines, and by the efficient Japanese locomotives rushing in and out of its station. Empson's own train ride—all 400 kilometres of it from central Tokyo to this—must have felt like a journey from the end of time back to the beginning.

Katharine Sansom has left the best description of Nara as Empson would have experienced it on his first visit. 'The wooden temples stand in noble simplicity, sacrosanct and ancient,' she noted during her own visit a year or two previously, 'within mouldering walls and gateways and splendid trees, set in a rich saucer of blue. Blue-smocked peasants lead their oxen about the lanes, looking as traditional as one could desire.'[10] Of course the authenticity only went so far: there were also the sideshows and tourist distractions that feature in all of the world's heritage zones. A contemporary guidebook noted dryly that one Shinto shrine was 'enlivened by several dancing girls who for one yen will go through the tedious motions of a so-called sacred dance (*kagura*), accompanied by chanting and deplorable music'.[11] But Empson was not the type to be dismayed by such evidence of quotidian human goings-on, and the place had an effect on him that was palpable to his friends. Even after his return to England two and half years later, I. A. Richards's wife Dorothea was able to report, 'he seems to have been bowled over by Nara'.[12]

What had bowled Empson over in particular were two sculptures kept at the great Buddhist temple of Horyu-ji, and one at the Chugu-ji Buddhist nunnery next door, both about twenty minutes' local train or rickshaw ride from Nara station in the tiny village of Ikaruga. The two complexes were constructed during the opening years of the eighth century after an older temple founded by Prince Shotoku, Japan's most famous early patron of Buddhism, had been struck by lightning and burned to the ground. Buddhism was a new religion in Japan in those days, having reached the islands from the northern Chinese end of the Silk Route via the cosmopolitan Korean kingdom of Baekje. With regard to the sculptures, the exact nature of the cultural trade winds that operated between the cultures of the Korean peninsula and those located on the Japanese archipelago has become, largely for political reasons, a horribly vexed debate. Were they made in Korea and exported to Japan? Were they made in Japan but by Korean artists? Were they made in Japan by Japanese artists who just incorporated conventions imported from Korea and from northern China? A large number of scholarly column inches have been expended in attempts to answer these questions, and the waters of the debate have become progressively muddier as

[10] Katharine Sansom to Alizon Slingsby, 15 April 1929. Katharine Sansom, *Sir George Sansom and Japan* (Tallahassee: Diplomatic Press, 1972), 31.

[11] T. Philip Terry, *Terry's Guide to the Japanese Empire including Korea and Formosa* (Boston and New York: Houghton Mifflin, 1927), 558.

[12] Dorothea Richards's Journal, Old Library, Magdalene College, University of Cambridge. Cited in Haffenden vol. 1, 317.

nationalistic tensions in the region have grown. Even during the thirties, Empson noted with interest that his three main authorities on the topic—Ernest Fenollosa, J. Andreas Eckardt, and his friend from Tokyo George Sansom—all proposed conflicting origins for the sculptures, backing their theories with contradictory evidence largely based on hearsay. With characteristic disregard for the experts, Empson tends to present his own views not as fact but as opinion, deciding upon them only because he thinks they are more interesting than the other theories. 'The few great early statues', he suggests, 'are so far beyond any surviving Korean work that *it is more satisfying to believe* they were produced in Japan during one ferment of innovation.'[13]

The Nara sculptures had such a tenacious hold on Empson's imagination that he was able to get excited about them even twenty-six years later, when his wife Hetta was touring Japan without him. 'At last,' Hetta wrote to him from Nara, 'I saw your gorgeous Maitreya and large standing Kwannon [i.e. Kannon]. The Kwannon came as a great shock. It must be the most beautiful sculpture in the world.'[14] Kannon is Gwan-eum in Korean and Guanyin in Chinese: all are localized names for the Bodhisattva Avalokitesvara. In Mahayana tradition—the dominant school of Buddhism in more northerly regions of Asia such as Tibet, Mongolia, most of China, and Japan—Bodhisattvas are 'saints' who have achieved enlightenment, but who have elected to remain manifest in the physical universe so that they can help other beings towards the same spiritual goal. Avalokitesvara is specifically identified with the quality of compassion—the name in Sanskrit means *the one who looks down and listens*—and is by far the Bodhisattva most frequently depicted by artists across Asia.

The particular image of the divinity that Hetta's letter praises so extravagantly was displayed in the Kon-do (main hall) of Horyu-ji, and was a seventh-century piece traditionally known in Japan as the Kudara Kannon (Fig. 39). Kudara is what the Japanese used to call the kingdom of Baekje, and though this artwork has a stronger claim than most to some form of Korean provenance, its construction from camphor wood (the preferred medium for religious sculpture in Japan) again makes its point of origin impossible to pinpoint with any certainty. A willowy, attenuated figure measuring more than two metres from head to toe, and with a base and halo-like mandorla that add another metre to its height, it is hardly surprising that the figure impressed Hetta. She was a sculptor herself, having served as an apprentice in her native South Africa to the architectural sculptor Ivan Mitford-Barberton, and would have appreciated the work that had gone into it as well as its aesthetics. It had been made using the *ichiboku zukuri* method,

[13] p. 47.

[14] Hetta Empson to William Empson, 14 July 1957. Cited in John Haffenden, *William Empson Against the Christians* (Oxford: Oxford University Press, 2006; hereafter Haffenden vol. 2), 410 (my italics).

meaning the artist had carved it more or less whole from a tree-trunk rather than fitting it together from smaller, separately prepared components.

An earlier literary visitor from London, the poet and British Museum curator Laurence Binyon, had been able to witness some of the carving of an identical Kudara Kannon at first hand. He was in Japan to deliver a short programme of talks on English Literature in 1929, about two years before Empson arrived to take up a longer-term appointment in the same field. Binyon had been using lantern slides of artworks from Horyu-ji for the past two decades in his well-attended lectures on East Asian art at places like London's Albert Hall, but had never previously seen them 'in the flesh'. The lectures had, among other things, introduced Japanese sculpture to members of London's pre-First World War avant-garde such as Ezra Pound, and Binyon's slides of the Kudara Kannon may even have formed the basis for the mysterious figure of Kuanon, who appears throughout the American poet's later *Cantos*.[15] In Nara, Binyon asked his Japanese hosts whether a full-scale copy of the sculpture could be made for the British Museum. Failing to anticipate the complexity of such an undertaking, he thought he would be able to take the completed sculpture with him when he went home, but in fact Niiro Chunosoke, a renowned contemporary maker of Buddhist images, was occupied for two full years in carving it after scouring the district for a suitably auspicious camphor tree.[16] After he got back to London, Empson made a trip to the British Museum to see the finished article, but could not help noting that 'it does not grapple with the problem of copying the face'.[17]

Empson must have been very disappointed, for the face of the original Kudara Kannon was what set a lot of his ideas about Buddhist sculpture into motion (Fig. 40). Looking up at it in the kon-do (main hall) at Horyu-ji temple, he could see that the left and right profiles appeared to show expressions that were quite dissimilar to one another. 'The puzzlement and the good humour of the face are all on the left, also the maternity and the rueful but amiable smile,' he observed. 'The right is the divinity; a birdlike innocence and wakefulness; unchanging in irony, unresting in good works; not interested in humanity or for that matter in itself.'[18] Going next door into the Chugu-ji nunnery, Empson was able to perceive a similar ambiguity in the face of the Maitreya figure that would later become the second of the two sculptures Hetta sought out on her own trip to Nara (Figs. 48–50). 'The calm left is a normal Buddha face,' he noted; 'from the right you can extract various sorts of child according to the lighting. It is a wonderfully subtle and tender work.'[19] He had evidently told Hetta something very similar, and must also have shown her a photograph, for she tells him in her

[15] See Rupert Richard Arrowsmith, *Modernism and the Museum: Asian, African, and Pacific Art and the London Avant Garde* (Oxford: Oxford University Press, 2011), especially 200–15.

[16] John Hatcher, *Laurence Binyon: Poet, Scholar of East and West* (Oxford: Clarendon Press, 1991), 252.

[17] p. 100. [18] Ibid. [19] p. 121 (Appendix).

letter that 'the seated Maitreya is all that I expected only far warmer and more loving than the picture'.[20]

Maitreya is the second most frequently depicted Bodhisattva in the art of the Mahayana Buddhist tradition. Gautama Siddhartha, born in Lumbini in modern-day Nepal sometime near the beginning of the fifth century BCE, is considered to have been the fourth being to attain Buddhahood during the current aeon. Maitreya, who is often nicknamed *the future Buddha*, is to be the next and final one, and is predicted to arrive at a time when Gautama's teachings have been forgotten or are misunderstood. Knowing this led Empson to interpret the 'calm left' and childlike right of the Chugu-ji figure's face as 'a conscious effort to describe the unborn creature in the heavens with its Buddha nature not fully developed'.[21] This is another artwork associated with Prince Shotoku and with Korea, but, similarly to the Kudara Kannon, its construction from camphor wood makes it equally likely that it was carved locally. It emulates an earlier piece, also admired by Empson, which certainly was imported from the Asian mainland. Held 30 kilometres away at Koryu-ji temple in Kyoto, this second Maitreya image is carved from red pine—a tree regularly used in sculpture on the Korean peninsula but far less so in Japan—and is probably the sculpture listed in certain Japanese historical documents as having been received as a gift from Baekje at the beginning of the seventh century (Figs. 44–6). Empson was quick to note its similarities with the Chugu-ji version. 'I take it that a childish charm is still present in the unborn Buddha,' he noted with regard to its facial expression; 'but he is all the while plotting to appear in glory as a redeemer.'[22]

Back at Horyu-ji, there was a third, uniquely mysterious sculpture that Empson would remember more vividly than either of the other two. Answering Hetta's letter in the summer of 1957, he seems genuinely perturbed not to have heard it mentioned. 'Look, I am glad you liked the statues,' he wrote in response to her praise of the Kudara Kannon and the Chugu-ji Maitreya; 'but I don't gather that you have seen the Yumedono Kwannon, which is the one I was fussing about before. Do insist on that.' She would need to have insisted on it, for the Yume-dono Kannon falls into the category of *hibutsu*, or 'secret Buddha', meaning that it is kept under lock and key, and is only aired out twice a year for very brief periods (Figs. 36–8). Prior to 1884, it had never, as far as anyone could remember, left the confines of its sealed shrine. In that year, Ernest Fenollosa, one of the earliest Westerners to become an authority on Japanese art, prevailed on the authorities at Horyu-ji to unlock it. 'I shall never forget our feelings as the long disused key rattled in the rusty lock,' he wrote later, describing the event. 'Within the shrine

[20] Hetta Empson to William Empson, 14 July 1957. Cited in Haffenden vol. 2, 410.

[21] p. 100. [22] p. 98.

XX THE FACE OF THE BUDDHA

appeared a tall mass closely wrapped about in swathing bands of cotton cloth, upon which the dust of ages had gathered. It was no light task to unwrap the contents, some 500 yards of cloth having been used [...] it was the aesthetic wonders of this work that attracted us most.'[23] For his own part, Empson agreed that the Yumedono Kannon was 'perhaps the most beautiful of these early Japanese statues' even though it did not seem to fit in with his quickly emerging theory of facial asymmetry. 'I had best end with it,' he concludes in his essay 'Buddhas with Double Faces' 'not to appear crazy over the split-face theory; because the face seemed to me completely symmetrical on the two occasions that I saw it.'[24]

The fact that Empson had been able to see the Yumedono Kannon twice on different visits to Nara tells us that he was prepared to pay a guide to accompany him. On top of the temple's gate charge for tourists of two *sen*, an official guide could be engaged for a further twenty-five, which was the equivalent of six United States cents in the mid-thirties (the price of a newspaper, or in today's money about $1.50 in real terms). These guides were equipped with keys to otherwise restricted parts of the site, and would have opened up the locked shrine in the Yumedono, or 'Dream Hall', of the temple in exchange for a small additional tip.[25] Empson seems to have engaged guides as a rule on his subsequent visits to Buddhist sites elsewhere, although their services were not always as useful to him as they had proved at Horyu-ji. Years later, his guide to Bodh-Gaya in India, 'filthy and naked except for a loincloth and a pendant asserting that he is the British Empire's official guide', kept assuring him 'that all statues belong to the Asoka period, from which no statues survive'.[26] These are small points, but they serve to introduce a more significant one: when researching his theories on Buddhist art, Empson always insisted upon seeing the original sculptures in their traditional contexts. Already with a view to collecting his observations into a book, he had begun to collect photographs of various key works, 'not that any photo is more than a souvenir', he was apt to caution, 'or one wouldn't take the trouble to go'.[27] Photographs, then, were never able to substitute for a personal encounter with an artwork set in its living environment. In the wake of the Nara visit, Empson began to travel increasingly further afield and to put up with progressively more challenging travelling conditions, all with the objective of enabling further such encounters.

Soon after the trip to Nara, Empson decided to make a sea voyage to Korea in order to follow the timeline of East Asian sculpture back beyond the horizon of the pieces he had seen at Horyu-ji and Chugu-ji. Once again he was on the same trail the Sansoms had followed a few years previously, and for precisely the

[23] Ernest Fenollosa, *Epochs of Chinese and Japanese Art* (London: Heinemann, 1912), vol. 1, 51.
[24] p. 121 (Appendix).
[25] Terry, *Guide to the Japanese Empire*, 585.
[26] William Empson to George Sansom, 2 September 1934. Cited in Haffenden vol. 1, 316–17.
[27] William Empson to John Hayward, 7 March 1933. *Letters*, 57.

same reasons. 'For George's book,' Katharine Sansom explained about their own trip, 'to see the art products that fathered those in Nara, the visit is essential'.[28] Like his friends, Empson would doubtless have taken the government-operated boat-train to Busan from Tokyo via the south-western Japanese port of Shimonoseki, which offered an eight-hour crossing in new and comfortable vessels for twelve yen.

Empson's route passed through the Strait of Tsushima, where a strictly enforced prohibition against photography would have reminded passengers of the area's strategic sensitivity. In 1904, Tokyo had come to blows with Moscow over what were seen as aggressive inroads by the Russians into territory that the Japanese considered part of their own sphere of influence—namely the Korean peninsula and north-east China. Hostilities came to a head the following year, when the Baltic fleet sailed through the strait on its way to reinforce Russian ships at the Chinese port of Lushun. It was met by the Japanese Admiral Togo, who sank most of it in what is generally regarded as one of the most dramatic pitched battles in naval history. The victory—the first in recent history by an Asian maritime power over a Western one—bolstered the confidence of military strategists in Tokyo, leading directly to the full-scale occupation of Korea in 1906. This policy was initially justified by the Japanese in terms of the need to establish a bulwark against future Russian aggression, but rapidly segued into overt colonialism, and the peninsula was formally annexed by Japan four years later. By the time Empson arrived, an American guidebook was able to note that his destination city of Busan 'resembles a transplanted bit of the hustling Island Empire'. Foreigners were not even required to take passports if they were travelling there from a Japanese port.[29]

Seoul, too, had lost much of its indigenous character. Empson noted that the Gyeongbokgung, built at the turn of the fourteenth century and the most important of Seoul's royal palaces, 'had a fine site in town with a great avenue in front of it, and the Japanese have built an administrative barrack to usurp the view'.[30] The building was in fact the Government House of the Japanese colonial regime. It had been designed in a European neoclassical style by Nomura Ichiro and Georg de Lalande, the latter a German architect whose practice was based in Yokohama. Empson's use of the verb 'usurp' in his description of the building's positioning was perceptive. A significant number of buildings at the front of the Gyeongbokgung compound had been razed in order to accommodate it, so that

[28] Katharine Sansom to Alizon Slingsby, 23 October 1923. Katharine Sansom, *Sir George Sansom and Japan*, 26.

[29] Terry, *Guide to the Japanese Empire*, 694–5. One contemporary traveller, the artist Elizabeth Keith, however reported being questioned and confined to a hotel in Nagasaki when she tried to return to Japan without her passport from a short trip to Korea. Elisabeth Keith, *Eastern Windows* (London: Hutchinson, 1928), 122.

[30] Quoted in Haffenden vol. 1, 316.

views of the palace from central Seoul were deliberately blocked by a powerful symbol of Japanese political hegemony.

Empson found more to like at another of Seoul's palaces, the sixteenth-century Deoksugung, a short ride away on an electric tram. Parts of this had also been demolished by the Japanese, but in this case to make way for an ambitious botanical garden and an art museum. It was here that Empson found what he had come to Korea for, an object he describes in *The Face of the Buddha* as 'a life size bronze Maitreya (sixth century) [...] a very fine creature in itself, and of interest for its likenesses to the greater sculpture soon afterwards accomplished in Japan'.[31] He includes with the manuscript some photographs of the famous seated figure of the Bodhisattva Maitreya (*Mireuk Bosal Bangasang* in Korean) that is often known these days simply as *78* after its position on the list of the country's National Treasures (Figs. 33–5). Empson makes it more obvious that it is this sculpture he is describing when he compares the 'conventional cloud patterns' of the figure's drapery to those of the Maitreya he had seen at Chugu-ji in Nara, which have the same geometrical quality. Interestingly, however, at the time he saw the sculpture, he did not think it inferior to the things he had seen in Japan, but rather the opposite. 'I only remember one large bronze Maitreya,' he says in a letter written just after his return to Tokyo; 'the same type as the one at Koriuji [Koryu-ji], and I think better.'[32] 'I have no decent photographs', he goes on to say, and it is possible that he reversed his opinion much later in London, by which time photographs, with all their disadvantages, were the only method via which he was able to compare the sculptures and to recall their relative merits. In *The Face of the Buddha*, however, as in the letter, he dwells with particular emphasis on the modelling of the hands, the tubular fingers of which are very similar in the Seoul piece and the one in Kyoto. 'They seem at first mere cylinders bent crudely with tweezers when hot enough to be soft,' he observes. 'But you begin to imagine what it would feel like to have those hands, and realise that if you saw them in a living creature it would affect you as divine.'[33]

Empson was a great deal less impressed with the other artworks he saw in Korea. Taking the train back south, he stopped off at the coastal city of Gyeongju, and hiked a couple of hours up into the nearby mountains to look at the cave temple of Seokguram, today a UNESCO World Heritage Site and the peninsula's most famous Buddhist monument. A dome-like man-made grotto of interlocking granite slabs, it had been built during the mid-eighth century, at the height of the North South States Period that followed Baekje's defeat and assimilation by the eastern Korean kingdom of Silla. The grotto faces east, and may partly have been intended as a magical palliative against attacks by pirates from the lawless western

[31] p. 44. [32] Quoted in Haffenden vol. 1, 316. [33] pp. 44–5.

coast of Japan. By the time Empson visited, the place had spent two decades in the hands instead of Japanese archaeologists, who, like their European counterparts elsewhere in Asia, were given to implementing half-baked, if originally well-intentioned, restoration projects. Though by no means as catastrophic as the botched attempts by the British to restore India's Buddhist caves at Ajanta, these had already caused considerable damage to the artworks of Seokguram. The first blunder, occurring just before the First World War, had been to plug the gaps in the rounded structure by sheathing it in concrete, a measure that negated airflow and led to a thick growth of mould across every interior surface. A coating of bitumen was subsequently laid onto the concrete, which exacerbated the airflow problems still further. By the late 1920s things were so bad that an attempt to clean the sculptures had to be made using an industrial steam-jet.

Visible through a thick glass seal erected during the 1960s that gives today onto an air-conditioned, temperature-controlled environment, Seokguram's central sculpture still dominates the space inside the compromised granite dome (Pl. 5). Done in the same white granite as its surroundings, the figure is not a Bodhisattva, but the historical Buddha, Gautama Siddhartha, positioned in the *Bhumisparsha Mudra*—his right hand reaching down to touch the ground with its fingertips, effectively calling upon the earth to witness his enlightenment. It was this sculpture, five metres tall including its lotus base, that the British Museum curator Laurence Binyon and his friend Robert Lockheart Hobson had climbed into the hills above Gyeongju to see just a few years before Empson went himself. Hobson was awestruck enough to call it 'one of the best existing examples of Buddhist sculpture of the period'.[34] Empson tended to disagree. Even at this early stage, it seems he was already looking for evidence to support his ideas about different expressions on each side of the faces of Buddhist figures. The Seokguram Buddha, with its highly symmetrical visage, therefore left him completely cold—he thought it looked like 'a great slug [...] where only the little root-lets of the earth-touching fingers seem still alive'.[35]

There was still further to go, however, in tracing the aesthetic lineage of the Nara figures back to their early origins, and more opportunities to explore his theory more deeply. The next stop on Empson's sculpture tour would be the rock-cut Buddhist temple complex at Yungang in northern China—once the eastern terminus of the Silk Roads that had brought Buddhism to East Asia from India. The only way to get to Yungang from Tokyo was via Peking (today's Beijing), and in March 1933 Empson would again have resorted to a boat-train, this time probably via the port city of Dalian in northern Manchuria. The 1920s

[34] R. L. Hobson and Laurence Binyon, 'A Journey to the Far East', *The British Museum Quarterly*, vol. 5, no. 1 (June 1930), 35.
[35] pp. 40–1

had seen the Japanese army take advantage of the power vacuum in north-east China left by the retreating Russians to consolidate its grip on the region. Two years before Empson's visit, a very minor terrorist attack was used as justification for the full-scale occupation of Manchuria and the imposition of martial law. The Japanese then brought in the former Qing Emperor Puyi, who had been forced by a series of uprisings to abdicate as sovereign of China in 1912, and installed him as puppet ruler of the newly invented state of Manchukuo.

The South Manchuria Railway, upon which Empson would have travelled as far as Mukden, was itself designed to assist a projected future invasion of the rest of China, with its first president writing in company missives of '*buso teki bubi*', meaning 'soldierly preparedness in civilian garb'.[36] Probably because of its concealed military character, the railway functioned with an efficiency that impressed its Western passengers. Empson's contemporary, the popular travel writer T. Philip Terry, found it 'as modern, as safe, and as dependable as the best American railway'. At Mukden, Empson would have switched to the Chinese Eastern Railway, still run until 1935 by the Russians, upon whose trains Terry informs us, 'the soap is bad, the towels are sleazy, but a trifle larger than handkerchiefs [. . .] the lavatories at the end of the aisles are medieval'.[37] Such contrasts were certainly not lost on Empson, who would write a poem, 'The Beautiful Train', about them four years later, on the occasion of having switched to the South Manchuria Railway from the Trans-Siberian. 'The train itself was beautiful after the Russian one all right', he would note then in explanation of the poem's title.[38]

Empson found Peking, like Gyeongju, disappointing as regarded his primary objective of looking at Buddhist art. John Haffenden tells us that one of his first stops in the city was 'a white dagoba to the north-west' of the Zijin Cheng, or Forbidden City palace.[39] This would have been the Bai Ta pagoda that crowns the rocky island at the centre of the *Beihai*, or 'Northern Sea', which is actually a freshwater lake at the centre of an ornate park. Built in its current form during the seventeenth century, the pagoda had been designed to resemble a *chorten*—a Tibetan version of the traditional Buddhist reliquary mound. Though it is clear from accounts by contemporary travellers that many examples of Buddhist sculpture were on display there at the time, not one of them succeeded in capturing Empson's attention. Back at his hotel, he wrote in disappointment to Richards that the city possessed 'no Buddhas of any merit'.[40]

[36] Joshua Fogel, *The Cultural Dimension of Sino-Japanese Relations* (New York: M. E. Sharpe, 1995), 118–21.

[37] Terry, *Guide to the Japanese Empire*, 756–9.

[38] William Empson, note on 'The Beautiful Train' in *The Gathering Storm* (London: Faber and Faber, 1940).

[39] Haffenden vol. 1, 432.

[40] William Empson to I. A. Richards, 2 April 1933. *Letters*, 61.

The reason for Empson's disappointment is not difficult to figure out. The sculptures at Bai Ta were all Lamaist pieces from Tibet—an art tradition for which he was never able to muster much enthusiasm. 'The appalling character of the climate has affected the religion and customs of the country,' he says in *The Face of the Buddha*, 'and much Thibetan art is merely nightmarish.'[41] Peter Quennell, whose idiosyncratic travelogue *A Superficial Journey through Tokyo and Peking* Empson knew, had reacted in exactly the same way on his own visit to the Bai Ta a few years previously. Before the Red Guards smashed it to pieces during the Cultural Revolution, a very large image of Yamantaka (a wrathful aspect of Manjusri, the Bodhisattva of Wisdom) used to occupy the space at the foot of the pagoda (see Pl. 22 for a similar example). 'It was difficult to look at this tawdry demon, fresh painted and in excellent repair, without a moment of disgust and even alarm', says Quennell, adding that 'the creations of the Lamaistic cult have a loathsomeness transcending all absurdity [...] they seem, as do the Aztec gods and goddesses, to have sunk their roots deep in blood and squalor, till their meanest manifestations are genuinely horrible'.[42] Such routine misunderstanding of wrathful Lamaist deities is just as widespread today, but these fierce beings, many of whom were carried over into Tibetan Buddhism from the shamanistic village cults collectively known as Bon, are recognized within the tradition as protective figures whose violence is deployed not towards, but in defence of the devotee.

If there is a question that is troubling the minds of readers familiar with the art collections of Beijing, it will be this: was Empson's dismissal of the city's Buddhist sculptures meant to include the Jade Buddha that occupies Behai Park's Cheng-guang Dian, or 'Hall that Receives Light'? At the time of Empson's visit, this enigmatic carving of Gautama Buddha was believed by many commentators to have come from Cambodia (Pl. 3). Its style and construction materials are conspicuously Burmese, however, and it is now considered far more likely that King Thibaw Min sent it from Mandalay as a gift to the Guanxu Emperor during the second half of the nineteenth century. Shaped out of a pale block of fine stone, one and a half metres in height, it is one of Peking's most arresting and beautiful artworks. The face is particularly fine, and the fact that it seems to illustrate many points of Empson's theories on asymmetry make it incredibly unlikely that he saw it and then chose to leave it out of *The Face of the Buddha*. If one looks particularly at the eyes, one can see immediately that the pattern Empson perceived in the face of the Kudara Kannon at Horyu-ji is also here. The left side of the face has a level eye and an overall expression of detachment, while the incline in the angle of the other eye and the 'Mona Lisa smile' in the corner of the mouth make the right side of the face appear to engage sympathetically with the viewer.

[41] p. 34.
[42] Peter Quennell, *A Superficial Journey through Tokyo and Peking* (London: Faber and Faber, 1932), 81.

The fact that Peter Quennell also fails to mention the Jade Buddha in his own, otherwise very detailed description of Behai Park is suspicious, and makes one think there may have been something that prevented either traveller from taking note of it. The Cheng-guang Dian building, which houses the sculpture, is located on a spur of the park's island next to the bridge that connects it with the lakeshore, and is often overlooked by sightseers heading for the Bai Ta even today. L. C. Arlington and William Lewisohn, whose guidebook-cum-travelogue *In Search of Old Peking* came out shortly after Empson's visit, note in addition that its glass doors were 'kept carefully locked and sealed' allowing the visitor only to 'catch a glimpse of the famous "Jade" Buddha seated on a raised platform in the background'.[43] Juliet Bredon, who had visited the site a few years earlier to research her own guidebook, adds that the view through these panes was further obstructed by something she frostily describes as 'Nottingham lace curtains'.[44] Even if Empson had discovered the Cheng-guang Dian, then, he would not have been able to get anything like a good enough look at the Jade Buddha to describe its aesthetic qualities.

There is something else important about Empson's letters home from Peking. They demonstrate not only that Empson's experiences with Buddhist sculpture had fundamentally affected his thinking on visual culture, but that they were beginning to inform his approach to philosophy in general. It was again from his hotel just outside the German section of Peking's Legation Quarter that he penned the letter to John Hayward that contains the statement I used to begin this introduction: 'the Buddhas are the only accessible Art I find myself able to care about.' Empson was sitting on a barstool and was 'half drunk' as he tried to read Edward A. Westermarck's *Ethical Relativity*, 'a stupid book about Theories of Value' that he was in the process of discussing by mail with I. A. Richards.[45] The book basically says that the development of moral values is determined by the reactions of an individual to particular stimuli, and that judgements of *good* and *bad* are therefore based on the said individual's specific cultural background and upon socialization rather than deriving themselves from anything impersonal and universal. 'Buddhism is relevant to what I am trying to think about, in connection with the Value business', Empson then wrote to Richards from his barstool, adding in parentheses, 'what a stupid writer Westermarck is'.[46] The main reason the discussion about *Ethical Relativity* is interesting is that, after having brought in Richards's own opinions on the subject, and also those of the psycho-analyst Roger Money-Kyrle, Empson begins deliberately to argue from a Buddhist standpoint. 'The Buddhist position as I understand it,' he says to Richards, 'is that

[43] L. C. Arlington and William Lewisohn, *In Search of Old Peking* (Peking: Henri Vetch, 1935), 80.

[44] Juliet Bredon, *Peking: A Historical and Intimate Description of its Chief Places of Interest* (Shanghai: Kelly & Walsh, 1931), 147.

[45] William Empson to John Hayward, 7 March 1933. *Letters*, 57.

[46] William Empson to I. A. Richards, 2 April 1933. *Letters*, 61.

impulses within causation are essentially avoidances of pain, and that (apparent) satisfactions are harmful because they are creators of desire which eventually produce more pain [...] there are positive satisfactions, but they are essentially apart from causation and therefore "impersonal".' Empson very obviously finds the 'the Buddhist position' to be the most rational of the four discussed, and such insider thinking would increasingly become a hallmark of his discussions of Buddhist ideas, and of his approaches to East Asian culture in general.

Given his disappointment in Peking's Buddhist artworks, it is fortunate that they only represented a sideshow for Empson. The sculptures he had really come to China to see were 275 kilometres due west. 'No train to the caves with Buddhas in a loop of the [Great] Wall till Tuesday', he complained to Richards. He was talking about the grottoes of Yungang, a collection of meditation halls and monastic dwellings cut from the living rock during the fifth and early sixth centuries. This had been the time of the Northern Wei, a regional dynasty of either Turkic or Xianbei ethnicity, and the most important early patrons of Chinese Buddhism. Buddhism had been known in China since at least the beginning of the Common Era, but had usually been perceived as an alien religion. Its artworks were mainly imported, and it was able to flourish only by emphasizing its points of convergence with indigenous systems of thought such as Confucianism and Taoism. Their position on the Silk Route, which led to Central Asia and ultimately to India, made Northern Wei territories a vibrant interface between the Buddhist world and the rest of China. With the adoption by the Northern Wei of Buddhism as a state religion, it was not long before monastic sites such as Yungang became home to the first Buddhist sculptures with unmistakably Chinese characteristics.[47]

According to the railway timetables for 1933, the only way that Empson could have reached Yungang by train would have been to travel to nearby Datong on the sixteen-hour night service, which arrived at its destination at around four in the morning. Unfortunately Datong, the erstwhile Northern Wei capital, was still 16 kilometres away from the caves. There was no paved road, and so the only option for this final stretch was a bullock-drawn cart of the crudest possible design, with a mobile axle and solid wooden wheels. 'Always rather embarrassing to wonder what one gets out of travel to make up for its privations,' Empson wrote to John Hayward on arriving back in Peking, 'except that it requires so much imagination to stay at home.'[48] The American watercolourist Mary Augusta Mullikin had used the same route to get to Yungang a year previously, and wrote the following evocative description of the approach to the grottoes:

[47] See James O. Caswell, *Written and Unwritten: A New History of the Buddhist Caves at Yungang* (Vancouver: University of British Columbia Press, 1988).

[48] William Empson to John Hayward, 7 March 1933. *Letters*, 57.

Jogging in our heavy carts though the almost dry, stony bed of the Shih Li river, past miles of scantily populated land, we felt a pervading curiosity growing to excitement as we neared our goal. The cliffs grew higher; there were a few premonitory caves flanked by carved figures; then a bend in the road revealed the little village, the gleaming tiles of a temple and the black mouths of caves in tiers and rows up the face of the cliff.[49]

For his own part, Empson was interested to see the ways in which the carved figures had been adapted to reflect what he thought were typically Chinese social norms (Pl. 16). 'The novelty about the first Buddhas in China is that they have already a suggestion of ironical politeness and philosophical superiority,' he noted later in *The Face of the Buddha*. 'Delicious conversation pieces are found in progress between the reserved but winking figures, withdrawn like the classical Chinese poets from the vulgar herd rather than the world.' He was thinking here about one of the most popular motifs in Chinese Buddhist art, the meeting between Gautama Siddhartha—the historical Buddha—and another Buddha from a previous world-age named Prabhutaratna. This illustrates a story from the Lotus Sutra, one of the most influential texts of the Mahayana tradition, in which Gautama demonstrates the eternal nature of the Buddha by calling upon Prabhutaratna to manifest himself in the present moment in order to enter a philosophical discussion. Empson was correct in seeing the many carvings of Gautama and Prabhutaratna at Yungang as particularly relevant in a Chinese context, for the emphasis of the myth on the importance of continuity between past and present, and upon reasoned dialogue as a strategy for under-standing, meant that it converged very effectively with pre-Buddhist Chinese tradition.

Empson's letter to John Hayward about Yungang also reminds us once again of the central importance he placed upon examining sculpture 'in the flesh' rather than via photographs. Some of the 'privations' he had to endure in order to keep doing this have already been described, and still more ambitious voyages in search of Buddhist art—to Cambodia's Angkor Wat, to Anuradhapura in Ceylon (to-day's Sri Lanka), and to the Ajanta caves in central India—were yet to come. Unlike the sterile museum environments in which he had examined Buddhist art in Seoul and Tokyo, Yungang was still a functioning network of temples, albeit a pale shadow of its former self and with the barest skeleton crew of monks. As in Nara, therefore, Empson was able again to get a sense of the sculptures in their living context. He was lucky to be able to get any kind of sense of them, for the site was deteriorating rapidly both due to neglect and, unfortunately, to deliberate vandalism. 'When I was there in 1933 vast numbers of the heads had already been hacked off for private sale,' he recalls in *The Face of the Buddha*. 'Some of the caves

[49] Mary Augusta Mullikin and Anna M. Hotchkis, *Buddhist Sculpture at the Yun Kang Caves* (Peiping [Peking]: Henri Vetch, 1935), 18.

had goats in them, and there had been falls of rock from the cliffs which were expected to end in the collapse of the caves.'[50]

An examination of these disembodied heads encouraged Empson to think he might actually be on to something with his ideas about asymmetry. Because they had been lined up on the ground for sale, it was easy to compare their facial expressions, and to shape his very specific reactions to sculptures seen elsewhere into a more general theory. It seemed to him now that the asymmetry was the result of a compositional 'trick' whereby 'in the right hand face, as usual, the lines slant upwards from the centre; in the left hand face similar lines are horizontal or are made to seem so' (Pl. 9 & 10, Fig. 61). After a while, he was able to simplify things still further. 'The single rule *more slant on the right*', he thought, 'would cover most of the ground.'[51]

The question was whether anybody would agree with him. Ever since the earliest version of the asymmetry theory, roughed out while standing in the middle of Horyu-ji temple a year earlier, he had been scouring the scholarly literature for anything that might fit in with what he thought about the Buddhist sculptures he had seen, but without very much success. 'It is shocking to think how I have failed to get on with any experts about them,' he told Richards, 'but after all many experts prefer you to know something about their subject before they "get on" with you.'[52] Ever the polymath, Empson's instinct was instead to look at other disciplines for corroboration. 'There is obviously a great deal to be said about how they get their effect,' he said to Richards of the asymmetrical visages at Nara, 'simply on the lines of Darwin's book about the origins of facial expressions.'[53] He was talking about Charles Darwin's *The Expression of the Emotions in Man and Animals*, an 1872 study of non-verbal communication across various cultures. Unusually cosmopolitan for a work composed in Britain at the apogee of European colonial banditry, Darwin's book strongly emphasizes that 'the different races of man express their emotions and sensations with remarkable uniformity throughout the world'.[54] This perceived universality of looks signifying everything from terror to love is what allows Empson, in *The Face of the Buddha*, to apply his ideas about asymmetry not only to historical Buddhist sculpture but also to more recent Western art, and even to mugshots of contemporary celebrities such as Winston Churchill. In 1934, on the eve of his final departure from Japan, he was still thinking about books in English that might have had something in them to help lend more scholarly authority to such

[50] p. 36. [51] p. 92.

[52] William Empson to I. A. Richards, 2 September 1932. *Letters*, 45.

[53] William Empson to I. A. Richards, 23 April 1932. *Letters*, 42.

[54] Charles Darwin, *The Expression of the Emotions in Man and Animals* (London: John Murray, 1872), 139.

experiments. 'Imbecile of me not to have asked you for those books a year ago,' he wrote to Richards then. 'It is too late now to try and get them discovered and sent out, while one is still in reach of the statues.'[55]

Despite the difficulty of obtaining books in English, residents of Japan had one very considerable advantage over those of Western countries—namely the ease of arranging a meeting with a global authority on Buddhist thought. With this in mind, Empson took himself over to Tokyo Imperial University (today's Tokyo University) to discuss things with Anesaki Masaharu, an international scholar of philosophy and religion who had previously taught at the universities of Harvard and Chicago, and at the Collège de France. Empson chatted to Anesaki about the early Buddhist sculptures he had seen in Nara and Kyoto before 'very timidly' outlining his ideas about asymmetry. Empson was 'expecting him to treat it as a fad', and was surprised instead to hear Anesaki say he thought the theory was more or less orthodox. Anesaki advised Empson to look into the way Noh theatre masks were manufactured, saying that they represented a continuation of the same aesthetic tradition, as 'the maker was taught to construct them with two expressions for two positions of the actor's head' (Pl. 8 & Fig. 60).[56]

Noh theatre has existed in its present form since the fourteenth century, when a cultural renaissance under the cosmopolitan Ashikaga Shoguns fostered vibrant developments in Japanese visual art and literature, as well as in theatre. The facial expressions of Noh masks are actually ambiguous in two quite separate ways. There is lateral asymmetry, in that the two sides of the face have subtly different expressions, and there is also a vertical ambiguity, in that the mask reveals contradictory moods depending upon whether the wearer's head is tilted backwards or forwards. Of the former kind of ambiguity—the lateral kind—the great contemporary Noh performer and mask-maker Udaka Michishige has the following to say:

The narrative [of a Noh performance] is divided into a first and a second half: in the first half an actor's movements place emphasis on the right side of the mask, and in the second, the left.

Because the Shite [protagonist] in the first half is a wandering spirit unable to rest in peace, the right side features an eye that looks downward; the cheek is gaunt, and the corner of the mouth downturned, as if to express the state of limbo. In the second half of the play the character's soul is cleansed by the offering of a memorial service, resulting in a calmer countenance: A left eye that gazes upward, a fuller cheek, and a corner of the mouth curved upward. Thus the right and left sides of the mouth are as different as yin and yang, and though the difference may be subtle in design terms, it is essential to keep in mind when making a mask.[57]

[55] William Empson to I. A. Richards, n.d. (1934). *Letters*, 77. [56] p. 83.
[57] Udaka Michishige, *The Secrets of Noh Masks* (Tokyo: Kodansha, 2010), 154–5.

Such aesthetics do indeed seem to sit with Empson's theories about Buddhist sculpture extraordinarily well, but unfortunately he seems only to have found out about the second, non-lateral type of Noh-mask ambiguity. 'The contrast is always vertical,' he writes in *The Face of the Buddha*, 'not one of asymmetry.' He is describing here the technique of carving the mask so that its expression appears to change depending upon whether the audience is looking at it from slightly below, or from slightly above. Udaka explains this as follows:

The action of pulling in the chin and angling downwards is known as *kumoru* or *kumorasu* (literally 'to cloud'); it represents sadness. Tilting slightly upwards is referred to as *teru* or *terasu*—literally, 'to brighten'—and this represents a cheerful, joyous state of mind. Such small alterations in angle dramatically change the countenance of the mask, and contribute greatly to the sophistication of the acting.

As with the Burmese Jade Buddha in Peking, then, it is unfortunate that Empson missed out with the Noh masks on what would have been an important corroboration to his theories about Buddha- and Bodhisattva-faces.

One question that the contemporary reader of *The Face of the Buddha* will definitely want answered is the following: do Empson's theories about asymmetry make any sense to *contemporary* scholars of Buddhist art or not? The answer is that to many they do not, but that the camp is divided. 'There is no religious textual basis or tradition in belief or practice that I know of for a non-symmetrical face for Buddhist images', Katherine Tsiang, currently Associate Director of the Centre for the Art of East Asia at Chicago University, wrote to me in late 2012. 'I think it is accidental when it occurs,' she added in a later message, 'and has to do with the fact that these images were carved by hand, often in difficult working conditions, like dark caves.'[58] Her opinion is echoed by Lukas Nickel of London University's School of Oriental and African Studies. 'I must admit that I have never looked for or noted such asymmetries,' he told me, 'although I would not expect the faces to be a hundred per-cent symmetrical as they were stone carvings [...] slight asymmetries may be the natural result of the carving (or casting in the case of bronzes) process.'[59] Professor Dorothy Wong at Virginia University is one of a very small number of Buddhist art experts familiar with Empson's writings on literature. Though she finds the asymmetry theory intriguing, however, she also remains sceptical. 'I am not aware of any writings that suggest the asymmetry seen in early East Asian (Northern Wei and Hakuho—or early Nara—Japanese) Buddha and bodhisattva faces to be intentional or carry specific meaning,' she told me. 'If anything, they are supposed to be idealized spiritual beings, detached from the world and transcending human emotions.'[60]

[58] Katherine Tsiang, email to the author, 5 and 6 December 2012.
[59] Lukas Nickel, email to the author, 4 December 2012.
[60] Dorothy Wong, email to the author, 5 December 2012.

Begging to differ, however, is the great Sinologist Victor Mair, who kindly wrote to me on the subject from the University of Pennsylvania. Professor Mair is the only global authority on Buddhist sculpture to have read the manuscript for *The Face of the Buddha* in any detail, and he finds its ideas about *deliberate* use of asymmetry by East Asian sculptors entirely convincing. Discussing Empson's idea that the right side of a sculpture's faces tend to communicate an active impression, and the more levelled-off features of the left a passive attitude, Professor Mair says, 'I fully agree with this insight and long ago arrived at it independently by myself, though I referred to the right side as the masculine / forceful / dominant side of the individual and the left side as the feminine / passive / recessive aspect of the individual—traits that I saw both in men's and women's faces.'[61]

At the risk of digressing into autobiography, I also recently had the opportunity of talking about asymmetry with one of the most famous purveyors of genuine and imitation antiquities of the city of Macao. He has asked not to be named in this account, but pointed out to me that even the most modern of the fake Yungang heads currently on the market, of which he was able to show me several examples, all replicate the asymmetrical visage noted by Empson in a highly palpable way. 'If it's symmetrical, it doesn't look like a Yungang head, so obviously they aren't going to make it any other way', he explained to me. When I asked whether he thought the creators of the imitations might have accidentally made them asymmetrical, he began to laugh. 'Are you serious?' He then said, 'These guys can make *by hand* a Michelangelo that even you wouldn't know from the real thing. If they put asymmetry into these heads, it's in the original. Do you think the people who made the originals were *less* skilled than they are?'

Empson was also keen to deride the idea that the asymmetry of the various Buddha and Bodhisattva faces he had seen had been created inadvertently. 'I have been told that these effects of asymmetry must be imaginary or accidental, or anyway can have no meaning of any importance, because the statues were made to order by simple masons who often would not understand the religion at all,' he writes in *The Face of the Buddha*. 'You can read things "into" a Far Eastern painting because it was made by a cultivated gentleman, but not into a statue, because it was not. This makes me impatient; I do not understand why a man troubles to become an expert on these things if he thinks they were made by dolts.'[62] He must have been comforted by the fact that one authority of his own time at least, Anesaki Masaharu, had given his theory the time of day. As to whose opinion of the asymmetry thesis is more convincing today, it is up to the reader to decide.

Professor Anesaki's *History of Japanese Religion* had come out in 1930, and was probably one of the large books Empson was seen reading by his friend Sato

[61] Victor Mair, email to the author, 11 December 2012. [62] p. 101.

Nobuo at the municipal swimming baths where he spent many of his days off during the warmer weather. It is telling that when Empson invited anybody for a day out around Tokyo, he tended always to select destinations where Buddhist art could be viewed. When the poet Hatakeyama Chiyoko travelled to the city to visit him, he suggested what seems at first sight a fairly bizarre combination—namely the sculpture galleries at the National Museum in Ueno followed by a Ginza ice-cream shop. Empson's biographer John Haffenden thinks the fact that Hatakeyama was known to be a Catholic makes Empson's decision to take her to the Ueno museum inexplicable, but Empson did not consider Buddhist art to be of interest only to Buddhist practitioners. Like paintings of Christian subjects from the Italian Renaissance, rather, he felt it to possess universal appeal, as his letter, already quoted twice, to John Hayward from Peking illustrates very clearly. Following a cultural destination with an ice-cream shop just demonstrates that Empson's understanding of traditional Japanese womanhood was considerably more profound than has generally been recognized, a proposition that we will have cause to revisit shortly. To Sato himself, who Empson's university colleague Fukuhara Rintaro thinks 'may have been a young doctor with a literary taste', he suggested a trip to the coastal city of Kamakura that would combine temple-hopping with swimming at the beach.[63]

About 80 kilometres from the centre of Tokyo, the place had been the seat of the Kamakura shogunate, which had exerted *de facto* rule over a large proportion of the country for around a century and a half beginning officially in 1192 CE. This was a period of relative disunity in Japanese history, with troops loyal to the shogunate clashing regularly with those of clans from the north and west of the country, and even at times with the Emperor's own soldiers. Perhaps because of the general sense of mutability and historical uncertainty that such a situation tended to encourage, it was also one of the most dynamic periods of Japanese history with regard to the appearance of new branches of Buddhist philosophy. Several of these appeared in the city of Kamakura itself, including the populist and accessible Nichiren group of schools, of whose beliefs and methods Anesaki Masaharu was a particularly enthusiastic proponent. A network of temples was established at Kamakura to rival that of Nara, but when Empson visited, much of the architecture would still have lain in ruins as a result of the Great Kanto Earthquake, which in 1923 had devastated the Tokyo area with the loss of more than a hundred thousand lives. The epicentre of the quake had been located beneath the bed of Sagami Bay just east of Kamakura, and had generated a ten-metre tsunami that flattened almost every remaining building along the coast. Caught up in the destruction was the Countess Mutsu Iso, author of *Kamakura:*

[63] Fukuhara Rintaro, 'Mr William Empson in Japan', in Roma Gill (ed.), *William Empson: The Man and his Work* (London and Boston: Routledge & Kegan Paul, 1974), 23.

Fact and Legend, a classic guide published in 1918 that Empson would certainly have known. Countess Mutsu, a Kamakura resident whose unmarried name had been Gertrude Ethel Passingham, was the wife of a Japanese diplomat who had met her while studying at Cambridge. When the earthquake struck, she had been swimming in the sea, from which she wisely extracted herself and scrambled up a nearby cliff before the subsequent tsunami rolled in. She has left the following account of the aftermath of the disaster:

The descent into the horror of the world below seemed to be a page from Dante's Inferno, beyond the possibility of ordinary language—a scene only a few moments before so gay and smiling, and now plunged in the twinkling of an eye into a barbarous caricature of crushed and burning dwellings; maimed and shattered people, with blood streaming from great wounds; the ground torn and rent by seams and fissures, and everywhere water left by the invading wave.[64]

Even leaving aside the effects of the Great Kanto Earthquake, the population of Kamakura had never recovered from the fall of its shogunate in 1333 and the intensive period of inter-clan warfare that followed it, one of the notable features of which was the relocation of shogunal power back to Kyoto by the ascendant Ashikaga regime. All of this meant that by the 1930s Kamakura was more a rural than an urban area, its dramatic landscape and beaches a popular destination for recreational day-trips by Tokyoites. 'Very small steep dark green hills looking out over acid light green flat ricefields and the sea,' Empson described the scenery to John Hayward the day after his own excursion in the company of Sato Nobuo. 'Damp boiling electric sunlight, with wild tiger lilies and great velvet black butterflies.'[65]

Sato later wrote up his own account of the day in the form of a 1935 essay in the journal *Eibungaku fukei,* or 'English Literature Landscape'.[66] One of the places he remembers visiting was Hase Dera, a coastal temple constructed in the eighth century to house Japan's largest sculpture in wood, a nine-metre, gilded representation of Juichimen Kannon Bosatsu, the eleven-headed version of Kannon. The sculpture was one of a matching pair said to have been carved from the trunk of a particularly large camphor tree discovered by the monk Tokudo, who enshrined the first at the original Hase Dera temple in Nara, and had the second thrown into the sea. The Kamakura version of Hase temple came into being after the second sculpture washed up fifteen years later on a beach on the nearby Miura Peninsula.

[64] Mutsu Iso, Foreword to second edition, *Kamakura: Fact and Legend* (Tokyo: Times, 1930), p. vii.
[65] William Empson to John Hayward, 12 July (1933). *Letters,* 67.
[66] 佐藤信男 (Satō Nobuo), エムプソンさんの憶ひ出 ('Emupuson-san no omoide', 'Reminiscences of Empson'), 英文学風景 (*Eibungaku fūkei, English Literature Landscape*), 2/1 (January 1935), 27–34. I am greatly indebted to my friend David Ewick for tracking down the original Japanese text of this article for me, and to Isaka Riho at Tokyo University for being kind enough to translate the parts relevant to this introduction.

At the time Empson visited, the immense carving was still lit for the visitor by the traditional method, which involved a monk hoisting a pair of lanterns on a rope in stages up the sculpture's façade, so that only one section of it became visible at a time. Lafcadio Hearn has left the best description of this gradual process of revelation:

More of the golden robe is revealed as the lanterns ascend, swinging on their way, then the outlines of two mighty knees; then the curving of columnar thighs under chiseled drapery, and as with the still waving ascent of the lanterns, the golden vision towers ever higher through the gloom, expectation intensifies. There is no sound but the sound of the invisible pulleys overhead, which squeak like bats [. . .] And at last a face, golden, smiling with eternal youth and infinite tenderness, the face of Kwannon.[67]

Empson did not think much of eighth-century sculptures from Japan, feeling them to be far inferior aesthetically to early masterpieces such as the Kudara Kannon and the Chugu-ji Maitreya. 'The later ones I can't like, though they are good sculpture (drapery and so on),' he explained to Sylvia Townsend Warner; 'the face rapidly becomes a slug-like affair with a pool of butter around the mouth.'[68] As with the Seokguram Buddha of southern Korea, then, the Hase Kannon was mainly a disappointment to Empson because of the conventionalized and symmetrical composition of its features, and he conspicuously leaves it out of the pages of *The Face of the Buddha*. What is really significant about Sato Nobuo's account of his and Empson's visit to the sculpture, however, is that Empson—the foreigner—plays the guide, while Sato himself—the local—is relegated to the role of the perplexed tourist. At one point, for example, Sato asks Empson about the significance of a line running beneath the nose of the sculpture, only to have Empson explain that it is actually a crack that occurred when the head of the sculpture was knocked off during the Great Kanto Earthquake. The exchange is just one more example of Empson's growing tendency to assume the perspective of an insider when it came to Buddhist art.

Around the corner from Hase Dera, the second largest metal sculpture in Japan gave Empson the opportunity to apply what he had understood from Professor Anesaki's comments about the connections between Buddhist statuary and Noh theatre masks. This was Kamakura's most famous landmark, the colossal *Daibutsu*, or 'Great Buddha', cast in the mid-thirteenth century out of 121 tonnes of bronze (Fig. 59). Despite the immense weight of the artwork, it was, like the nearby Hase Kannon, affected by the 1923 earthquake, which shunted it half a metre across its stone platform. Noticing that the undersides of the meditating figure's eyelids were covered in gold leaf, in contrast to the verdigris of the rest

[67] Lafcadio Hearn, *Glimpses of Unfamiliar Japan* (Boston: Houghton, 1894), 81–2.
[68] William Empson to Sylvia Townsend Warner, 4 June [1932]. *Letters*, 44.

of the sculpture, Empson formed the hypothesis that this had been deliberately—the intention being 'that the thing opens its eyes for you when you go up and pray under it'.[69] He was not to have known that the entire surface of the Daibutsu, which had been designed to sit inside a hall rather than out in the open air, had once been gilded in the same style as the Hase Kannon. The hall itself had been destroyed by an earlier earthquake and tsunami in the fifteenth century, and the sculpture's golden coating had gradually disappeared due to its subsequent exposure to the weather. The only exceptions to this were the sheltered patches immediately beneath its eyelids and earlobes. Despite this misunderstanding, however, the train of thought carried Empson to the more viable realization that it was less often the eyes, and more often the mouths of Buddhist sculptures that are apt to appear different when their faces are observed from various vertical viewpoints, appearing suddenly to be 'smiling in normal light, when you bob down and look at them from underneath'.[70]

So preoccupied was Empson by this time with sculpted visages and their subtleties of expression that he began to visit Kamakura for another, quite different reason: to attend art lessons, 'mainly in the hope of getting to understand faces'.[71] His teacher was Marjorie Nishiwaki (née Biddle), a talented English painter and Kamakura resident who was married to the surrealist poet Nishiwaki Junzaburo. Like her neighbour, Countess Mutsu Iso, Marjorie had met her husband while he was studying in England—in his case at Oxford. Empson was doubtless introduced to her by Katharine Sansom, for whose book *Living in Tokyo* she was at that time producing flowing, almost calligraphic illustrations in ink.[72] Despite her husband's preference for the most up-to-date movements in visual art, Marjorie maintained a robust allegiance to Henri Matisse's post-1905 Fauve manner, and enjoyed painting swimsuit-clad women on the Kamakura beaches in homage to the master's endless parade of frolicking bathers.

Only one of the paintings completed by Empson under Marjorie's tutelage appears to have survived. Known simply as 'William's Painting', it is a depiction in oils of a female nude walking beneath cherry blossoms, and with a basket carried upon her head (Pl. 25). One can see Matisse in the loose and expressionistic brushwork, in the use of unmixed colour applied direct from the tube, and in the areas of primed canvas left deliberately exposed. Like many French artists of the later nineteenth century, Matisse had his own fascination for Japanese art—in his case not Buddhist sculpture, but the *nishiki-e* woodblock prints that had previously influenced Monet and Van Gogh. Matisse allowed these to affect both the motifs and aesthetics of many of his Fauve period pieces. For his own part, Empson was not overly keen on *nishiki-e*, considering them to offer

[69] p. 83. [70] Ibid. [71] William Empson to I. A. Richards, 5 September 1933, *Letters*, 68.
[72] Katharine Sansom, *Living in Tokyo* (London: Chatto & Windus), 1936.

foreigners as clichéd an image of Japan as Lafcadio Hearn's ubiquitous tales of the supernatural. Empson even went as far as to advise the novelist Sylvia Townsend Warner to delay a proposed visit to Japan until winter, because 'it's only then that the country isn't irritatingly like Japanese prints'.[73] Despite this aversion, Marjorie's own stylistic proclivities ensured that the third-hand influence of printmakers such as Hokusai and Hiroshige found its way fairly obviously into 'William's Painting'. It is there not only in the motif, but also in formal conventions such as the steep line of the path beneath the cherry trees, which intersects the plane of the picture with an abruptness quite alien to 'traditional' European painting.

Alongside his efforts at drawing and painting, Empson had also begun to experiment in the photographic darkroom, manipulating images of the faces of Buddhist sculptures in an attempt to better understand their asymmetries. The resultant images put particular sides of the faces together with their mirror-images in order to produce what Empson called 'left-left' and 'right-right' combinations (Figs. 40; 61–3; 67 & 68; 71–2). 'You need a film, not a plate negative,' he explains in *The Face of the Buddha*, 'because you have to print it backwards.' He started with the 'hacked off' Yungang heads he had seen on his China trip, which seemed to him to provide the most obvious examples of asymmetry. In the original photographs, he thought, the facial expressions of these seemed to suggest 'ironical and forceful politeness. But,' he continues in *The Face of the Buddha*, 'if you make a picture with the left side twice over it has hardly any of this expression. The eye and the mouth are level and the face is calm and still [Fig. 62]. On the right the eye and mouth slant, and this gives the sardonic quality; in fact, if you take it twice over the thing approaches the standard European face of the Devil [Fig. 63].'[74]

Essentially, these photographic experiments allowed Empson to mentally reduce the faces of the sculptures he had seen at Nara, Seoul, and Yungang into abstract patterns, converting them, in a very real sense, into the constituent elements of an obsessive geometrical puzzle. Empson was, of course, tipped for a career as a mathematician before he chose instead to specialize in literary studies, and his erstwhile travelling companion Victor Purcell has noted that he often worked on an actual geometry problem as a kind of displacement activity during difficult journeys in Asia. 'It had something to do with a proving that a certain circle touches a triangle at nine points', Purcell remembered of the problem, adding that Empson seemed to find in it 'a never failing source of consolation'.[75] Entering eyes, nose, and mouth as lines in various positions, and set at various angles on the oval plane of a face seems to have provided him with a similar source of intellectual distraction. Years later, while skiing with Empson in the Rhône-

[73] William Empson to Sylvia Townsend Warner, 10 October [1933]. *Letters*, 71. [74] p. 120.

[75] Victor Purcell, *Chinese Evergreen* (London: Michael Joseph, 1938), 77. See also Haffenden vol. 1, 450–1.

Alpes, another travelling companion witnessed him buying a mathematical *cahier* to be used exclusively for such exercises. While everyone else admired the view of the mountains, she recalled later, Empson instead 'drew buddhas in the squared notebook he had just bought at Bourg St Maurice'.[76]

The face of the figure in 'William's Painting', walking beneath her springtime cherry blossoms, shows evidence of similar experimentation. Judging from the very small number of available photographs of her, the model for the figure is almost certainly Empson's Japanese girlfriend Haru, about whom very little is currently known save for her given name. The meanings of Japanese names depend not upon their pronunciation, but upon their spelling in *kanji* (classical Chinese characters), and Haru is usually written 春, signifying 'spring'. The painting then, represents Haru in more ways than one. In Japan, the spring season also provides a handy euphemism for matters connected with sex. Artworks featuring nudity and intercourse are traditionally nicknamed 'spring pictures', and the liaison between Empson and his model had a strong physical element to it. Haru, who was employed as a nanny by the German ambassador, used to sneak out at night to sleep at Empson's house. On one occasion the two were woken at dawn by one of Tokyo's frequent earthquakes. Fearing that the ambassador's offspring would also have been shaken awake, Haru had to hurriedly put her clothes on and rush back. 'The thing was that being woken he would bawl | And finding her not in earshot he would know', recalls Empson's poem 'Aubade', which describes the incident.

On one level, both 'Aubade' and 'William's Painting' record the stresses and strains of conducting an intercultural love affair during what was a time of immense political uncertainty. Empson would later remember an 'old hand' among the British expatriates telling him, 'don't you go and marry a Japanese because we're going to be at war with Japan within ten years; you'll have awful trouble if you marry a Japanese.'[77] A depressingly concrete illustration was very close at hand. Marjorie Nishiwaki's marriage to Junzaburo had already foundered amid the storm that was gathering between Japan and the West, and she would return to Europe a divorcée before the onset of the Second World War. 'It seemed the best thing,' concedes Empson's poem about Haru, 'to be up and go', but the decision is sodden with reluctance, as in any situation where pragmatism takes the upper hand over feelings. 'We have to put up with it,' he later glossed the end of the poem; 'we can't avoid this situation of history.'

It is the sense of emotional ambiguity surrounding his relationship with Haru that makes it interesting to look at 'William's Painting' in the light of his theories

[76] Janet Adam Smith, 'A is B at 4000 Feet', in Roma Gill (ed.), *William Empson: The Man and his Work* (London and Boston: Routledge & Kegan Paul, 1974), 36–8.

[77] Haffenden vol. 1, 327.

on asymmetry. Even though we are looking at a three-quarter view of the figure beneath the cherry trees, the left side of the face looms out to give a strict frontal view reminiscent of the photographs used to create Empson's right-right and left-left images, and the sense of frontality is further emphasized by the regular, umlaut-like dots of the nostrils. If one uses something straight-edged to screen off the right, this left side, with its soft, straight eyebrow and mouth, conveys a palpable sense of detachment: precisely the 'we have to put up with it' resignation of Empson's 'Aubade'. If one covers the left side instead, the right, with its downturned mouth and contorted slash of eyebrow, seems to connect powerfully, distressfully with the viewer, perhaps with a sense of recrimination. Exactly as in Empson's appraisals of sculpture from Japan, Korea, and China, then, the success of 'William's Painting' depends upon its ability to balance 'things that seem incompatible'.[78]

Both the painting lessons and the photographic experiments were going on at the same time as Empson was writing the first comprehensive draft of *The Face of the Buddha*. 'I have smacked out a lot of words on my typewriter about Far Eastern Buddhas', he told Richards in September 1933, with ten months still to go before his departure from Japan.[79] Though lacking the observations on Buddhist art from South-East Asia and the Indian subcontinent that he would add to his repertoire on the voyage back to Europe, this version of the manuscript would closely have resembled in most respects the polished draft produced in London at the end of the Second World War. The letters quoted elsewhere in this essay demonstrate very clearly that the theory of asymmetry as proposed in the final version was already fully formed as early as the spring of 1932, when Empson returned from Yungang. A year later he was still worried about its theoretical underpinning, however, adding in his announcement to Richards about the new manuscript that he still felt the need to further research 'the recent work on facial and bodily expression'. It was probably this last factor that discouraged Empson from discussing asymmetry at all in the article he published on Buddhist sculpture in *The Listener* early in 1936. Though he titled this 'The Faces of Buddha', it lacks the sparkling innovativeness either of the letters or of the final manuscript, and basically represents a chronological round-up of Empson's favourite artworks.[80] He was evidently still worried about the reactions of 'the experts', and seems in the article to be moving into this new field of publication with an uncharacteristic degree of caution.

Though it interrupted his writing of *The Face of the Buddha*, Empson's departure from Japan in 1934 allowed him to extend his personal experience of Buddhist art back beyond the earliest examples of East Asian sculpture, and

[78] p. 81. [79] William Empson to I. A. Richards, 5 September 1933. *Letters*, 69.
[80] William Empson, 'The Faces of Buddha', *The Listener*, 5 February 1936, 238–40.

towards their precursors in India and Ceylon. In making the long journey from Tokyo to see the famous Buddhist murals at the Ajanta caves in central India, Empson was following a route that had regularly been trodden by Japanese artists and art historians since the beginning of the twentieth century (Fig. 15). His most notable predecessor had been Okakura Kakuzo, founder of the *Nihon Bijutsuin*, the first institution to teach traditional Japanese techniques of art production in an academy-style environment. Okakura, who visited in 1902, thought all Asian traditions of painting, whether they were located on the Indian subcontinent, in East or South-East Asia, or in Indonesia, originally stemmed from the ancient murals at Ajanta. Originally painted between the second century BCE and the sixth century CE, the frescoes have often been seen as the stylistic root of Buddhist painting as it spread, via the Silk Route, to northern China, Korea, and finally to Japan. Okakura certainly agreed with the Silk Route thesis, describing the murals as 'the few remaining specimens of a great Indian art, which doubtless, thanks to innumerable travellers, gave its inspiration to the Tang art of China'.[81] Mukul Dey, another Indian Modernist, made his first visit to the caves in 1917, and remembered meeting a group of Japanese artists led by the painter Arai Kampo 'marching like soldiers, one behind the other, with tight bandages on their legs, wearing a peculiar white dress and crowned with white solar topees'.[82]

Empson had evidently seen some of the published reproductions of the Ajanta murals while he was still in Japan, but as usual he is keen in *The Face of the Buddha* to emphasize the paramount importance of seeing the original artworks, regardless of the logistical difficulties. 'I think the chief thing to say,' he says when he discusses the murals there, 'is that they are much better even than the best of their reproductions.'[83] Three comprehensive attempts had been made to create such reproductions since the rediscovery of the caves in 1819, after their disappearance from the pages of history for more than half a millennium. The first attempt was by Robert Gill, a major in the Madras army, who spent eighteen years at the caves at mid-century, making extraordinarily detailed, large-scale copies in oils. Unfortunately, he simultaneously attempted to conserve some of the paintings by applying a transparent protective coating, a decision whose disastrous results were very obvious to Empson, who noted that a key image of Gautama Buddha 'has been destroyed by varnish'. Gill's copies of the frescoes fared little better. Exhibited at the Crystal Palace in Sydenham on their arrival in England, all except five of them were consumed in an accidental conflagration.

[81] Okakura Kakuzo, *The Ideals of the East* (London: John Murray, 1903), 54.
[82] Mukul Dey, *My Pilgrimages to Ajanta and Bagh* (London: Thornton Butterworth, 1925), 40.
[83] p. 26.

A large proportion of the second set of copies, made by John Griffiths and a group of his students from Bombay's J.J. School of Art in the 1870s, were also burned to a cinder when the Indian section of the Victoria and Albert Museum caught fire in 1885.[84] Empson doubtless examined a few of the surviving paintings at the museum after his return to London, and may also have encountered Griffiths' reproductions while still in Japan via James Burgess's 1879 book on Ajanta, which presents a large number of them as collotype illustrations.[85] By the time the final draft of *The Face of the Buddha* was written, however, Empson's remarks imply that he had examined all of the available reproductions. He is bound, therefore, to have searched out the highest-profile of all the published examples—namely the ones produced during Lady Christiana Herringham's expedition of 1910–11.

Sponsored by the Nizam of Hyderabad and London's newly formed India Society, the Herringham expedition was mainly made up of students from the Calcutta School of Art. These included a talented young painter named Nandalal Bose, who would later become one of India's most important Modernists. The resultant reproductions in watercolour were published as a lavish India Society folio, and remained a standard work of visual reference for international audiences until after the Second World War.

For his own journey to the caves, Empson would almost certainly have taken the Bombay mail train from Calcutta (today's Kolkata), getting off at Jalgaon, an obscure stop a whisker under 1,600 kilometres inland from his point of departure. From the nearby village of Fardapur, he would then have found himself bumping along in a bullock cart again for the final 7 kilometres. Letters from the Herringham expedition describe the carts getting stuck in rivers and traversing boulder-strewn slopes, and the caves themselves as full of beehives, bats, and the substances bats produce.[86] By the time Empson arrived the experience was somewhat less traumatic. A 1932 account by a local aristocrat reports that 'the road from Fardapur is [...] being repaired and metalled and furnished with bridges', and that 'all the caves have doors with wire netting and the bats are no longer there [...] the beehives have all been burnt up and there is no scope for bees there'.[87]

[84] One of Major Gill's remaining five paintings was also destroyed in this fire. The Victoria and Albert Museum (formerly the South Kensington Museum) now holds the only four remaining Gill pieces and 153 canvases by Griffiths and his students. Divia Patel, 'Copying Ajanta: A Rediscovery of Some Nineteenth-Century Paintings', *South Asian Studies*, 23 (2006), 39.

[85] James Burgess, *The Bauddha Rock-Temples of Ajanta* (Bombay: Archaeological Survey of Western India, 1879).

[86] For a more detailed account of the Herringham expedition, see Rupert Richard Arrowsmith, '"An Indian Renascence" and the Rise of Global Modernism: William Rothenstein in India, 1910–11', *The Burlington Magazine* 152/1285 (April 2010), 228–35.

[87] Balasaheb Pant, *Ajanta: A Handbook of the Ajanta Caves descriptive of the Paintings and Sculpture therein* (Bombay: D. B. Taraporevala, 1932), 7–9.

The main reason for Empson's careful differentiation of the murals themselves from their reproductions is doubtless that each of the teams of copyists had unconsciously introduced different stylistic variations into the work. Gill's and Griffiths' Victorian sensibilities had encouraged them to 'Europeanize' their copies, making use of Academic techniques of pictorial illusionism such as volumetric shading and single vanishing point perspective. The Herringham expedition did the opposite. The Calcutta School students were all disciples of the contemporary 'Indian Style' artist Abanindranath Tagore, and tended to employ the flattened perspective and schematic ordering of objects that their master had learned from a study of much later Mughal and Rajput miniature paintings. Lady Herringham herself favoured a globalized, decidedly Post Impressionist aesthetic based, like Marjorie Nishiwaki's, on a reverence for Matisse. The murals' affinities with relatively recent movements in European art certainly were not lost on Empson. 'Perhaps your first impression', he noted of his own visit to the caves, 'is that it is all rather Gauguin.'[88] By the time he wrote the final draft of *The Face of the Buddha*, he was applying his own globalized perspective to the paintings, finding them not to describe the mythology of any single ethnic group, but to 'make a fair bid at summing up all racial experience [...] the actual racial types are very mixed. Negro and Chinese faces emerge from the dark, Persian and Burmese; there is a blond European saint with a long beard.'[89]

Empson does not seem to have realized before he left Japan in July 1934 that his departure date meant he would be touring northern India during the cool, wet weather of the monsoon. 'Shall go round by India in the heat, which they say doesn't kill you, and do a few sights', he told Richards not long before boarding his steamer at Yokohama.[90] Ceylon, by contrast, was experiencing during the same period the torrid apex of its dry season, and would have matched Empson's climatic expectations much more closely. The island's ruined former capitals—sometimes referred to as 'the Buried Cities'—are all inland, and despite his bravado about high temperatures, Empson must have found the conditions there challenging. 'The climate of the Buried Cities is uncomfortably hot,' noted one contemporary observer, 'even the acclimatized find it difficult to muster much energy.'[91] Such side-effects might help explain why Empson only visited Anuradhapura, the most ancient of the sites, and did not extend his tour to include the later Buddhist citadel of Polonnaruwa, or indeed the sublime rocky outcrop of Sigiriya, home of a set of murals comparable to those of Ajanta.

Empson says he only journeyed to Ceylon in the first place because of a photograph he had admired in Ananda Coomaraswamy's 1927 book *A History*

[88] p. 26. [89] Ibid. [90] William Empson to I. A. Richards, [n.d. 1934]. *Letters*, 78.
[91] Dorothy Jones-Bateman, *An Illustrated Guide to the Buried Cities of Ceylon* (London: Kandy Hotels, 1932), 9–10.

of Indian and Indonesian Art.[92] The photograph was of a two-metre marble carving of Gautama Buddha that had been unearthed during an excavation of Anuradhapura's Abhayagiri vihara site in 1886, and Empson had been captivated by what seemed 'a haunting softness in the lightly moulded body, which rises like a flower into its position of eternal deliverance and calm' (Fig. 12). When he got to Anuradhapura and examined the sculpture at first hand, however, he found none of the features he had been led to believe that it possessed. 'Actually the thing is very stocky,' he tells us, 'the face is not so much innocent and self absorbed as puggy and determined [...] and the straight sag of the jowl gives a Mussolini effect' (see Pl. 4 for contrast with Coomaraswamy's photograph).'[93] A standing Buddha-image illustrated in the same book also turned out to be a disappointment when Empson saw it 'in the flesh', though for quite a different reason. The details of the carving 'had been buried under inches of plaster' in a recent, badly botched renovation attempt, and so he was unable to verify the 'birdlike rigidity' and 'metallic shocking force' that had impressed him in the photograph. 'There is [...] always a puzzle about what you are really admiring,' he notes in *The Face of the Buddha*, 'when you see these things in photographs.'[94]

Though he would not return to Asia for almost three years, Empson's interlude in London did not stop him from discovering further examples of Buddhist sculpture. For one thing, Britain's centuries-long tradition of colonial piracy meant its capital's museums contained an enormous haul of extra-European art, much of it of an extremely high standard. The Asian collections on the upper floor of the British Museum, for example, included a set of architectural carvings at least as important in terms of world art history as the Elgin Marbles downstairs. Taken from a ruined *stupa* at Amaravati, east of the Indian city of Hyderabad, the carvings had already inspired Jacob Epstein and Eric Gill to produce Britain's earliest Modernist sculptures. Now occupying a dedicated glass enclosure within the museum, they are regarded by many as the finest artworks from the subcontinent to be found in Europe. Another world-class piece that Empson could hardly have avoided seeing was the exquisite, two-metre sculpture of Gautama Buddha that sat, as it does to this day, directly opposite the door of the Asian galleries. Brought back by the naval officer Frederick Marryat after Britain's first major incursion into Burma during 1824–6, its acquisition history, as with so many of the holdings of the British Museum, is decidedly murky. A product of Burma's immensely complex tradition of dry lacquer sculpture, it was undoubtedly one of the sculptures Empson examined in the company of his Cambridge friend Kathleen Raine before he had even set foot in Asia. 'Even before he left for

[92] Ananda K. Coomaraswamy, *A History of Indian and Indonesian Art* (London: Edward Goldston, 1927), pl. XCVIII, no. 295.
[93] p. 24. [94] p. 23.

Japan he had considered the faces of the Buddha,' she reminisced later of their visits to the British Museum together. 'I wish I had written in a journal at the time all the discerning things William used to say about the Buddhas.'[95] Whatever Empson may have said about them at the time, however, no mention is made of the Amaravati sculptures or of the Burmese lacquer figure in *The Face of the Buddha*, probably because neither exhibit provides a viable example of facial asymmetry.

The above digression on a sculpture from Burma might allow us briefly to consider another apparent omission in *The Face of the Buddha*—namely details of what Empson saw when he visited the country himself. Empson mentions having 'looked at Buddha' in Burma during his preface, but neither later in the book nor in any of his letters does he discuss a specifically Burmese sculpture. It is not even very clear when exactly he went there, though it is likely to have been as a stopover on his way from Japan to Calcutta. This last factor probably explains the situation. A stopover to Burma on this route would have meant a stay at the port of Rangoon (today's Yangon), a city designed along European lines by the British mainly to function as a terminus for the wholesale extraction of the country's agricultural and mineral resources. Though the city possessed a Buddhist monument of immense importance—the Shwedagon Pagoda—it was able to offer very little in the way of iconic, individual pieces of sculpture that were easily accessible. Most such pieces were located in Upper Burma, particularly around Mandalay, a place that still today represents the country's cultural heartland. Mandalay, however, was a train journey north of a day and a night, and for once, perhaps due to time constraints or because of Burma's notoriously heavy monsoon, Empson seems to have decided not to go.

Back in London at the end of 1934, however, Empson found he had arrived just as preparations were getting under way for the largest exhibition of Chinese art ever to be held in the West. It was to be hosted by the Royal Academy, and was intended not only to feature exhibits lent by Western museums, but also a large number of items specially shipped from China by the country's Nationalist government. There were fairly transparent political reasons for the timing of the exhibition. As has already been mentioned during the discussion of Empson's visit to Yungang, Japan had already formally occupied Manchuria, and seemed quite obviously to be biding its time before finding reasons to annex further territory. In 1934, the Nationalists saw the exhibition as a way of attracting the attention of Britain and the United States, mainly in the hope of bolstering political opposition to the looming threat of a full-scale Japanese invasion of China.[96] When the Royal

[95] Kathleen Raine, 'Extracts from Unpublished Memoirs', in Roma Gill (ed.), *William Empson: The Man and his Work* (London and Boston: Routledge & Kegan Paul, 1974), 16–17.

[96] For details of the exhibition's organization and political undertones, see Jason Steuber, 'The Exhibition of Chinese Art at Burlington House, London, 1935–36', *The Burlington Magazine* 1241/148 (August 2006), 528–36.

Academy show finally opened a year later, Empson paid little attention to the ceramics, paintings, and prints from various eras that made up the majority of the exhibits, and headed (somewhat predictably) for the small number of Buddhist sculptures on display. He found two of them to have been well worth the wait.

The first of these was a large, seated figure of earthenware decorated with the style of Chinese glazing known as *sancai*, which employs three individual colours, often allowing them to overlap or to run into one another (Pl. 7). It depicted a *luohan* ('arhat' in Sanskrit)—a being that has deliberately sought its own spiritual liberation, usually via intensive meditation and monastic practices. In Mahayana Buddhism, such rigorous focus upon one's own enlightenment, rather than upon assisting others towards the same goal, means that the *luohan* is not accorded the prestige of the Bodhisattva, and so tends to be depicted as a human being rather than as a deity. The exhibition catalogue says the sculpture was a product of the Tang Dynasty, but Empson preferred to think it was Song—he was quite warm, in fact, for it has since been reattributed to the Liao, a Khitan dynasty that coexisted with the Song during the eleventh century.

The ceramic *luohan* had been lent by the University of Pennsylvania Museum, and its journey to the eastern United States, though bumpy and unceremonious, was typical of that of many Chinese objects acquired by Western museums until quite recently. In 1912, Friedrich Perzynski, a German scholar and adventurer who was living in Peking, heard about an unexpected archaeological discovery by some villagers in a rugged part of Yizhou province to the south-west, and journeyed there saying that he needed the mountain air for health reasons. As has already been mentioned, 1912 was the year that the Xinhai Revolution forced the abdication of Puyi, the last of the Qing emperors, and the country's administrative and legal systems were in turmoil, all of which made it the perfect moment for an opportunistic acquisition. Perzynski was able to buy the *luohan*-image from some local farmers, who had dragged it from a cliffside shrine, and managed to sneak it back to Peking along with some other items pillaged from the site. From Peking, it found its way to an art dealership in Paris, and was exhibited for a while at the Musée Cernuschi before its purchase by an agent of the University of Pennsylvania in the summer of 1913.[97] When Empson saw it at the exhibition in London, he immediately noted the high degree of naturalism that had been achieved as a by-product of the artist's attempt to make the figure appear human rather than divine—an intention that set it quite apart from the abstract power of the saintly Bodhisattvas at Yungang. 'It seemed to me so much alive,' he says in *The Face of the Buddha*, 'that it turned the people looking at it in the London Exhibition into twittering ghosts.' As usual, the figure had mainly attracted his attention because

[97] Richard Smithies, 'A Luohan from Yizhou in the University of Pennsylvania Museum', *Orientations*, 32/2 (February 2001), 51–6.

its face was undeniably asymmetrical. 'It is clear that the two eyes were planned differently. The right, it seems to me, has pride and suffering and looks out with a certain cunning; the left has a stubborn and intelligent placidity' (Fig. 24).[98]

As mentioned above, *luohan* sculptures tend to dwell on the human side of the figure to a greater extent than those of the more saintly Bodhisattvas. It is interesting, then, that the second sculpture that caught Empson's eye at the Royal Academy was also a Liao piece, but this time of the so-called 'white-robed' aspect of Guanyin—his favourite Bodhisattva, Avalokitesvara (Pl. 17). Empson was therefore able to compare two contemporaneous pieces that seemed to apply the same facial expression to subjects with quite different personalities. The white-robed aspect of the Bodhisattva, depictions of which are unique to the warlike Liao, was conceptualized as a deity not of compassion but of military triumph. This particular example was cast in bronze at the beginning of the eleventh century for the famously pugnacious empress Chengtian, having been given a face that appeared to fit Empson's 'more slant on the right' generalism perfectly (Fig. 35). He found the steep angle of the right eye and the levelled-off appearance of the left to be identical in formal terms to the features of the *luohan*, but to convey quite dissimilar subtleties of character. 'In the Guanyin, the left has a gentle placid humanity and the right the dignity of the aristocrat,' he says in *The Face of the Buddha*; 'she is highly placed in the court of Heaven.'[99] Empson's *Some Versions of Pastoral*, published in the same year he attended the Chinese exhibition, contains an analysis of a speech from Shakespeare's *Henry V* where the same words are meant to apply, albeit with quite different senses, to the deaths of both the noble Hotspur and the earthy Falstaff. It is a very similar approach to the double meaning he imputes here to the same facial expression used in two separate, but related artworks.[100] Such technical parallels serve to illuminate the continuing relationship between Empson's analyses of visual art and his remarks on literature.

Attending the Royal Academy exhibition can only have increased Empson's desire to be back in Eastern Asia, and he subsequently applied for a position in Singapore before accepting a lecturing job in Peking instead for the 1937–8 academic year.[101] While packing, he had second thoughts about China after hearing reports of an outbreak of fighting at Lugouqiao, a strategically important bridge south-west of the capital, but decided to press on anyway. The disturbance at Lugouqiao, which would come to be known to Western military historians as the 'Marco Polo Bridge Incident', was taken by most observers to signify the tipping over of tensions between Nationalist China and Japan's Manchuria

[98] pp. 92–3. [99] p. 92.
[100] William Empson, *Some Versions of Pastoral* (London: Chatto & Windus, 1935), 44.
[101] Haffenden vol. 1, 432.

occupation force into all-out warfare. Sure enough, after a brief ceasefire, hostilities re-ignited, and by the time Empson arrived in Peking at the end of August, the city had fallen to the Japanese general Kawabe Masakazu. Empson's university was on holiday at the time, and plans were quickly made to reconvene for the new term not in Peking, but in the city of Changsha in Hunan province, which at that time was still under Chinese Nationalist control. While he was waiting for the new arrangements to come into effect, Empson toured the south of China, and also crossed the border for a brief visit to Hanoi.

Though the future capital of Vietnam did not provide Empson with anything he could put into *The Face of the Buddha*, the ease of travelling there opened up the possibility of venturing further south to the jungle-bound, legendarily awesome ruins of Angkor. For Empson, who by this time seemed fully intent on 'collecting the set' when it came to historical Buddhist sites, it was an opportunity that could hardly be turned down, and he took advantage of it the following year, during the spring vacation of his university in China. From Hanoi to Saigon (today's Ho Chi Minh City)—the jumping-off point for a visit to Angkor—was a journey of about 1,600 kilometres. Luckily for Empson, 1936 had seen the opening of a new railway line that joined the two cities via a two-day run along the beach-fringed shore of the South China Sea. These days, most travellers from Saigon prefer to fly the rest of the way to Phnom Phenh or to Siem Reap, the nearest town to the Angkor ruins, in order to avoid the fractious border areas that separate present-day Vietnam from Cambodia. In the thirties, however, both nations were still rolled together into the artificial continuity of *L'Indochine française*, within which Empson detected a palpable tension between the 'delicious', brightly dressed locals with their 'serious attention to Buddhism', and the 'intense and successful narrowness of provincial France'.[102] If provincial was the word, Harry Hervey's fascinating descriptions of Saigon, penned in 1927, must still have held true. 'One sets out from his hotel in a rickshaw,' he says in one of them, 'and sees on either side numbers of Annamites [Vietnamese] in sloppy trousers drifting along in the midst of Frenchmen in trousers equally sloppy, all pausing now and again to gaze into windows displaying the latest styles from Paris. Overhead, signs in French laugh soundlessly at the tamarind trees and other languid proof that Saigon is in the tropics.'[103]

Booking a tour by car was the fastest way to get around, and Empson's guidebook to Angkor, which he probably bought in Saigon (where it was published), is packed with advertisements by drivers willing to make the journey. The

[102] William Empson, 'Letter from China', *Night and Day* (25 November 1937), 21. See also Haffenden vol. 1, 449.

[103] Harry Hervey, *King Cobra: An Autobiography of Travel in French Indo-China* (New York: Cosmopolitan, 1927), 3.

standard route was to go to Phnom Penh first for a quick look at the Albert Sarraut Museum, and then to speed back from Siem Reap on the new metalled highway, opened in 1931, which linked the town directly with Saigon via a ferry across the Mekong River at Kampong Cham: such, assuredly, would have been the itinerary followed by Empson in the spring of 1938.[104]

Cambodia's Albert Sarraut Museum (now the National Museum) had actually been the brainchild of George Groslier, a Phnom Penh-born French painter who had been put in charge of art education in the province in 1917. Like the erstwhile principal of the Calcutta Government School of Art in British India, Ernest Binfield Havell, Groslier was dismayed at the evaporation of indigenous technical and aesthetic approaches to visual art production, and their replacement with, or 'bastardization' by, models derived from Europe.[105] He was also worried about the wholesale disappearance—just as in Yungang—of historical Cambodian art treasures into Western museums and private collections. The museum, diplomatically named after the colonial governor of the day, but built in the style of a contemporary Khmer Theravada Buddhist temple, was designed both as the default receptacle for archaeological discoveries made in the country, and as the core of a new art academy where traditional approaches to visual art could be practised and developed into contemporary forms. This dual function meant the Albert Sarraut became in 1920 the first global museum to incorporate a gift shop as part of its integral design—Groslier's idea being to replace the old aristocratic structure of Khmer artistic patronage with a system based on the purchase of students' work by tourists, which he hoped, however misguidedly, would simultaneously heighten international awareness of Cambodian culture.[106] Empson does not appear to have bought anything, but he did find a new kind of asymmetry in the faces of two sculptures from the pre-Khmer history of the region—that of simply placing the eye on the right side lower than the left, suggesting somewhat vaguely 'the pride and the power of organisation' on the one hand, and 'a steady mild humanity' on the other (Pl. 11).[107]

The impact of Angkor upon Empson was such that for once it was totally irrelevant whether its sculptures backed up his theory of asymmetry or not. Now suspected in its heyday during the twelfth and thirteenth centuries to have

[104] Henri Marchal, *Guide to Angkor* (Saigon: Société des éditions d'extrême-asie, 1931).

[105] George Groslier, 'Les arts indigènes au Cambodge', *L'Indochine française: Recueil de notices rédigées à l'occasion du Xe Congrès de la Far-Eastern Association of Tropical Medicine* (Hanoi: Far-Eastern Association of Tropical Medicine, 1938), 163.

[106] For a discussion of the ideological problems inherent in Groslier's programme, see Penny Edwards, 'Womanizing Indochina: Fiction, Narrative and Cohabitation in Colonial Cambodia, 1890–1930', in Julia Ann Clancy-Smith and Frances Gouda (eds.), *Domesticating the Empire: Race, Gender, and Family Life in French and Dutch Colonialism* (Charlottesville: University of Virginia Press, 1998), 123–30.

[107] p. 94.

represented the world's largest pre-industrial urban space, Angkor's various groups of ruins incorporate hundreds of stone temples spread across an area more than 400 kilometres square. For Empson's generation, Angkor was the quintessential lost city, supposedly buried beneath lianas and lost to human memory until the French naturalist Henri Mouhot stumbled upon it in 1860. The narrative of a European scientist dragging this marvel of early civilization from the jungle continued to be useful to the French colonial project, as did Mouhot's assertion that the present-day inhabitants of Cambodia were far too decadent and drugged-up to have had anything to do with its construction. Taking a far more cosmopolitan view, Empson is keen in *The Face of the Buddha* to question whether Mouhot could really be said to have 'discovered' anything at all. 'When the dying French explorer staggered through the jungle,' he says there, 'he found a community of Hinayana [Theravada Buddhist] monks still in residence.' The reason the temples had become overgrown was not that they were forgotten, he goes on to propose, but because the collapse of the Khmer empire meant that the 'forced labour' necessary for their maintenance was no longer available. 'The mystery of Angkor,' the section concludes, 'has perhaps been rather overdone.'[108]

True to form, Empson preferred the Buddhist monuments at the site to their Hindu counterparts. Angkor, like many South-East Asian civilizations, took rather a syncretic approach towards religion, intertwining concepts and deities from local pre-Buddhist traditions, from Theravada and Mahayana Buddhism, and from Hinduism, with relative freedom. The royal cult of the Khmer monarch oscillated between depicting him during some reigns as the Hindu deity Shiva, during others as Vishnu, and in a smaller number of cases as one or other of the Mahayana Buddhist Bodhisattvas. The most colossal of all the monuments, Angkor Wat, was originally dedicated to Vishnu, and was intended to represent Mount Meru, the legendary world-mountain of the Hindu pantheon. Its sheer scale was enough to make it the favourite of most travel books written before Empson's visit, including the Cambridge anthropologist Geoffrey Gorer's depressingly parochial *Bali and Angkor*. This is a book that Empson mentions in *The Face of the Buddha*, and he seems to have read it before his own visit to the building. Gorer puts forward the proposition that the Wat's use of symmetry and proportion make it 'the most perfect building in Angkor'. Empson disagreed, telling Edith Sitwell in a letter that 'the Vat [*sic*] itself is a dignified public building, but it hasn't the noble and tender and extraordinary imagination of the Buddhist things like the Bayon and Neak Pean and Prah Khan'.[109] Gorer had assumed the Bayon, one of the most eccentric buildings in the world, to have been constructed earlier than the Wat,

[108] p. 33. [109] William Empson to Edith Sitwell, 28 April [1938]. *Letters*, 105.

and dismisses it in his own book as the 'primitive concept' of an 'opium-soaked community' with 'no signs at all of any technical architectural ability whatsoever' (Pl. 13 & 14).[110] After his own visit, Empson was able to retort with evident glee that 'the story of how "primativ" it was has now happily been smashed by a bouleversement des dates (tiens), which makes it later than Angkor Vat'.[111]

The Bayon was in fact built in the wake of a raid on the Khmer capital by the neighbouring Champa civilization in the late twelfth century. Stealing up the Mekong river and across the great lake of Tonle Sap in small boats, the Chams managed to lay waste large parts of Angkor Wat in addition to causing the death of the reigning monarch. After repulsing them, the incoming Khmer king Jayarvar-man VII began the construction of a new citadel somewhat to the north (Pl. 12). The Bayon, located at the centre of this, was supposed to represent a renewed spiritual heart for the empire. Jayarvarman was a Mahayana Buddhist, and the colossal heads he commissioned to decorate the Bayon's iconic towers were intended to represent a combination of his own features and those of the Bodhi-sattva Avalokitesvara. One of his successors would insert a *garbha grha*, or womb-chamber, into the building, thus converting it into a Hindu temple. By the time Empson visited there was still doubt as to which religion had originally inspired the building, but his inveterate sympathy for Buddhism led him, as usual, to prefer it in his own interpretation of the building. 'I hope that they stood for the Bodhisattva of Mercy,' he wrote later of the colossal heads; 'if they stood for Shiva in his aspect of lust and destruction the nightmare intended must have been a horrible one.'[112] The impression he actually found to be conveyed by the maze of stone-cut visages was quite the opposite. 'You are perfectly protected and enclosed, "safe in thine eternal arms,"' he told Edith Sitwell, 'a hushing, nursing, milky security.'[113]

The tiny, gemlike shrine of Neak Pean, also the brainchild of Jayarvarman VII, affected Empson with a similar intensity (Pl. 15). Neak Pean is best translated from Khmer as 'the interlocked snakes', and describes a circle of four pools corresponding to the four mundane elements, joined by an island at the centre that might represent the Vedic fifth element (always very hazily defined) of ether. According to the thirteenth-century Chinese diplomat Zhou Daguan, with whose impressions of Angkor Empson was very familiar, that central island had originally been furnished with a golden tower and a horse sculpture associated with Avalo-kitesvara via a set of local mythologies. 'It was a lotus temple in the middle of a bathing pool,' Empson noted during his own visit, 'with elephants trunks and

[110] Geoffey Gorer, *Bali and Angkor* (London: Michael Joseph, 1936), 195/178/173. See also *Face of the Buddha*, 33.
[111] William Empson to Edith Sitwell, 28 April [1938]. *Letters*, 105.
[112] p. 30. [113] William Empson to Edith Sitwell, 28 April [1938]. *Letters*, 105.

snakes and huge petals curving up to the little rectangular niches for the God of Mercy, and I think must have been wonderfully beautiful.'[114]

He was using the past simple tense advisedly, for the roots of a particularly octopine set of thitpok (*Tetrameles nudiflora*) trees had wound their way through and about the foundations of Zhou Daquan's little tower, had expanded, and had cracked it into pieces. Most Western visitors before Empson had found the situation highly picturesque. The Franco-Russian art historian Pierre Jeannerat de Beerski, arriving in the early 1920s, had written of 'the gloomy, superb, withal delicate harmony which reigns in the mixture of free vegetation and ruined works of men, of remains of human toil and untamed animal life'.[115] A far bigger celebrity, the *Titanic*-survivor Helen Churchill Candee, refers in her own account to the thitpoks as 'forest ladies who had tried to flee but who were petrified in flight and turned into trees like Daphne pursued'.[116] Empson was pretty annoyed by all of this. 'The French have pulled down that beastly tree that destroyed Neak Pean, which everybody writes of so tenderly', he wrote approvingly from the desk of his hotel back in Hanoi. 'Pray God they put the stones back now instead of saying how picturesque they look lying in a heap.'[117] Empson clearly approved of the restoration methods put into practice by Maurice Glaize and his predecessor as *conservateur* at Angkor, Henri Marchal. Both were champions of anastylosis, which meant that if reconstruction of a damaged building was undertaken, masonry from the original structure had to be used as far as possible.

The very evident emotional depth of Empson's experiences in Cambodia suggests that he was by this time thinking as an insider not only about the art history of East Asia, but also to an extent about the region's core spiritual and ethical traditions. The rest of his travels around Vietnam and the deep south of China did not deliver any further examples of sculpture that he considered worthy of inclusion in *The Face of the Buddha*, but they did yield up one very telling encounter with the mysteries of the religion itself. Stopping off at Guilin, a city famous for its tower-like outcroppings of karst and its extensive systems of limestone grottoes, he found himself one afternoon clambering through a dark warren of caves on the outskirts of a temple complex. 'Then, far down out of the depths of this tunnel, I heard the deep and splendid chanting of the Buddhist ritual', he recalled later.

All the legends of the religion (those that I know) turned over together in my heart where they lie forgotten; and when Maitreya has arisen and superseded the Blessed One so that

[114] Ibid.
[115] Pierre Jeannerat de Beerski, *Angkor: Ruins in Cambodia* (London: Grant Richards, 1923), 217.
[116] Helen Churchill Candee, *Angkor the Magnificent* (London: Witherby, 1925), 255.
[117] William Empson to Edith Sitwell, 28 April [1938]. *Letters*, 105.

his cult is entirely abandoned by men I should wish my spirit to revisit that small tunnel and hear the great rhythms still pulse unweakened in the black heart of the mountain.[118]

Empson's instinctive antipathy towards organized religion prevented him, however, from publicly identifying himself with a particular Buddhist school of thought. 'Buddhism deserves respect,' he would write in an open letter more than twenty years later, 'but I naturally would not want to present myself as a believer by mistake.' If it was necessary for human beings to have organized religion at all, however, he thought organized Buddhism was greatly to be preferred to other systems, especially to the monotheism held out by Christianity and Islam. He was very clear on the two main reasons for this. First, Buddhism insisted neither on the incontrovertible historical veracity of its mythological narratives, nor on the existence of an all-knowing and infallible godhead. 'To be sure,' the open letter goes on to acknowledge, 'the coolness of Buddhism towards Heaven, and towards the supernatural in general, is one of its most attractive features.'[119] Secondly, Buddhism placed no ethical value on the idea of martyrdom, which Empson thought permeated New Testament theology in particular. 'I think Buddhism much better than Christianity,' says another of his open letters, 'because it managed to get away from the neolithic craving to gloat over human sacrifice.'[120] On a more mundane level, Empson may well have held back from associating himself any more closely with a Buddhist worldview because to do so was becoming uncomfortably fashionable among celebrity intellectuals in the West. 'I have at times felt that Buddhism was true,' he confessed to the poet and critic Kathleen Raine in 1948, 'but the hardening of Aldous Huxley into disapproval of everybody who isn't an arahat does now *rather unreasonably* make me feel that it isn't.'[121] Both of the open letters quoted from were written during the course of a discussion of Empson's translation of the Pali Canon's Adittapariyaya Sutta, or *Fire Sermon Discourse*, which he used as a preface to many of his poetry volumes. Despite his official downplaying of what was clearly quite a profound involvement with Buddhist ethics in particular, it should be remembered that when he died, Empson's family felt strongly that it was a Buddhist text, rather than any of the usual Christian material, that he would have wanted read out at his graveside. So it was that at his funeral in 1984, Empson's *The Fire Sermon* was read out by his wife Hetta. On the request of his two sons Mogador and Jake, it also forms the epigraph to this book.

[118] Haffenden vol. 1, 447–8.

[119] William Empson, 'Everything, beggars, is on fire', *Arrows* (New Year 1957), 5–6. *Letters*, 261–2.

[120] William Empson, 'Mr Empson and the Fire Sermon', *Essays in Criticism*, 6/4 (October 1956), 481–2. *Letters*, 256.

[121] William Empson to Kathleen Raine, 20 March 1948. *Letters*, 157. My italics.

A NOTE ON THE TEXT

The text that follows is that of William Empson's unpublished final version, completed in London around 1947, of a manuscript originally drafted in Tokyo in 1933. In editing the work for publication, I have tried not to damage its 'period' feel, and have altered spellings and transliterations from languages that do not use the Roman alphabet only when the author himself has presented more than one equivalent during the text for the same original word, name, or phrase. In the cases of locations whose contemporary equivalent the general reader is unlikely to recognize, or when a place name in the original manuscript is rendered either idiosyncratically, or sufficiently archaically, to present an obvious stumbling block, I have given a more familiar equivalent in square brackets. Also in keeping with the original manuscript, I have not used any special characters in transliteration of words and names from Sanskrit, Pali, Japanese, or other languages that would normally require them in a contemporary rendering, and have carried over this approach into my introduction in order to maintain the integrity of the publication as a whole. I have altered punctuation and grammar only in cases where not to do so would inhibit readability. Where there have been more significant changes, for whatever reasons, I have indicated these in an endnote.

The essay 'Buddhas with Double Faces', which is included as a part of the original manuscript, I believe from internal evidence to be an article that was meant to accompany the publication of *The Face of the Buddha* in a literary or art-historical periodical. The article provides a functional abstract of the book as a whole, and might have been useful as a prolegomena or as a coda to it, were it not for the fact that it reproduces word-for-word many of the ideas (and even idiomatic phrases) of the main text. Given the additional fact that Empson describes the piece from within as an 'article', it is probably best to assume that it was intended for parallel, rather than contiguous, publication, and for this reason it is presented here as an appendix.

The original manuscript of *The Face of the Buddha* contains no footnotes, and I have tried in the cases of quotations and references to other works to locate titles and page numbers, or to suggest possibilities for publications to which Empson might have been referring. Partly due to Empson's well-known penchant for misquotation, this has not always been possible. I have indicated in an endnote when I think a misquotation may have occurred, or when a text referenced by Empson does not seem to contain any recognizable version of the material attributed to it.

A NOTE ON THE ILLUSTRATIONS

Along with the manuscript for *The Face of the Buddha* when it was discovered was a heap of black-and-white photographs, and a list by Empson of other images he thought should be included in the finished book.

It was decided between the author's estate and I that the presentation of the black-and-white photographs should follow the style of the editing of Empson's main text in attempting to maintain the 'period feel' of the finished book, and therefore only minimal digital processing of the images has been undertaken. Empson's list of black-and-white plates is also presented here as he intended, rather than altered to fit current academic norms, though I have made some small corrections and additions in square brackets when I thought these might assist the reader's understanding. For those interested, Empson's figure numbering as it appears in the unedited manuscript may be seen in the section at the back of this book entitled, 'Original Numbering of William Empson's Black-and-White Illustrations'.

Empson refers often in his discussion to specific illustrations from Ananda K. Coomaraswamy's seminal *History of Indian and Indonesian Art* from the year 1927, and included six of these images in his list of plates. Important parts of the main text, however, refer to numerous others of Coomaraswamy's illustrations that are not in the list, and I have taken the liberty of adding these in square brackets to show that they were not originally mentioned there. As is mentioned in the acknowledgements to this volume, we are grateful to Peter Coomaraswamy for his generosity in allowing the Press to reproduce images from the book free of charge.

A number of Empson's original images were missing—for example his photograph of the Elephanta Trimurti and his copy of the Karsh Churchill portrait—and so substitutes have been added to the colour plates, again to show that the images are not those originally supplied by the author. Most of the other images included in the colour plates are there because Empson had added to the bottom of his plates list a number of suggested items he thought would 'would make the book more lively' if the publisher could get hold of them. These include the Pharaonic head, the woodcut of a Japanese Ronin, and the Chartres Madonna.

Others in the colour plates were included because the Press encountered objections from the current owners to our reproducing older, black-and-white images of certain works. These include the two Buddhist sculptures from the Musée Guimet, and the Pietà from London's National Gallery.

I have listed and captioned the colour plates in a contemporary style that deliberately contrasts with Empson's own, in order to make clear that these are recent supplements that were not included with the original manuscript.

Even though Empson notes on his list of plates that in most cases he acquired formal permission to reproduce photographs at the time he purchased them at various museums and temples, every effort has been made over the past four years to secure the approval of the current owners of the works. Inevitably, due to problems in communications with institutions, or due to the apparent disappearance of certain items during the period since Empson picked up his photographs of them, one or two may have slipped through the net, and we apologize if this is the case. If contacted OUP will be happy to rectify any errors or omissions at the earliest opportunity.

LIST OF PLATES (BY WILLIAM EMPSON)

LIST OF COLOUR PLATES

17. Image of the White-robed Guanyin in copper alloy from Manchuria, China, 10th century CE (Liao Dynasty). University of Pennsylvania Museum (image courtesy University of Pennsylvania Museum).

18. Red sandstone balustrade carved with a Buddha-image from Mathura, India, 1st–3rd century CE (Kushan). Musée Guimet, Paris (image copyright RMN Grand Palais (Hervé Lewandowski), Musée Guimet, Paris).

19. Sandstone Trimurti (head detail) from Cave 1 at Elephanta, Gharapuri Island, Maharastra, India, probably 5th–8th century CE (editor's photograph).

20. Photographic portrait of Winston Churchill by Yousuf Karsh, 1941 (courtesy Karsh estate/Camera Press).

21. *The actor Nakamura Utaemon III as Oboshi Yuranosuke* by Utagawa Kuniyoshi, woodblock print (*oban tate-e*), mid-19th century CE (Edo Period). British Museum, London (image courtesy trustees of the British Museum).

22. Bronze figure of Yamantaka Vajrabhairava in the Sino-Tibetan style from Beijing, China, 19th century CE. British Museum, London (image courtesy trustees of the British Museum).

23. Virgin and Child ('The Madonna of the Pillar') in carved wood, 1508. Chartres Cathedral, France (editor's photograph).

24. The Dead Christ and the Virgin by a Neapolitan follower of Giotto (formerly attributed to Lorenzetti). Tempera and gold leaf on wood panel, probably 1330s–1340s, National Gallery, London (image courtesy National Gallery Picture Library).

25. William's Painting by William Empson. Oil on canvas, 1932–3. Collection of Mogador Empson, London.

THE FIRE SERMON

Everything, Bhikkhus, is on fire. What everything, Bhikkhus, is on fire? The eye is on fire, the visible is on fire, the knowledge of the visible is on fire, the contact with the visible is on fire, the feeling which arises from the contact with the visible is on fire, be it pleasure, be it pain, be it neither pleasure nor pain. By what fire is it kindled? By the fire of lust, by the fire of hate, by the fire of delusion it is kindled, by birth age death pain lamentation sorrow grief despair it is kindled, thus I say. The ear ... say. The nose ... say. The tongue ... say. The body ... say. The mind ... say.

Knowing this, Bhikkhus, the wise man, following the Aryan path, learned in the law, becomes weary of the eye, he becomes weary of the visible, he becomes weary of the knowledge of the visible, he becomes weary of the contact of the visible, he becomes weary of the feeling which arises from the contact of the visible, be it pleasure, be it pain, be it neither pleasure nor pain. He becomes weary of the ear ... pain. He becomes weary of the nose ... pain. He becomes weary of the tongue ... pain. He becomes weary of the body ... pain. He becomes weary of the mind ... pain.

When he is weary of these things, he becomes empty of desire. When he is empty of desire, he becomes free. When he is free he knows that he is free, that rebirth is at an end, that virtue is accomplished, that duty is done, and that there is no more returning to this world; thus he knows.[1]

[1] William Empson's translation of the *Adittapariyaya Sutta* (*Fire Sermon Discourse*) of the Pali Canon, as given in the epigraph to *Collected Poems* (London: Chatto & Windus, 1955).

THE FACE OF THE BUDDHA

William Empson

Preface by William Empson

A brief survey of the sculpture of the Buddha and Buddhist personages, such as is aimed at here, must of course leave out an enormous amount; the field is wide, rich and hard to know. But the elementary facts are not so generally known as they ought to be, considering that the Buddhist work includes some of the best sculpture in the world. I have tried to distinguish the main types, give dates, argue against some popular prejudices, give some account of the general cultural background in which the statues were produced, and above all give enough photographs to suggest the variety and the supreme merit of the material.

I am in no way expert in this very technical field, and wish I had read more before doing the museums. But I have looked at Buddha all right, in Japan, Korea, China, Indochina, Burma, India, Ceylon and the United States; I have seen all that I give photographs of. While in Japan I formed a theory about asymmetry in Buddha faces, and had it in mind when looking at the sculpture in all the other countries named. The evidence given for the theory here is of course very inadequate; I can only hope that it will be enough to make some better-qualified person examine the evidence on a proper scale. But as the ground for my own conviction I have a very considerable amount of evidence which I cannot produce, in that I have seen the theory working on a large number of examples for which I have no photographs. I have kept the theory separate from the survey.

The Type in General

There are two common misunderstandings about Buddhist sculpture; that the faces have no expression at all, an idea set on foot by Lafcadio Hearn, who had a genuine feeling for the East but was almost blind, or else they all sneer, a thing that G.K. Chesterton, for instance, often said, which is less easy to answer.[1] Certainly in each Buddhist country, after a few centuries, the type becomes conventional and is liable to be complacent; also one thinks first of the Buddhas of China, and as soon as the Buddha arrived in China he was given something of the polite irony of a social superior. There was some real falsity when the Far East came to treat the Bodhisattva of Mercy as a fashion plate of the court lady.[2] But before merely disliking the look of complacence one should in fairness consider how it enters the theological system. The Buddha has delivered from the world and may well look superior to it. But he is telling you that you could do the same; also he could not have achieved this apparently private purpose without first learning complete unselfishness, giving his body to a hungry tiger in a previous incarnation and so on.[3] He spent a long life in labouring to teach others the Way, and is worshipped for having done so. As to the afterdinner look of many Buddhas, and the rings of fat on the neck, a puzzle of the translators of the Pali texts may bring out the point; one expert gives a remark of the Buddha as 'While I live thus, after having felt the extreme sensations, I am free,' another as 'after having felt my last sensation.'[4] An idea that you must be somehow satisfied as well as mortified before entering repose goes deep into the system, and perhaps into human life. It is also important that the Bodhisattvas have chosen not to become impersonal like the Buddha and are inherently self-sacrificing like the Christ. But this argument should not be pushed too far, because they remain extremely *like* Buddhas; they do not avoid a certain impersonality which belongs to Asia as opposed to Europe. In any case they are not sneering. The drooping eyelids of the great creatures are heavy with patience and suffering, and the subtle irony which offends us in their raised eyebrows (it is quite a common expression among Europeans, though curiously avoided in our portraits) is in effect an appeal to us to feel, as they do, that it is odd that we let our desires subject us to so much torment in the world.

The next thing that most people would say is that the Buddhas are monotonous. There is a sort of democracy about the repetition of the stock type; it is the

simplest conception of high divinity that the human race has devised. The Lotus Sutra (with a touch of prophecy, as the type seems hardly to have been fixed when it was written) says that even boys in their play who draw the Blessed One with their fingernails are gradually acquiring merit and becoming pitiful in heart.[5] There could not be a parallel saying about the Christ, because though Europe has in a way agreed on his face you have to be a trained artist to draw it. The boys would be able to draw the Buddha with their fingernails; if you keep to the formula even the crudest version gives him his effect of eternity. It is done by the high eyebrow, soaring outwards, by the long slit eye, almost shut in meditation, with a suggestion of squinting inward, that would be a frighteningly large eye if opened; and by a suggestion of the calm of childhood in the smooth lines of the mature face—a certain puppy quality in the long ear often helps to bring this out. If you get these, they carry the main thought of the religion; for one thing the face is at once blind and all-seeing ('He knows no more than a Buddha' they say of a deceived husband in the Far East) so at once sufficient to itself and of universal charity. This essential formula for the face allows of much variety; it is hardly more than a blank cheque, but one on a strong bank, so to speak, and I feel that even an unrealistic Buddha does more than a head of Christ to impose itself as a real person in the room.

Such is the stock type when fully developed; we are to examine its origins and some of the variant forms. It seemed best, after this attempt to recall to the reader a general impression of Buddhist work, to put in at once a list of various details of iconography by which the types are distinguished. They would otherwise keep cropping up at random in the historical survey which follows.

Iconography

The rules cannot be laid down entirely without reference to countries and dates, but when the first images of the Buddha appear (in India and Afghanistan about the first century AD) he himself has most of his later attributes, and the same can be said of two of the Bodhisattvas. The degree of strictness varies, but the fundamental rules were accepted by all the countries which adopted Buddhism.

The term Buddha means Awakened or Wise One. The historical Buddha (Sakyamuni or Gautama Siddhartha)[6] can take many positions commemorating different occasions, and may be standing or lying down (this means his death-scene); but in most cases he will be in the cross-legged position with the soles of both feet pointing upwards [(paryanka)].[7] This was his usual position for meditating, but is perhaps generally taken to mean the time when he received illumination. The position is not at all impossible; I have known an Englishman who could not only get into it but proceed to walk upon his knees. The Buddha wears tight curls, has a knob on the top of his head (the *ushnisha*: perhaps originally a Kushan fashion in hairdressing, but soon regarded as a sacred deformity) and a spot between the eyebrows (the *urna*).[8] This was perhaps originally a caste-mark, though he had rejected caste; it is described in the Lotus Sutra (probably first century AD) as a circle of white hair from which he can send out light to illuminate all worlds; is sometimes marked by a jewel; and may have had magical importance as marking the site of the pineal gland.[9] He has empty pierced earlobes, dragged down by the weight of the ornaments which he used to wear when a prince (Pl. 3). The positions of his hands and arms have a set of names and interpretations called *mudras*. The main ones with their Indian names are: *abhaya*, 'do not fear', the right arm raised from the elbow and the palm facing forwards (in the early Muttra [Mathura] work sideways) the left normally lowered; *dhyana*, 'meditation', the hands lying palm up one above another on the crossed legs—in this position he received enlightenment; *dharma-cakra* [dharmachakra], 'preaching', with the forefinger and thumb of the right hand meeting in a circle before the chest and the left hand curling up to point at it—this is also called 'turning the wheel of the law'; *vara* [varada], 'giving', the left hand palm outwards held down; and *bhumi-sparsa* [bhumisparsha], 'earth-touching', when the fingers of the right hand reach below the crossed legs to the ground (Pl. 5). This commemorates the occasion

[FIG. 01. Mathura sculpture (from A.K. Coomaraswamy, *History of Indian and Indonesian Art*, London (Edward Goldston) 1927, figure no. 78)]

immediately before enlightenment when Mara the Spirit of Sense tempted the Buddha and he called the earth to witness that he was sinless, or alternatively Mara asked who was witness that the Buddha had ever done good deeds or bestowed alms; but a European will think of Antaeus who regained strength when he touched the earth, and the reason why the Buddha appealed to the earth may enter regions of myth not otherwise connected with Buddhist theology.

Avalokitesvara, the Bodhisattva of Mercy, is represented as early as the first surviving Buddhas. Thus there is a standing figure, part of the pillar of a railing dug up near Muttra [Mathura], and dated early Kushan period (first century AD) shown in Ananda K. Coomaraswamy's *History of Indian and Indonesian Art* (Fig. 01). It is in secular costume, wearing a crown with a seated Buddha in the meditation position in the front, holding a vase in the left hand, and raising the right arm from the elbow. These are all the marks of Avalokitesvara, except that his left hand often holds a lotus; but the Horiuji [i.e. Kudara] Kwannon in Japan, for instance, has all the other marks and the vase instead of the lotus (Figs. 39 & 43).[10] Avalokitesvara changed sex in China and became the Lady Kwan-yin, pronounced Kwannon in Japanese. The decisive detail is the *dhyana* Buddha in the head-dress,[11] which is regarded later as representing Amida.[12] Other Bodhisattvas have other distinctive marks in this crown; they all wear one because they are still regal beings and not a monk such as a Buddha has become. The supposed meaning of Avalokitesvara, used in the Chinese translation, is 'aware of imploring voices.'[13]

[FIG. 02. Mathura sculpture (from Coomaraswamy, *History of Indian and Indonesian Art*, figure no. 80)]

There are later versions, in the Far East as well as in India, with many heads because the creature can see suffering from any direction.

The other early Bodhisattva is Maitreya, who will become the next Buddha. He is older than Avalokitesvara in the literature, being mentioned in the Pali Canon of Hinayana [i.e. Theravada] Buddhism. Coomaraswamy gives what appear to be two Kushan period examples (Figs. 02 & 04), and identifies as Maitreya a supposedly fourth century head in Ceylon, which remained a Hinayana area. In India and Ceylon, and sometimes in the Far East, Maitreya has a sacred mount of monument (*stupa*) in the headdress and holds a vase and a rosary. He is called Mi-Lo [Mi-Le] in China and Miroku in Japan; in early Chinese sculpture he is generally seated with crossed ankles and crossed arms. Somewhat later he has the fingers of the right hand just touching the cheek (Figs. 33, 44 & 48). Being the [eighth] and last Buddha of a cycle he is sometimes shown with seven Buddhas in the aureole behind him.[14] He connected the older and newer conceptions of a Bodhisattva, and could therefore be worshipped in Ceylon. At first '*the* Bodhisattva' was used for Gautama before he received illumination; the term meant a person who was going to become a Buddha and attain perfect knowledge (*bodhi*). Mahayana Buddhism (the term means 'Great Vehicle') then developed permanent figures such as Avalokitesvara, in effect deities, who are holding back from Buddhahood in order to help others. Maitreya is not holding back for so long, and

may even be represented as a Buddha if conceived as at the time when he will
become one.

Only two other Bodhisattvas need be mentioned: Manjusri and Ksitigarbha.
Manjusri (Monju in Japanese) represents wisdom and intellect and has a book and
the sword of knowledge. His mudra is that of teaching the law. He is prominent in
early Mahayanist scriptures but not known before. The Chinese pilgrim I-Ching
[Yijing] in about 670 says that the Indians believed he came from China, but the
earlier Chinese pilgrims had not heard this.[15] Kshitigarbha (Ti-tsang [Dizang] in
China and Jizo in Japan) appears late in the literature and seems never to have
been important in India, but became so in China and Japan. The name means
Earth-womb: he is lord of the nether world. He alone of the pantheon has the
shaven head of a monk and an itinerant's staff, usually also a pearl. Later in Japan
he became a guardian of children.

We must now consider the rival Buddhas. Amida or Amitabha Buddha, the
Lord of Measureless Light, who has a paradise in the west, is mentioned in the
Lotus Sutra though without emphasis, and some of the scriptures which make him
prominent are said to have been translated into Chinese in the middle of the
second century, so that they probably date back to the first. His devotees treat him
as the saviour of all mankind, with the historical Buddha as little more than a
forerunner. He does not seem to have been prominent in India, and Sir Charles
Eliot suspected that he, also Kwannon, Monju and Jizo, were products of central
or western Asia; but Sir George Sansom says that Amida can be traced in India to
at least the second century BC.[16] The Amidist scriptures say that he vowed not to
become a Buddha except on condition that he could help others and share his
accumulated merit with them, so this Buddha has also the claims to attention of a
Bodhisattva. His worshippers aim at entering his western heaven rather than
attaining nirvana.[17] The metaphysical idea that the Buddha nature is inherent in
all sentient creatures seems to come to prominence with his cult. The chief mark
of an Amida in iconography is that he is in *dhyana* position with folded legs. His
standard mudra has the hands palm upwards on the lap as in meditation but has
the foremost joints of the index fingers and the tips of the thumbs touching each
other; the joined fingertips point up to meet the thumbs (Fig. 59).

Vairocana (Taiji [Dari] in Chinese, Dainichi or Dainichi Nyorai in Japanese) is a
still later conception; the main scripture about him was being translated into
Chinese about the end of the fourth century (Fig. 55).[18] The name was a title of
the sun. He is the energy behind the universe, so that with him the Buddha's
withdrawal from the world has been turned into a full-blown pantheism, which
makes the Buddha nature essential to the structure of the world. He is treated as a
profounder object of worship lying behind Amida and the previous pantheon. His
mudra in the Far East is a right fist clenched before the body except for a long
vertical extended forefinger, with the clenched left hand fitted on top of the

forefinger so as to suggest that it is even longer. This is sometimes called the *mudra* of generation, and seems to be a phallic symbol. He is always given a great deal of bounce. In Thibet [Tibet] the belief in female incarnations with which the Buddhas copulate appears as part of the Vairocana doctrine, but the Far East did not put up with this mystical development.

The Buddha of Healing is prominent in the Far East: Yao-shih in China and Yakushi in Japan; the Indian name is Bhaisajyaguru. He appears in the lotus sutra but as a raja, not as a guru, as he was then only a Bodhisattva. He became lord of the eastern heaven. He holds a medicinal fruit in an offering position in the left hand, and was worshipped for specific purposes (Fig. 28). In theory there are unlimited numbers of Buddhas, but the others are not prominent.

The whole of this superstructure and much more belongs to Mahayana Buddhism, not to the Hinayana [Theravada], which survives in Burma and Ceylon. Guardian spirits are represented there, and of course it is not denied that other Buddhas may have existed; the Buddha is not conceived as unique, like the Christ. It might seem that the present Buddha, let alone the earlier ones, is not a useful being to pray to, because he has entered peace. But the nature of nirvana remains a mystery only to be described by the double negatives of Indian logic, and the fact that he is represented and prayed to is a step towards the Mahayana view. Neither side entirely forgets the other. On a Hinayana view it is a false step to become lord of a heaven, since, though agreeable, it delays your advance towards nirvana. A man has a fair chance of getting there first, and there is a fine story in the sacred texts about an angel raising a point of theology which was referred upwards and upwards in the divine hierarchy till at last the senior king of all the heavens was approached, and he replied with some embarrassment 'the only person who knows that is a man, down there,' and pointed at the Buddha wandering with his begging bowl.

Survey

The Buddha lived about 500 BC (possible dates [for his birth and] for his death, in his eightieth year, are 554 and 437) and the first surviving representations of him were made at about the time of Christ.[19] The Buddhist King Asoka (273–232 BC) of the Maurya Dynasty put up pillars with symbolic wheels and lions, but apparently no human figures.[20] In the Sunga period (184 BC–20 [70] AD) monuments were erected (at Sanchi, Bharhut, and Bodhgaya) with reliefs giving scenes from the Buddha's life, but the Buddha himself is not represented except by a symbolical tree, umbrella, wheel, or pair of footprints.[21] In the following Kushan period (50–320 AD) statues of the Buddha appear; it was a central Asian dynasty, and the main centres for the sculpture are Gandhara in Afghanistan and Mathura (now Muttra) in India, also Sarnath and Amaravati perhaps rather later. The Sunga reliefs imply a definite prohibition, but there is no evidence of how it came to be made or broken. One of the sacred texts makes a disciple ask the Buddha if images of Bodhisattvas may be made, since images of his own body are not allowed; but the text is dated about the third century AD and the scene appears to be a reconstruction of history such as we might make ourselves.[22] I do not know why Sir Charles Eliot says in a footnote that images were used by Buddhism about the fourth century BC.[23] Wooden statues now lost, of course, had been made for a long time before the stone ones, but the first stone ones seem to be going through an early development of the type.

In the centuries around the time of Christ the trade routes between India, China and Imperial Rome were in regular use. On the whole, the influences went out of India and not into it; for Diana of the Ephesians, who had many breasts, has been described as a typical Indian cult object; whereas the Indians have left no reference whatever to their invasion by Alexander in 327.[24] While the sacrificial religion of Christianity was being formed, Buddhism was also developing a sacrificial conception, in the Bodhisattva. This is a very different sacrificial being from the Christ, because he gives up not this life but (broadly speaking) his death; ordinary death indeed has little dramatic value in the religion, because of the fundamental doctrine of reincarnation which it took over from Hinduism. The object of a Buddhist is to escape from personality and desire so as to enter Nirvana, however the term is interpreted, but a Bodhisattva has so strong desire to help

others that it has renounced its chance to do this till the last grain of sand has entered Nirvana before it. At least, that is the final doctrine; references in the early Mahayanist sutras show that Bodhisattvas had already taken vows to wait for all mankind. In spite of the unlikeness of this idea to the Christian one it has the same tearing moral splendour; the means are the greatest personal sacrifice and the end is the good of all with an emphasis on the good of the lowest. In Hinduism, Krishna appears not much earlier, in literature at any rate, and the Bhagavad Gita presents him as 'a loving deity who offers salvation in return for faith and devotion.' The important likenesses are not in details but in the *zeitgeist* from which the cults proceed. The corresponding event in China is the development of the Taoist church, about 130 AD, which, if less glowing, is at least a mass movement.

The Buddha, on the other hand, was roughly speaking a contemporary of Confucius, Parmenides, and Amos the prophet. Indeed there is some evidence of contact in his time between India and the west; for example, transmigration appears in Egypt about 500 BC, where it was found by Pythagoras. The Buddha, in fact, lived when the first world philosophies, with doctrines about 'all men' and about the just treatment of them, were being formed. He believed that he could show the way to escape the torment of the world, but there is no paradox of personal sacrifice about him any more than about his contemporaries elsewhere. He decided that asceticism if carried to self-torture did not work. Also one of his chief doctrines was the denial of the existence of *atta*, the self, as a permanent unit. It may be suspected that he would have thought a Bodhisattva, refusing to enter Nirvana out of insatiable benevolence, had overshot the mark of good works and become rather a busybody. However, Sir Charles Eliot has made clear that the germ of the Mahayana beliefs was present in the older scriptures if anyone chose to develop them.[25] The question is who wanted the development; it has been argued that the popularisation of the religion in India which followed the conversion of King Asoka would create a demand for more popular doctrines, and the same argument would apply to foreign converts. The date of the first Mahayanist scriptures, such as the Lotus sutra, is obscure, but they are thought to be of about the first century AD. In any case, the change of theology is likely to be connected with the appearance of the sculpture. A Bodhisattva was still active in the world, and therefore worth praying to personally; he could save you if you had enough faith in him, whether you deserved it or not; the emotional relationship of the worshipper to a divine person is given more importance than before. To contemplate his person in art is a natural step.

We now approach the great controversy about whether Greek influence was important in the first Buddhist sculpture. The first experts to go into the question were Europeans (the great name is M. Foucher); they were charmed to discover that work from Afghanistan certainly influenced by Greek art, is among the earliest known, and they called it 'the Greek origin of the Buddha type.'[26] Indians

FIG. 03. Parkham Yaksha [i.e. Yaksha
Manibhadra] (Op. cit. [i.e. Coomaraswamy,
History of Indian and Indonesian Art,
figure] no. 09)

(the great name is Mr. Coomaraswamy) then became experts in this field, and
found it easy to maintain that the frontier Greco-Buddhist work was extremely
debased, whereas the force of the new art came from Indian centres such as
Mathura, and drew on purely Indian traditions.[27] India certainly had an older
sculptural tradition; at least one massive *yaksha* at Mathura is dated back to the
Maurya period, 320–185 BC, the dynasty which included King Asoka (Fig. 03).[28]
This need not mean the breaking of a rule that Hindu deities were not represented.
Hinduism is a compound of the beliefs of the Aryan or Sanskrit-speaking invaders,
who are believed to have come from the northwest about 1000 or 1500 BC, and the
indigenous Dravidian cults which gradually regained power by infiltration into it. It
is doubtful whether there are statues of *devas* (Aryan divinities) before the first
century AD, but in any case the indigenous cults made statues of local genii, *yakshas*
and *nagas*, and of goddesses of fertility, and it seems clear that these were among
the sources of the Buddha type of Mathura.[29]

The Mathura type has open eyes and in general high rounded eyebrows; the
combination makes it look young, sometimes comically so, like a Mabel Lucie
Attwell baby; and the effect may be increased by a round head and face and short
thin pouting lips (Pl. 18 & Fig. 04).[30] The high eyebrow seems to be used
intentionally for Buddhas, in that supposed 'donors' on the reliefs have lower
ones. This baby effect seems peculiar to the early Mathura Buddhist work, but
Sunga and even Mauryan *yakshas* seem to have had the open eye end the high

FIG. 04. Mathura Buddha (Op. cit. [i.e.
Coomaraswamy, *History of Indian and
Indonesian Art*, figure] no. 87)

[FIG. 05. Yaksha sculpture (from
Coomaraswamy, *History of Indian
and Indonesian Art*, figure no. 08)]

[FIG. 06. Yaksha sculpture (from Coomaraswamy, *History of Indian and Indonesian Art*, figure no. 17)]

[FIG. 07. Early sculpture (from Coomaraswamy, *History of Indian and Indonesian Art*, figure no. 67)]

eyebrow, though with enough jowl and general massiveness of physique to make them look older (Figs. 05–07). Possibly the changes made in the type by the Mathura sculptors was merely intended to reduce the potential aggressiveness of the figure, while still letting it throw a fullgrown chest. The high brow and the round face have become part of the standard Buddha head, but when taken separately as at Mathura they give something very unlike it.

The Gandhara Buddhas of Afghanistan are very evidently Greek, in the face as well as the drapery, and yet at first sight much more like the eventual tradition than the Mathura ones. This is chiefly because they have the half-shut eye (Pl. 6). As a rule, they make the upper lid the one which is curved slightly open, whereas the standard Buddha eye curves the lower lid; but this is not a striking difference. The chief difference of early Gandhara work from the eventual Buddha type is that it does not raise the eyebrows at all. The raised eyebrow comes in later; it is found for instance on my example from the Musée Guimet dated third or fourth century; but one can reasonably suppose that this is due to influence from the Mathura style. As a rule the Gandhara Buddhas have the Greek straight line from nose to forehead; this convention was often used for the Buddha in the Indian Gupta period, but not I think afterwards, and it keeps cropping up in the Far East, particularly at Yun-kang [Yungang] in China (Pl. 16). Also the curve of the eyebrow often runs into the nose as an unbroken curve, but this simplification is found on some Indian *yakshas* as well as some Greek work. It is more important that the early Gandhara Buddhas have the *ushnisha*, the bump on top of the head, and there seems to be no indubitable case of this on early Mathura work.

The hair is a neat case of absorption. The Gandhara Buddhas have wavy hair of a normal Greek type, or curls clearly intended as hair, whereas the early Mathura ones have what seems to be close-cropped hair (that is, only the hairline is marked) or a sort of twisted cap (which might be a form of *ushnisha*), or a headdress (presumably to mark a Bodhisattva). By the Gupta period in India (320–600 AD) the Buddhas have tight curls which look like snailshells and are actually said to be snailshells; this became the permanent convention.[31] The Buddha naturally wore his hair when a prince and shaved it off on becoming a monk, and worshippers want to think of him as both (on the same principle his earlobes are pierced and pulled down by the weight of jewels, but he has taken them out). Compromise was achieved by a legend that when in meditation he failed to observe that the shadow of the sacred bo-tree [bodhi tree] had moved away from him and would have got sunstroke if a number of devout snails had not climbed onto his head (the leaves of the sacred tree still tremble at the memory of the struggle they witnessed).[32] This settled the matter satisfactorily; but it remains possible that the problem was first raised by Greek sculptors who simply gave him the hair which was the pride of Alexander the Great.

[FIG. 08. Sculpture labelled 'Indra as Santi' (from Coomaraswamy, *History of Indian and Indonesian Art*, figure no. 40)]

A neat solution can also be found for the *ushnisha*, the bump on top of the head. The Bimara Reliquary, dated provisionally as early as 35 BC (it is in the British Museum), shows a Buddha and other figures, obviously in the Greek tradition, but with their hair loosely bound in a bun on top of the head (Pl. 2).[33] This gives a natural origin for the lump, and one could treat the listing of the deformity among the sacred marks of a Buddha as a later invention to explain it. However there seems to be no doubt that a figure on a stone railing from Bodhgaya, described by Mr. Coomaraswamy as 'Indra as Santi' and dated back to the Sunga period has an *ushnisha* and tight, curly hair (Fig. 08). It seems as well therefore not to be too confident about these explanations, though they are probable.

It is reasonable, I think, to say that the impulse to start making any statues of the Buddha at all might well come from the frontier people, who would not feel bound by the Indian convention; and it seems clear that the later Buddha type is really influenced by the Greek ones. One might suppose that 'the frankness of the West' would make the Gandhara Buddhas extrovert and open-eyed, whereas the mysterious East would have put in the aloofness and transcendentalism. The contrary is the case; the Gandhara Buddha, and not the Mathura one, has the cold perfection, the slim body, and the half-closed eye, and these have established themselves in the tradition (Fig. 09). Before discussing this further, we had better examine a confusing question about the races involved, since it might be thought that the half-shut eye is merely a Mongolian racial feature.

FIG. 09. Early Gandhara Buddha (Op. cit. [Empson gives no figure number from Coomaraswamy here, but this image from the *History of Indian and Indonesian Art* closely matches his commentary])

These centres of Gandhara and Mathura, which appear as rival representatives of Greece and India, were at about that time under a single rule derived from neither. The Kushan Dynasty came from the Yueh-chi [Yuezhi] tribes of north-west China, which were driven westward in the second century BC. It was ruling Gandhara by 50 AD, and King Kanishka, an important Buddhist patron of the first or second century (probably reigning 78–123), extended his rule beyond Mathura in India and his influence to Khotan on the Chinese border. The sculpture almost certainly got started before they arrived, but the variety of racial types in view during the formative period was certainly very complete. It is usually supposed that the Kushan rulers were Mongols, whereas the population of northern India was largely Aryan, a term which the Buddha used generally but seems to have believed to apply to his stock. Mr. V. A. Smith, however, in the *Oxford History of India*, maintains that the Yueh-chi were not 'narrow-eyed Mongols.'[34] 'They were big pink-cheeked men', he says approvingly, 'built on a large scale, and may possibly be related to the Turks.' Many Mongols are big, and I do not see how he knows about the complexion, as apparently there are no surviving paintings. On the other hand, he maintains that the Buddha, being of warrior caste and not a Brahmin, and of a group which exposed its dead to birds, must have been a Mongolian type 'like hillmen tribes today,' and that this 'hillman or Mongol' type remained important in north India till after the Christian era. It is hard to believe that the Aryans who invaded India brought no soldiers with them, only priests, or

even turned all their soldiers into priests when they were holding their conquests down; and I understand that funeral customs were fairly open to change by borrowing in ancient India. However, in any case we might expect the early statues to be influenced by the Mongol type of face, whether we accept or reject the ethnical *bouleversement* of Mr. Smith. Photographs of some of the heads at Bamiyan in Afghanistan, of about the third century, do I think look Mongol, and unlike the rest of the work. It could not in any case be argued that the standard Gandhara type of Buddha has half-shut eyes out of *compliment* to the ruling dynasty, supposing it to be Mongol, because what statues of rulers there are seem to have more open eyes than the Hellenistic Buddhas (and on the other hand rather higher cheekbones). The actual slit eye only becomes a convention in the Gupta period, and I take it that even Mr. Smith does not say that the Guptas were Mongols. It seems clear that the eye was developed not on racial grounds but because it was thought expressive. On the other hand, I do not want to pretend that racial differences do not exist, a fashion which I think has been carried to rather absurd lengths recently among high-minded people; it would be fussy to deny that Mongols often do have half-shut eyes, that the Gandhara sculptors had opportunities to see people with eyes like that, and that it may have given them the idea for their peculiar Buddha eye. But the more important question is why they liked the idea, however they got it.

It may well be that, partly because of their Hellenistic background, they felt the Buddhist theology to be puzzling, and gave the Buddha a half-shut eye to suggest that he was hiding something or holding it back. The Buddha himself denied that he had a 'closed hand' or was withholding any of his wisdom; but he at first despaired of making people understand it, and seems to have been careful in teaching, to give the ideas only in their proper sequence with time for digestion; also he said that no correct answer could be formulated for some questions. This is the Hinayana picture; the Mahayana scriptures (particularly the Lotus [Sutra]) base their plausibility on claiming that for most of his life the Buddha was deliberately holding the final truth in reserve, and it is presumably on this view that the Gandhara artists were working. Whereas the Indian artists of Mathura would probably not feel to the same degree that the whole system was a mysterious or puzzling one, even after hearing the new version of it, so that there was nothing to prevent them from keeping the eye open. They seem indeed to have felt that the whole thing was radiantly simple and clear.

In considering the early Buddhas of Mathura one should rid oneself of the common idea that Buddhism is essentially a passive, pessimistic and indeed reactionary creed. It has been a civilising force in wide areas of the world, and there is nothing less reactionary than the idea that 'all this misery is unnecessary: if you renounce selfishness you can free yourself from your chains.' Asoka was a legend by the time these statues were made, but the spirit of his active and

FIG. 10. Mathura Buddha
'Ai' (Op. cit. [i.e.
Coomaraswamy, *History of
Indian and Indonesian Art*,
figure] no. 84)

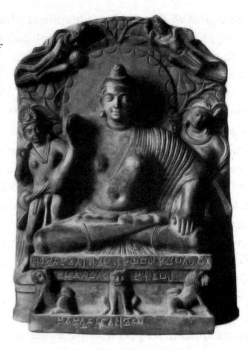

FIG. 10. Mathura Buddha 'Ai' (Op. cit. [i.e. Coomaraswamy, *History of Indian and Indonesian Art*, figure] no. 84)

un-theological good works is very evident in them. The great seated Buddha called 'Ai' in the Mathura museum is a rousing figure, in excellent health and temper, keeping his royal dignity but sure that people will listen to his good news and become kind and sensible (Fig. 10). A certain femininity which keeps cropping up in the Buddha might be suspected in his ample breasts, but this trait is derived from earth gods in whom it marks a beefy strength to defend the worshipper. His eyes are not merely open but eager to catch the glances of the crowd he is evangelising. The brows are comparatively low, so that he does not illustrate the infantile possibilities of the Mathura type; there is a certain Boy Scout quality about his eagerness and frankness, but from the side the mouth is prepared to sweep away opposition with a sneer. I am anxious to point out how very un-racial the early work is; a universal quality in it persists through many schools and countries; and the main point of trying to recapitulate the controversy about Greek and Indian influence is to show the humanity and breadth of the origins.

We must now move to Ceylon, where the earliest known sculptures are three standing Buddhist figures dated about 200 AD. King Asoka had sent missionaries to Ceylon in the third century BC, and it had remained in close contact with India; that it should get the sculpture early is not surprising, but the feeling of these works is very different from either Mathura or Gandhara. The chief standing Buddha has an almost birdlike rigidity; a metallic shocking force from the powerful body; the open stone eyelids, one can only say, are like the nostrils of a snorting

FIG. 11. Anuradhapura [Ceylon
(Sri-Lanka)] Standing Buddha
(Op. cit. [i.e. Coomaraswamy,
*History of Indian and Indonesian
Art*, figure] no. 293)

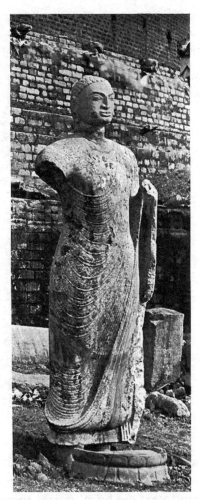

horse (Fig. 11). At least so it looks in the stock photograph, but when I got to
Anuradhapura I found that these things had been buried under inches of plaster in
a 'restoration' by their devotees; no doubt they are well preserved under it.
Ceylon, having kept to Hinayana Buddhism, believes that salvation must be
won by your own efforts, not by indulgences from a Bodhisattva, and the
puritanism of its doctrinal history may perhaps be felt in the concentration of its
early statues. There is however always a puzzle about what you are really admiring
when you see these things in photographs. There is a very fine Buddha seated in
meditation at Anuradhapura, dated third or fourth century (Fig. 12). I went to
Ceylon chiefly because of this photograph of it, and I was only able to convince
myself it was the right object by the cracks in the stone. The picture is taken from
below near the crossed legs, and gives the torso length; also it brings out a
haunting softness in the lightly moulded body, which rises like a flower into

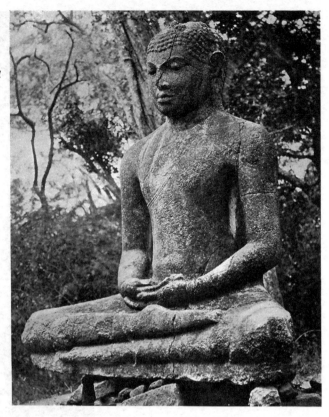

FIG. 12. Anuradhapura [Ceylon (Sri-Lanka)] Seated Buddha (Op. cit. [i.e. Coomaraswamy, *History of Indian and Indonesian Art*, figure] no. 295)

its position of eternal deliverance and calm. What is so touching about the photograph, in short, is that the Buddha is still almost a boy. Actually the thing is very stocky; the broad square shoulders rise from a narrow waist that seems acrobatic rather than youthful; the back curves in from the shoulder and juts out decisively at the bottom; the face is not so much innocent and self absorbed as puggy and determined; from the side the fully curved nose protrudes far beyond the chest, and the straight sag of the jowl gives a Mussolini effect (Pl. 4). You feel that if the champion stood up on his bandy legs he would look rather like a monkey—the Monkey of Arthur Waley's translation, to be sure.[35] Photography of course should not be blamed for being a branch of interpretative criticism; the moral is that one ought to have other photographs beside this very beautiful one; but I think it gives rather a one-sided account of the early work of Ceylon.

This statue in any case is a much more normal specimen of the Buddha type than the earlier standing ones, and may well be contemporary with the Indian Gupta work. The Gupta Dynasty (320–600 AD) is the classical period of Indian Buddhist art, not only for sculpture, but for the great mural paintings at Ajanta. The Buddha type is now fully established; the almost closed eye, an exaggeration

FIG. 13. Gupta Period
Buddha from Mathura
(Calcutta Museum)

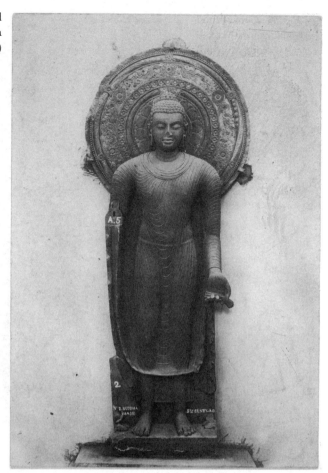

of the Gandhara eye, is universal, and the high eyebrow of Mathura is normal, though not always used in exaggerated form (Fig. 13). Thus the achievement of the standard Buddha type was a matter of fitting together these rival peculiarities of Gandhara and Mathura; they fit so perfectly that this seems an inherently unlikely theory, and I do not know that any authority has asserted it, but the evidence of the statues is very clear. By closing the eyes you remove the childish effect of the high eye-brow, and in any case the Gupta brow does not curve down again on the outside as much as the Mathura one. Drapery, if worn, clings to the figure as if wet and is marked only by rhythmical creases on the flesh; this is derived from Mathura and very unlike the Greek treatment of drapery as at Gandhara. I would say that a certain deadening has already set in with the great standing figures of the Sarnath and Calcutta museums, and their elaborate haloes; the more living of the Sarnath figures have a youthful and rather epicene effect, especially in

FIG. 14. Gupta Period
Buddha from Sarnath
(Calcutta Museum)

curving sideways at the waist, which seems the only positive quality still allowed them (Fig. 14).

As to the Ajanta frescoes, I think the chief thing to say is that they are much better even than the best of their reproductions (Fig. 15). The typical Ajanta upper eyelid is a double or triple curve, drooping in the middle and at the sides and sometimes turning up again at the ends; it is a long eye, dreamy but not withdrawn, and without the snakishness which later Indian work puts into this eyelid. The same curve is repeated by the mouth, the bottom of the nose, and the almost joined eyebrows, and is, in fact, the basis of the composition. There is sometimes a thin black line far outside the Buddha's mouth, level above and drooping below, a sort of transcendental pout. The caves make a fair bid at summing up all human experience, and the actual racial types are very mixed. Negro and Chinese faces emerge from the dark, Persian and Burmese; there is a blond European saint with a long beard (in cave *xvi d*, on the right near the door). Perhaps your first impression is that it is all rather Gauguin, but there is a variety of style between

FIG. 15. Ajanta
Bodhisattva [i.e. fresco
from Ajanta, India]
(bought there)

Great Bodhisattva (Padma Pani): Cave I

the scenes with violet high lights and harsh brick shadows, in which a negroid type
of Buddha seems baked into a state of menacing calm like a Byzantine, and the
mellow socially glittering Venetian crowd scenes; I remember a single yellow
charioteer turning in the saddle, a flash of observation in the sunlight, who
stood out from this rich texture with the personal freedom of the Florentines. A
detail in cave *xvii d* brings out the range of understanding behind these paintings.
The Buddha is here in a sacrificial incarnation and gives away everything, includ-
ing his wife and the horses with which he is escaping from his enemies.[36] At this
stage of the journey to perfection he has the face of a regular Renaissance Christ,
looking up sideways from a lowered head, with even the droop of the moustaches.
It is merely the proper face for him at that point, but it seems a claim to have put
Christianity into its place in the world scheme.

By the eighth century in India Buddhism is on the down grade, and the
competitive efforts of Hinduism have effects rather similar to those of the
counter-reformation in Europe. Popular support is to be won at all costs, and
the emotional appeal of the art is coarsened. Mr. Coomaraswamy himself, an
expert who would not say an unnecessarily harsh word about the arts of India,

describes the sculpture of the period after the collapse of Buddhism as having 'delicate, somewhat tormented outlines, with an expression at once nervous and sensual.'[37] But during the slow collapse India was in its great colonizing period, establishing Indian civilisation by sea voyage in many centres of Southeast Asia. It is odd to realise that India too once had a decentralised maritime empire, which claimed to spread a high civilization.

The first Indian royalty appears in southern Indochina about 400 AD, but trade and cultural contacts had been in progress for three centuries before. There is a great period in the fifth to seventh centuries (sometimes called pre-Khmer) followed by prolonged warfare, and another (the Khmer) in the ninth to twelfth centuries. The area, roughly the modern Cambodia, is called Funan in the first period, and Chenla in the second.[38] Buddhist and Hindu influences are always both present, but the main influence in the earliest work is Buddhist.

The pre-Khmer work in the Phnom Penh Museum, while extremely various, has a practical, administrative, physically powerful quality that you do not get in India after the Kushan period (Pl. 11 & Figs. 16–18). The eye of the Buddha is reopened, and the hollow of the collarbone at the throat makes what I believe are its only appearances in oriental sculpture. The hollow can only occasionally be seen, but I found that it could regularly be felt on pre-Khmer work, not on any other. I do not know any reason for this peculiar convention, but it seems a movement away from rolls of fat on the neck. The gods have to be competent here; it is touching how *useful* the Hindu pantheon seem to find all their arms. A sixth century Buddha is found sitting in European style on a chair; an important bit of evidence as to how the chair got to China in the Middle T'ang

FIG. 16. Sixth Century Head from Indochina (Phnom Penh Museum [Cambodia]) [see also Colour Plate 11]

FIG. 17. Seventh-
eighth Century (as
above) [i.e. sculpture
from Phnom Penh
Museum, Cambodia]

period (the chair has crossed legs at the side like a folding stool, and so has the chair in a copy of a T'ang painting which provides the only evidence for China. The Japanese learned their customs from China in the Early T'ang, and therefore just missed it).[39]

The pre-Khmer heads are very 'early Indian', or in a sense very normal: the peculiar contribution of Cambodia belongs to the later period. It is not true here, as so often elsewhere, that the later period loses the power to do good heads (Pl. 12 & Figs. 19 & 20). As elsewhere the best work of the later period is in architecture and decoration, but the standard Cambodian head repeated in the decorations has an extraordinary hypnotic power, and Cambodia is the only part of the world which made a success of colossal heads as a unit of architecture (Pl. 14).[40] The term colossal is often used for anything larger than lifesize, but here it is meant seriously: the heads carved in relief on the towers of the Bayon are six feet high. Very big heads were tried fairly often in Buddhist art up to a late date (Burma, northern China, and Japan have the main surviving ones) but they are all

FIG. 18. Another (as
above) [i.e. seventh-
eighth century sculpture
from Phnom Penh
Museum, Cambodia]

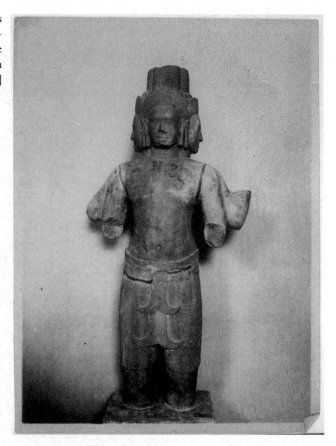

FIG. 18. Another (as
above) [i.e. seventh-
eighth century sculpture
from Phnom Penh
Museum, Cambodia]

as dead as mutton. The Khmer effect of being completely withdrawn into a dream, and yet dreaming with great activity and pleasure, is for some reason compatible with great size.

It is a pity that the photographs of the Bayon (now believed to be later than Angkor Wat) make it seem more destroyed than they need do (Pl. 13 & Fig. 21). It is constructed on an orderly foursquare plan with turrets rising in tiers, each big enough to hold one of the heads on each side; there are platforms going round them at several levels, and more of the heads on the central tower. Thus you can get right in among these monsters and see them from all angles at once, with a bewildering repetition, again like a dream in that ordinary perspective seems to be suspended. Sir Charles Eliot says that they must all stand for Shiva because they all have three eyes, but this seems merely untrue; however they also have not got the Amida in the headdress which would mark a Kwannon.[41] I hope that they stood for the Bodhisattva of Mercy even if identified with the reigning king (as is now generally believed); if they stood for Shiva in his aspect of lust and destruction the nightmare intended must have been a horrible one. But I was unable to shake off

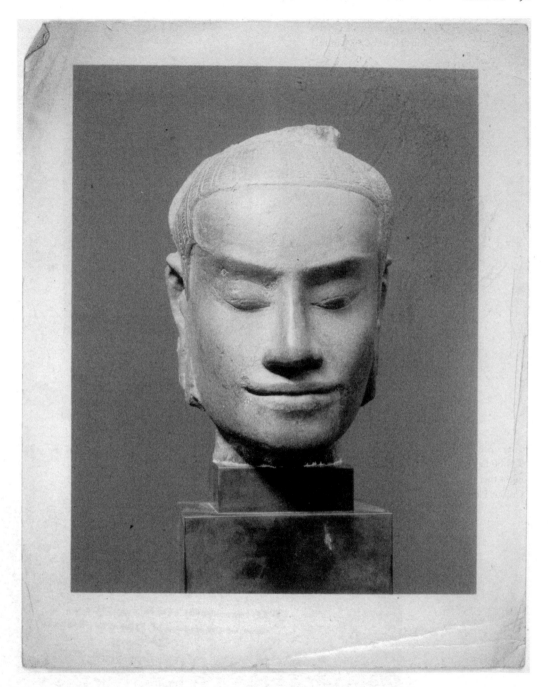

FIG. 19. Fourteenth Century Cambodian Head of a Divinity (acknowledgements to Museum of Fine Arts, Boston)

FIG. 20. Side view of 19 [the
Boston 'Head of a Divinity']

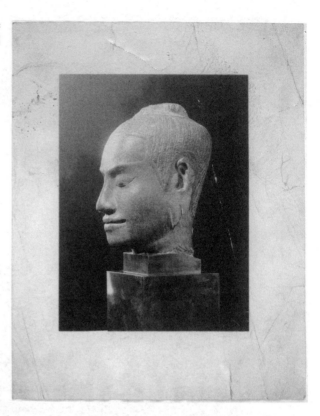

FIG. 21. Angkor Thom
[Cambodia] (postcard
bought there) [see also
Colour Plates 13, 14]

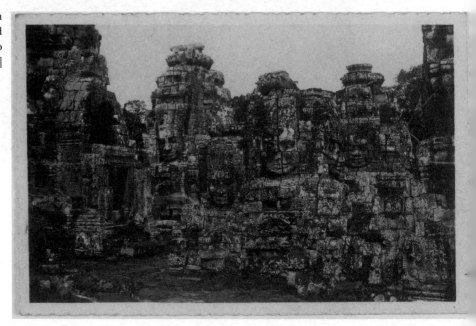

the idea of absolute protection and understanding which is the direct impression given by the stone.

The Khmers also made much use of the seven-headed or five-headed cobra, which already in Indian art raised its curved hoods in protection behind the meditating Buddha; at Angkor it is repeated for miles as a five-foot decoration along the terraces. At least it used to be, and after seeing one of them intact you can imagine the mass effect of this extraordinary decoration. I developed a fancy that this five-headed cobra is a metaphor for the *abhaya mudra* of the Buddha, that is, the raised hand with the palm forward which means 'do not fear.' It has nearly the same shape. To be sure, I have never had to do with a cobra, and perhaps after practical experience the paradox would seem an excessively monstrous one. But the high religions are devoted to contradictions of this sort, as in the *Facemi il primo amore* which Dante wrote over the gate of Hell, and the whole point about the snake is that the god has domesticated him as a protector.[42]

Mr. Geoffrey Gorer in *Bali and Angkor* developed a theory that Khmer art is essentially the production of a people soaked in opium, and that that is why the Buddhas are so dreamy.[43] M. Glaize, then *Conservateur des Monuments du groupe d'Angkor*, wrote to me that 'rien ne permet de supposer que les Khmers en aient fait usage.'[44] The mystery of Angkor has perhaps been rather overdone. When the dying French explorer staggered through the jungle and discovered the lost city he found a community of Hinayana [i.e. Theravada] monks still in residence, though it seems hardly good taste to point this out. Chou Ta Kuan [Zhou Daguan], the Chinese ambassador there in 1296, who wrote an account of it, does not seem to have been overwhelmed by any mystery, though he was much impressed by the erections, all of which he took to be Buddhist.[45] Building apparently stopped at Angkor because it was too near the territory of the aggressive Siamese, whom Cambodia was still resisting in the sixteenth century. The religion seems to have been closely tied to the cult of royalty, and the temples became overgrown as soon as the rulers no longer made forced labour keep them clear (I bought a photograph of a colossal detached head at Angkor on a site which had been completely cleared a few years before, and then tried to see it; this meant a struggle through the undergrowth till I bumped into it). It is recorded that Chinese artisans were imported for the work on Angkor Wat, and this does not give any impression of isolation. It is true however that, as no literature has survived from the great Cambodian periods, we know nothing of the distinctive doctrines which may have lain behind their peculiar style. Sir Charles Eliot, after describing the inscriptions, states positively that ancient Cambodia 'produced no books', and indeed Chou Ta Kuan [Zhou Daguan] remarked that he could not make out what books the priests were reading, but he does not assume they had not got any.[46] I do not even understand how the drugged effect on the faces was obtained. But I think the secret belongs almost entirely to the mouth,

which is straight and long, lies close to the nose, with thick and soft though well moulded lips, and then turns up a little at the very end. The big zygomatic muscle which pulls the mouth ends from the cheekbones is the one most under conscious control, and the impression one gets from the statues (I think) is that the muscles are entirely relaxed except for a faint reaction in this big one, by which the happiness within can still give the abandoned body the ghost of a smile (Pl. 12).[47]

About 630 AD what is described as the first king of Thibet [Tibet] married a princess of Nepal, where there are Buddhist monuments ascribed to Asoka; she converted him to Buddhism, if indeed the work was not done by the daughter of a T'ang emperor, who was also a Buddhist and his wife.[48] The story shows that Thibet was not a main land route through which Buddhism reached China. In the ninth century, Thibet extended its power to Tun-huang [Dunhuang] in eastern Sinkiang [Xinjiang], which had long been a Buddhist centre on the silk road, and there the oldest remains of Thibetan painting have been found.[49] Direct rule by Lamaist monks dates only from the sixteenth century, but apparently all Thibetan art is Buddhist. The country was influenced by Tantrism, a mystical Indian cult which pays much attention to lust and destruction. In 747 a preacher from India is said to have brought the Mantrayana [i.e. Vajrayana] doctrine centring round the Bodhisattva Vairocana, using magical spells, and giving the Buddhas female emanations. It was bad luck to get Buddhism so late. But in the case of Thibet, whatever you think about India, it would be hard to deny that the appalling character of the climate has affected the religion and customs of the country, and much Thibetan art is merely nightmarish. The bronzes of a god with many arms and a leering beast's head, who stands or adopts the Buddha position while copulating with a female emanation, are normally from Thibet; and are often I think agreeable to contemplate because their romantic sensuality, though fierce, is too direct to be sadistic (Pl. 22). The paintings can be very fine if the horror so fully recognised in the world is offset sufficiently powerfully by the mercy, purity and sanity of the central Buddha; indeed, I think that the big Thibetan scroll paintings in the Western Union University at Chengtu [Chengdu] are the most impressive statement of the Buddhist world outlook ever achieved anywhere.[50] The effect is that the Buddha is moving freely in the open air, whereas all the other figures are enclosed in their nightmare. But as soon as he becomes dim or simpering, as in nearly all the Thibetan work one sees, the whole conception I think collapses and its grotesqueness is felt to be trivial or downright nasty.

The first known Chinese contact with Buddhism is in 2 BC,[51] and it is believed that the first century Buddhism in China was Hinayana, not Mahayana. Twelve foreign translators, whether from India or central Asia, were helping to put Buddhist texts into Chinese before the fall of the Han dynasty in 221. After that

there were Mongol rulers in parts of north China until 590, who were naturally in touch with central Asia, and many of them were Buddhist. South China had a number of Chinese dynasties, mostly ruling from Nanking [Nanjing], and in most of them Confucianism seems to have been much weakened (Confucius was a northerner) so that they too were often Buddhist. The first translation of the Lotus Sutra, the chief Mahayanist scripture, was made in the middle of the third century. The earliest dated Chinese Buddhist sculpture is a bronze Maitreya statuette of 390 AD. 'In 381' says Sir Charles Eliot, 'we are told that in north-western China nine tenths of the inhabitants were Buddhists.'[52] The Chinese Buddhist pilgrims Fa Hsien [Faxian], Sung Yun [Song Yun], Hsuan Tsang [Xuanzang], and I Ching [Yijing] reached India around 400, 518, 630 and 670 respectively. Hsuan Tsang [Xuanzang] reports that Buddhism was already decaying and that erotic mysticism was prevalent in it. The memoirs of these travellers give important evidence for the history of India, a country remarkably barren of historians. Many Indian missionaries came to China and helped to translate scriptures, but none of them left memoirs.

Contact with India was both by land and sea, though of course both routes were costly, slow and dangerous. On the land route Tun-huang [Dunhuang] was an important contact town; it was on the crossroads where the Silk Road from China to Persia and Europe, with a branch to India, met the Thibetan road through Lhasa. Here and at neighbouring sites there are Buddhist remains of the fourth and fifth centuries, influenced by Greek and Persian as well as Indian styles. An inscription records that work on the caves was begun by a monk in 366 AD after a vision; it was resumed soon after 439 when the Northern Wei dynasty captured the site. No sculpture survives from the first period; some of the paintings now in the British Museum are very fine, but the main interest of the site is the historical one.

The Chinese, with their ability to calculate dates, decided that 433 AD was a thousand years from the historical Buddha, and therefore the end of his period; from then onwards the arrival of Maitreya as the next Buddha was expected daily, and the year was actually used as the starting date of a new era. Maitreya is therefore prominent in early Northern Wei sculpture, where the practice of putting him on a throne with his ankles crossed seems to argue an infiltration of the chair across central Asia, earlier than the one from Indochina which the Chinese finally adopted. During the sixth century there was naturally some loss of interest in Maitreya, and the T'ang period concentrates on Amida and Ti-tsang [Dizang—i.e. the Bodhisattva Ksitigarbha]. A temple of Manjusri at Wutaishan in Shansi [Shanxi] province was built at the end of the fifth century.

The chief source of Northern Wei sculpture is Yun-kang [Yungang], northwest of Peking, near Tatung-fu [Datong] and the Great Wall (Pl. 16 & Fig. 22). The Yun-kang caves were close to the capital of the dynasty, which lasted till 589.

FIG. 22. Group
from Yun-kang
[i.e. Yungang,
China] (bought
in Japan) [see also
Colour Plate 16]

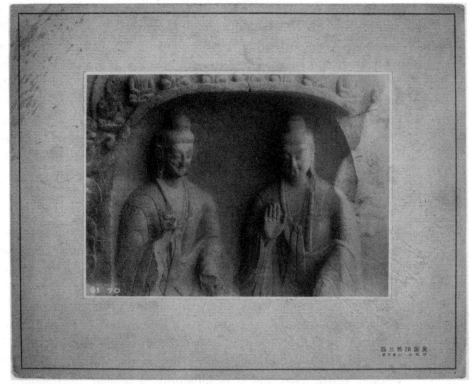

The work is said to have begun in 418, and to have been continued on a larger
scale from 452 to 466 as a sort of penance by the then (northern) Emperor for the
intervening First Persecution of Buddhism. This was set on foot by Taoists, not (as
it usually was later) by Confucianists. It is recorded that startling numbers of
artisans and their families were imported from Tun-huang to work on the site
under Imperial protection. When I was there in 1933 vast numbers of the heads
had already been hacked off for private sale, some of the caves had goats in them,
and there had been falls of rock from the cliffs which were expected to end in the
collapse of the caves. Many of the figures had been photographed before they
were destroyed, a good thing in itself but an irritating one for the student who has
looked at photographs before making the trip. There is now a regular branch of
Chinese art on sale and exhibition in the cultured capitals of the world, consisting
of bits hacked off these statues because the dealers loved them so much. In general
it is not possible even to see what was intended by a sculptured head unless you
have the rest of the statue; the whole proportion of the face will seem to change
according to the proportion of the body or the rhythm of the drapery. However,
after denouncing the business in principle one has to admit that a Yun-kang head
is impressive taken alone (Pl. 9 & 10, Figs. 23 & 61).

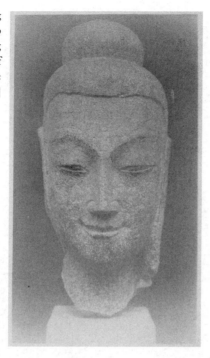

Fig. 23. Second Yun-kang head [i.e. secondary to Empson's 'main' Yungang head (Fig. 61)] (courtesy of Kansas City Museum) [see also Colour Plate 17]

The cliff of the caves is dominated by a dull but extremely ruthless colossal Buddha in high relief, and many of the life-size statues have a stark and devoted power. It has been suggested that the more human figures date from the second period, after 452, but one could not make a sharp contrast; there is certainly no weakness in the general effect. All the same the novelty about the first Buddhas in China is that they have already a suggestion of ironical politeness and philosophical superiority. Delicious conversation pieces are found in progress between the reserved but winking figures, withdrawn like the classical Chinese poets from the vulgar herd rather than the world. The Chinese Buddhas do not start off as administrators or empire builders (like the Cambodian ones, for example); the missionary work in China was to be done in a society already civilised in its own terms. I am not clear how far the work corresponded to a strong popular movement, but the idea of the Thousand Buddhas, which is carried out in several of the caves (a sheer wall of innumerable Buddhas like a wallpaper pattern, to show that the Buddha nature is omnipresent) was well suited to a mass religion; even a peasant could afford to sponsor one of these repeated objects, which would count as his own.

Taoism as a philosophy dates back to about the fifth century BC, but the formation of a Taoist church occurred in the second century AD. This incorporated the local deities of fertility, and by so doing appears to have become the first large religious organisation in China to affect the peasantry. The ancestor

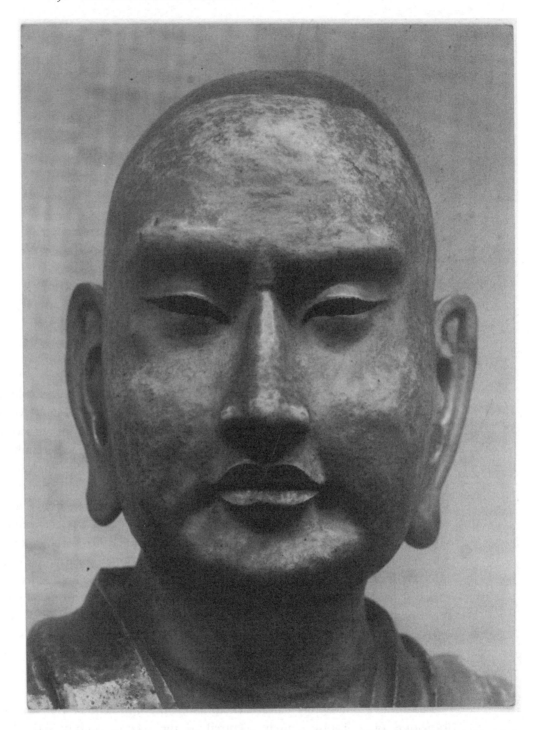

FIG. 24. Head of Sung [i.e. Chinese Song Dynasty] Pottery Lohan ([University of] Pennsylvania Museum) [see also Colour Plate 07]

worship of Confucianism was of course already practised by the people, but rather as part of their local cults than because Confucius had recommended it. The Taoist church, as it were, dug over the soil in China, and made people used to the idea of a life of contemplation, before the universal religion of Buddhism appeared there in any strength. It might perhaps be argued that the Taoists had had fair warning.

Be that as it may, it seems to me that the Yun-kang figures are popular art, in so far as they suggest that one has somehow got round the class distinctions of the world, which are still there but no longer matter. In the T'ang dynasty (618–907) the Buddhist work, though more accomplished and still of great spiritual power, has lost this peculiar merit and become definitely upper class. It appears that the strength of Buddhism in that period is bound up with the rise of the merchants. By the middle of the period Ti-tsang [Dizang] is important; the first dated example is of 667 AD. He appears at the sacred mountain Tai-shan, which had already been first a place of pilgrimage for long life and then a place of congregation for dead souls. Buddhist influence made it a place where the dead were judged to decide on their next incarnation, which might be in hell, and the function of Ti-tsang is to improve your chances. It is in the T'ang period that the Kwan-yin changes sex (there was a rather wicked Empress Wu [i.e. Wu Zetian] (684–705)—who claimed to be a female incarnation of the Bodhisattva of Mercy), and the very elegant statues have already a touch of the fashion plate.[53] From 600, under the Sui dynasty (590–618), there had been renewed contact across Central Asia because China became suzerain of Turfan and Khotan, and therefore a further question of Greco-Buddhist influence. The trade routes were closed for a time by the Mohammedan conquests.

These points seem important to give the general background for the development of the sculpture and possible influences on it. I cannot attempt to deal with Chinese Buddhist art in detail, and have few photographs. The life-size pottery Lohan (saint) from the Pennsylvania Museum, which was in the 1935 London Exhibition (Pl. 7 & Fig. 24), may serve to show for how long the religious power of the first class work was maintained. It has been believed to be T'ang dynasty, but is now thought to be Sung [Song] (960–1280), partly because of its realism as a portrait; and whether because of its realism or not it seemed to me so much alive that it turned the people looking at it in the London Exhibition into twittering ghosts.

A monk in the Diamond Mountains of Korea, to which I understand that Koreans who knew English often withdrew from the world, assured me that his monastery was founded in the first century AD by direct sea contact from India, and it seems that this is a common tradition. In any case, the various Buddhist influences from Tun-huang [Dunhuang] and north and south China were reaching Korea in the fourth century. Buddhism was officially introduced in the north in 372, but in the southern kingdom not till 528. A proscription of Buddhism in

FIG. 25. Korean
Primitive Head
(bought at Keishu
[Gyeongju] Museum,
Korea)

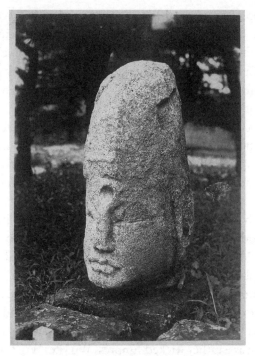

north China from about 574 drove many craftsmen from the city of Shantung [Shandong] to Korea; in any case, it was usual to send craftsmen as imperial presents. The T'ang dynasty sent a large invading force which was repulsed by the Koreans in 646, but part of the country was annexed soon after. Most of the early Korean work has been destroyed, but enough survives to show that it made an interesting separate development. The Japanese have done some fruitful diggings in the south near Keishu [i.e. Gyeongju], and an archaic head from that area shows how very un-Chinese the Koreans could be, especially in big heads (this detached head is nearly five feet high). Un-Indian too, for that matter; it is more like a Pharaoh than anything else (Fig. 25). The Koreans related the Buddha to local deities of fertility, as did the Indians with their *yaksha*, but in Korea (at any rate in the southern kingdom of Silla, whose capital was Keishu [Gyeongju]) they appear to be conceived as underground. A Buddha would be buried beside the tomb as a guardian —a squat, cosy, gnomelike figure (Fig. 26). The nose of this example was broken in transport, so that the photograph taken when it was half dug out is the only one of the complete statue. The earth-touching hand of the Buddha, a noble symbol which always seems to mean more than its justifying myth, is combined here and seldom elsewhere (but it seems occasionally in Thibet) with the Yakushi *mudra* of the left hand, the medicinal fruit held out by the Buddha of Healing (Figs. 27 & 28). There is a huge Buddha in the hillside at Sokkulam [Seokguram], himself buried in a domed tomb, a great slug surrounded

FIG. 26. Buddha Buried beside Tomb (as 25) [i.e. bought at the museum in Gyeongju, Korea]

FIG. 27. Yakushi [Yaksabul] in Earth-Touching Position [Bhumisparsha Mudra] (as 25) [i.e. bought at the museum in Gyeongju, Korea]

FIG. 28. Early
Yakushi [Yaksabul]
(as 25) [i.e. bought at
the museum in
Gyeongju, Korea]

FIG. 29.
Entrance to
Sokkulam
[Seokguram]
Cave (bought in
Korea) [see also
Colour Plate 5]

FIG. 30. Figure from Dome of Inner Room [at Seokguram] (as above) [i.e. bought in Korea]

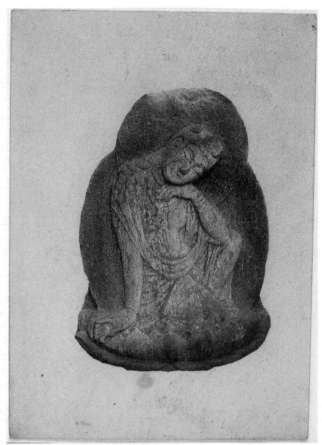

by exquisite Sinified Bodhisattvas in low relief, where only the little root-lets of the earth-touching fingers seem still alive (Pl. 5 & Fig. 29). One of the saints found on the inside of the dome of the roof is worth illustrating for the angular medieval pose of his austerity (Fig. 30), in contrast with the courtly Kwannons on the reliefs below him (Fig. 31). There is a great variety of style handled with complete control for a unified design. The cave is dated 752 AD.[54]

The standard early Korean type has a peculiar nose, said to be derived from the Chinese reliefs of the Han period, to which it is supposed to have come across central Asia. The Koreans, it struck me, have actually got straight noses, and did not need to borrow the idea from the already ancient Han reliefs. But the sculptured nose is very distinctive; it is the straight sharp nose of intelligence rather than rule but perked out at the end so as to imply a refined inquisitive sensuality. It seems really connected with the Han one. I have included a row of Korean Buddhas (around 600 [AD]) who have become absurdly rigid and mousey in their efforts to combine it with the Greek straight line from nose to brow (Fig. 32).

FIG. 32. Korean
Buddhas

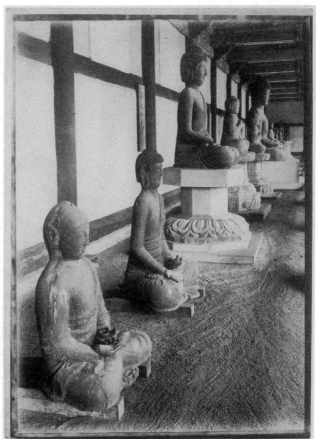

(Figs. 34 & 35). Maybe the fact that the fingers are equally thick all the way down is what keeps them from oversoftness. The eternity of the calm is contrasted with the carelessness with which the pose has been adopted for a moment; the universe is holding its breath till the coming Buddha completes the movement of its right hand and opens its eyes.

The early connections of Japan with the outside world are obscure, nor is it clear how much of Japan was under one rule, but the Japanese appear in history as anxious to learn and able to induce the local Korean courts to send them instruction. In the fourth century AD, it seems, whole villages of Koreans were being imported, including potters, weavers, and silkworm growers. A Korean teacher of Chinese characters was sent for the Japanese heir apparent in 405, but Sir George Sansom thinks that writing was mainly left to clerks till it came to be considered important for reading Buddhist texts, which was at the end of the sixth century.[55] The date of the official introduction of Buddhism to Japan is 552, and it is recorded that images were sent from Korea with the missionaries. An embassy

FIG. 33. Maitreya
[Mireuk Bosal] in
Keijo [i.e. Seoul]
Museum, c. 6th Cent

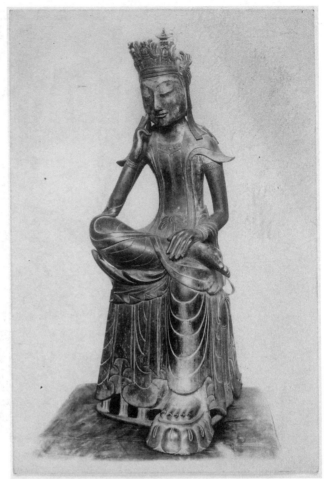

from the emperor of (south) China had arrived thirty years earlier, but the early
official contacts with China do not seem to have been concerned with religion (no
religious presents are recorded till 700). Buddhism became a state religion in Japan
under the Empress Suiko (reigned 592–629) whose son Prince Shotoku (d. 621)
was a patron of considerable learning; a commentary on the Lotus Sutra survives
in his handwriting.[56]

There is considerable doubt as to whether the great early statues were made by
Japanese, by a school of foreign craftsmen in Japan, or not in Japan at all. Ernest
Fenollosa, who did most important work on the statues in the exciting period of
Japanese Westernization, since he had not merely to tell the rest of the world
about them but urge the Japanese to recognise their value, seems to have been
assured as a matter of tradition that the Horiuji [i.e. Kudara] and Yumedono
Kwannons were made in Korea (Figs. 36–43; 71 & 72).[57] It is on record that the

Tamamushi Shrine at Horiuji Temple was presented to the Japanese court by one of the Korean courts around 590 AD, and the Maitreya in the Koriuji temple at Kyoto in 604 (Figs. 44–6). The Kwannon in the Yakushiji toindo [i.e. the east hall of Nara's Yakushiji temple] is probably also from Korea (Fig. 47). However, there is evidence of foreign hereditary schools in Japan; thus Fenollosa says that a sculptor who took the Japanese name of Tori arrived from south China about 500; his son was also a sculptor, and his grandson made the trinity in the Horiuji kondo (main hall), supervised by Prince Shotoku.[58] A. Eckardt claimed the Tori family as Korean, but Sir George Sansom reaffirmed that they were 'of Chinese descent.'[59] The grandson must at least have been well acclimatised in Japan, if not three-quarters Japanese by birth. The few great early statues (particularly the Horiuji [Kudara] and Yumedono Kwannons and the Chuguji Maitreya) are so far beyond any surviving Korean work that it is more satisfying to believe they were produced in Japan during one ferment of innovation. The official acceptance of Buddhism appears as a matter of testing whether it brought good luck, and later of gulping down as much Chinese culture as possible; but the spiritual power of the great early statues is overwhelming and must be accepted as historical evidence. The strength of Buddhism as a civilising agent was never more impressive than at the end of its journey across Asia.

The three works just mentioned are all in the village of Horiuji near Nara, one in the Chuguji nunnery, one in Horiuji temple which has a great deal of other sculpture, and one in a separate one-room structure called the Yumedono, which means 'Hall of Dreams'.[60] The Yumedono Kwannon is a particularly striking case of the effect of pregnancy, also found in medieval Madonnas, which is sometimes given to Kwannons by a graceful sloping forward of the body (Fig. 36). The whole question of why Avalokitesvara became a woman in the Far East, and why she sometimes holds a baby, has remained very obscure. But the haunting beauty of the Yumedono Kwannon I think partly depends on the suggestion of pregnancy, whatever it meant. Fenollosa, who unwrapped her after she had been hidden for a few centuries, said that she had the Han [Chinese] nose which had been adopted by the Koreans, also that she had a Mona Lisa smile.[61] I should have thought that her rather heavy and curving nose might as well have been called Indian; it has not got the Han perk. The actual noses of Japan are in any case extremely various. But certainly she and the Horiuji [Kudara] Kwannon are drawing on the tradition which came from north China through Korea, especially in the tall thin bodies and long flamelike draperies (Fig. 38). The influence of south China is said to have been for a comparatively squat body and composition, as in the Horiuji trinity (Figs. 56 & 57).

The Chuguji Maitreya is traditionally a portrait of Prince Shotoku made soon after his death, perhaps 630, but Sir Charles Eliot puts it after 710 (Figs. 48–50).[62] There was a court fashion by which the hair was tied up comparatively loosely

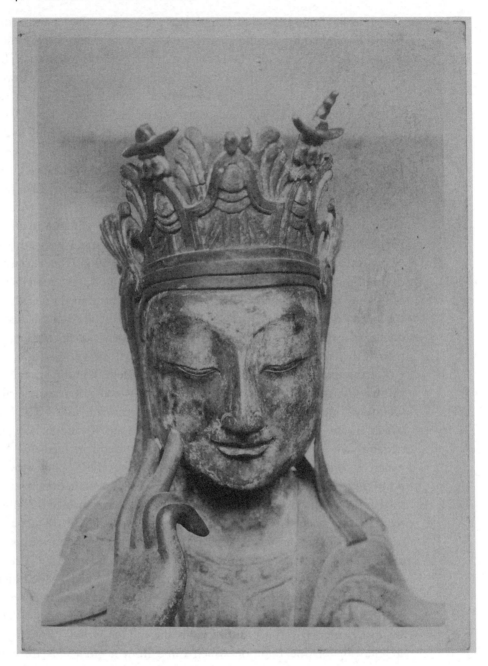

Fig. 34. Head of 33 [the Seoul Maitrya]

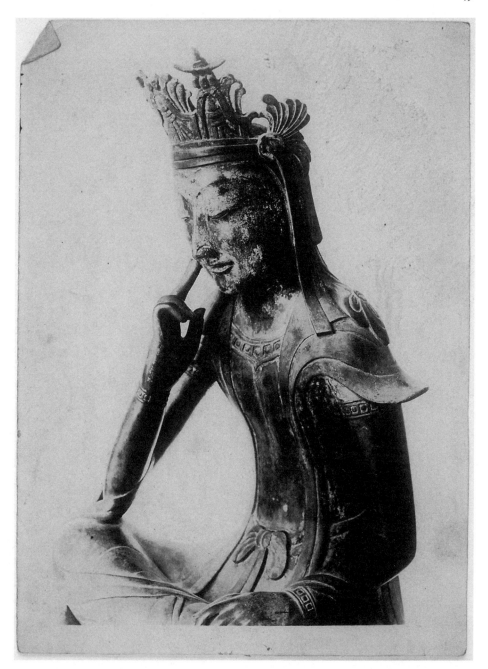

FIG. 35. Side view of 33 [the Seoul Maitreya]

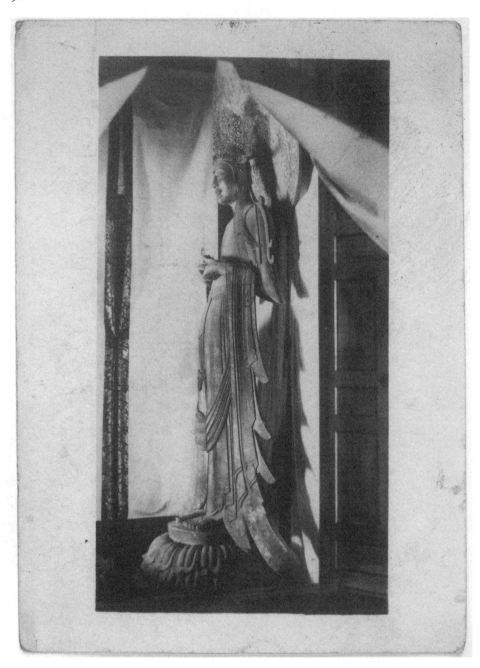

FIG. 36. Yumedono Kwannon [the Yumedono Kannon of Horyu-ji Temple, Nara, Japan] (bought in Japan, as are all the following till further notice)

FIG. 37. Half Length of
36 [the Yumedono
Kannon]

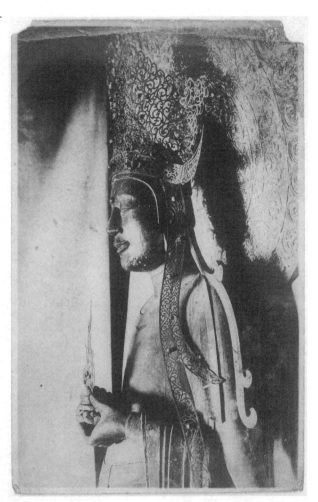

in two bunches on top of the head; this explains the two knobs on the head of
the Chuguji figure, which are therefore a formalisation of hair very like the Kushan
one which led to the normal *ushnisha*. The hands taper to the end and turn back a
little at the nail, with elegance and perhaps rather the effect of questing worms
(Figs. 42 & 43). The hands of the Horiuji [Kudara] Kwannon begin their turn
back a nail's length behind the nail, which takes the childish liveliness out of the
movement and gives it a passive vegetable sensitivity. I should find it hard to
discuss these statues except in terms of the theory expounded later in this book,
and want here only to praise their freedom, tenderness, and power and the
universality which makes them citizens of the high art of the world.

The frescoes of the Horiuji temple are considered later than the usual dating of
these three statues, as the temple was rebuilt on the same plan after a fire in 680,

FIG. 38. Front View of
36 [the Yumedono
Kannon]

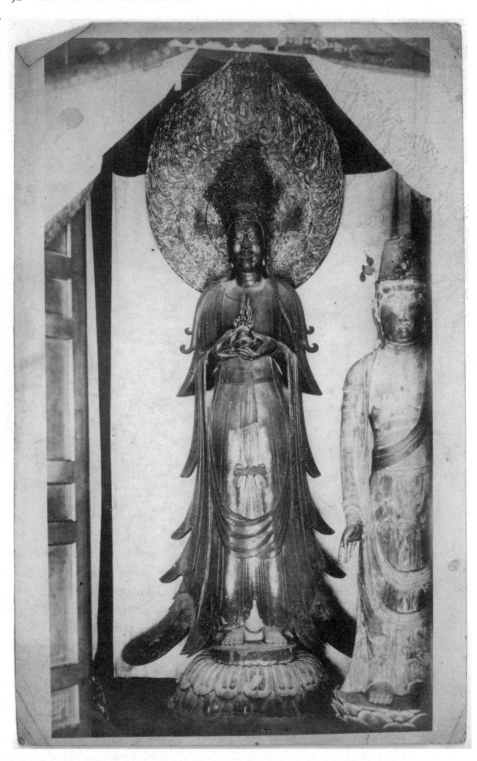

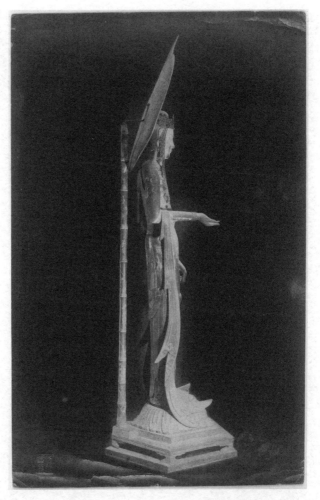

FIG. 39. Horiuji Kwannon [the Kudara Kannon of Horyu-ji Temple, Nara, Japan]

and the frescoes show no sign of it (Fig. 51). Eckardt naturally says they are Korean work, and puts them at the end of the century.[63] Sir George Sansom puts them around 710 and says they are like early T'ang painting.[64] It is asserted and denied that they are like Ajanta work. They are also said to show the influence of Tun-huang [Dunhuang] wall paintings, maybe in a certain bold circularity of outline, which is a contrast to the long, drawn-out statues. I can only say blankly that they are rather like Michael Angelo [Michelangelo], and not at all like the eventual tradition of Japan. It is usual for a country to set out on its career of Buddhist art with a blaze of brilliance, but no other country, except perhaps India itself, gives such an impression of range and depth envisaged at the start and then forgotten.

The Tempyo period (725–794) was in close touch with China and produced some dignified 'classical' statues, noticeably Hellenistic, and plumper and more

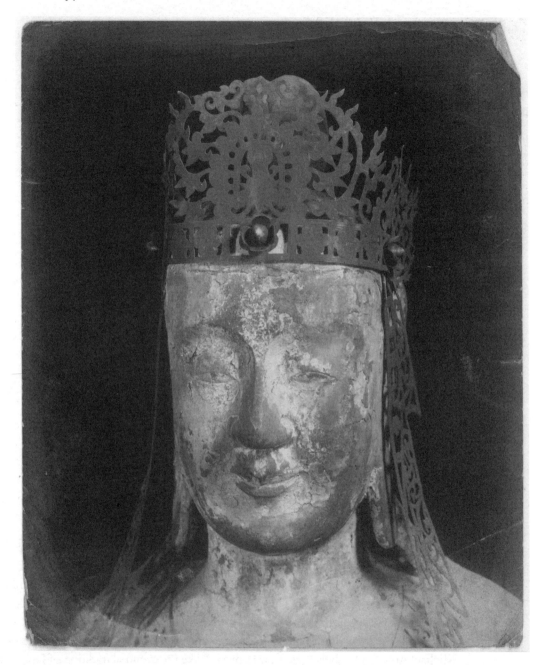

FIG. 40. Head of 39 [the Kudara Kannon]

FIG. 41. Left View of
Head [i.e. of the head
of the Kudara Kannon
(Fig. 40)]

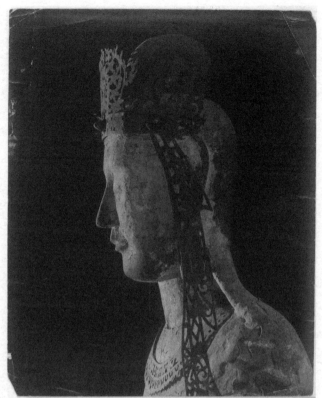

secular than the earlier work, as in the example here from the Todaiji temple
(Fig. 52). The Konin or Jogwan period (794–897),[65] when official contact with
China temporarily ended, introduced Jizo, who saved you from hell (Figs. 73 & 74),
and Fudo, a manifestation of Vairocana who embodied divine wrath. These symbols
of fear are the most striking developments in the sculpture, but it is fair to add that
the cult of Vairocana, the primordial Buddha, was itself introduced at the beginning
of the period. The Fujiwara [Regency] (897–1185) is the first fully Japanese-y period,
considered by many Japanese the best, but not represented here. To complete the
survey, I have put among the photographs two examples of the final corruption
of the Far Eastern Buddha type, one good and the other bad; the fact that one is
Chinese and the other Japanese is not meant to be significant. One is a charming
but quite irreligious Chinese ornament of the seventeenth century (Fig. 53), and the
other is a typically dead cult object, I think of the Japanese Kamakura period
(Fig. 54).

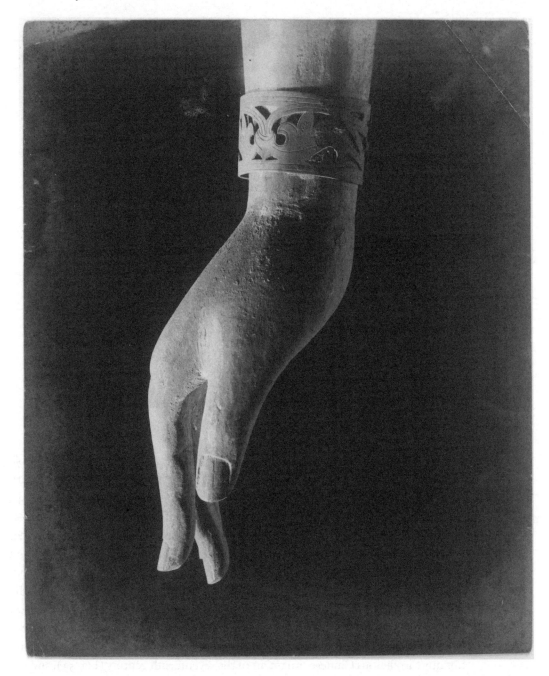

FIG. 42. Right hand of 39 [the Kudara Kannon]

2. Golden reliquary from Stupa 2 at Bimaran, Gandhara, Afghanistan, 1st century CE. British Museum, London (image courtesy trustees of the British Museum).

1. Colossal granodiorite head of Amenemhat III from Bubastis, Egypt, 1854 BCE–1808 BCE (12th Dynasty). British Museum, London (image courtesy trustees of the British Museum).

4. Buddha image in granite, probably 3rd–4th century CE. Mahamevnawa Park, Anuradhapura, Sri Lanka (editor's photograph).

3. Buddha image in white jadeite or marble from Myanmar (Burma), probably mid to late 19th century CE (Konbaung Period). Cheng-guang Dian, Behai Park, Beijing (editor's photograph).

6. Head of Gautama Buddha in schist from Gandhara, present-day Afghanistan, 1st–3rd century CE. Musée Guimet, Paris (image copyright RMN Grand Palais (Thierry Ollivier)), Musée Guimet, Paris.

5. Buddha image in white granite, 8th century. Seokguram Grotto, Gyeongju, South Korea (image courtesy Huntington Archive).

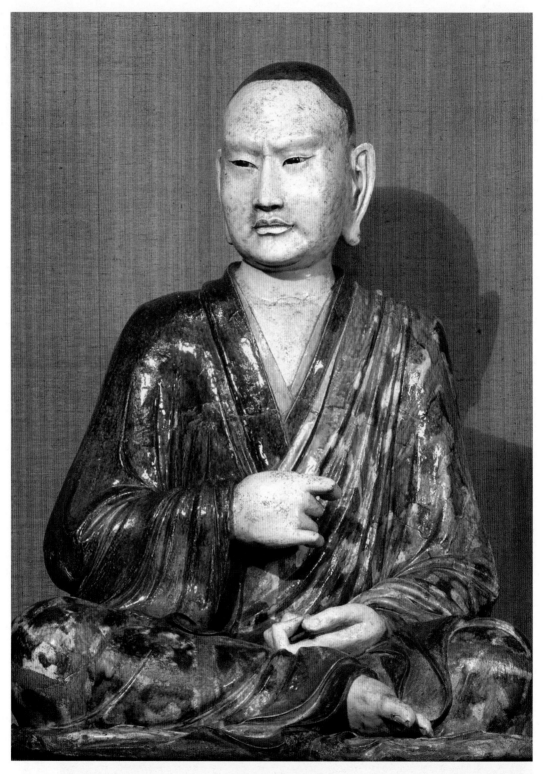

7. Glazed ceramic image of a *luohan* from Hebei, China, 10th–13th century CE (Liao Dynasty). University of Pennsylvania Museum (image courtesy University of Pennsylvania Museum).

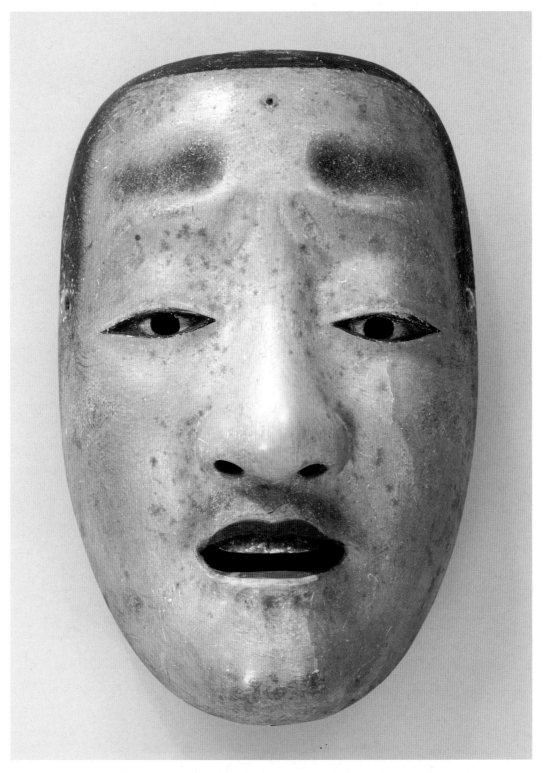

8. Subtly asymmetric Noh theatre mask (*chujo*) of the Edo Period in the Tokyo National Museum collection (image courtesy Tokyo National Museum/DNP Art Communications).

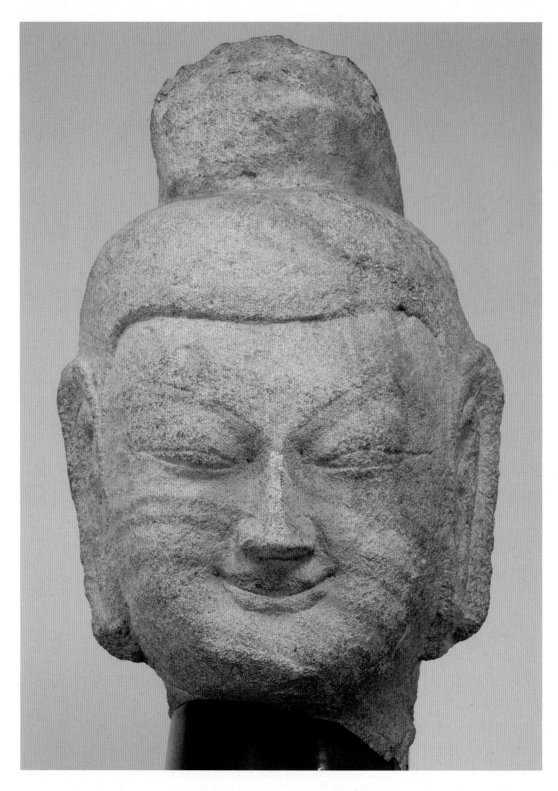

9. Asymmetric sandstone head of a Bodhisattva from Yungang, China, 5th–6th century CE (front view). Tokyo National Museum, Tokyo, Japan (image courtesy Tokyo National Museum/DNP Art Communications).

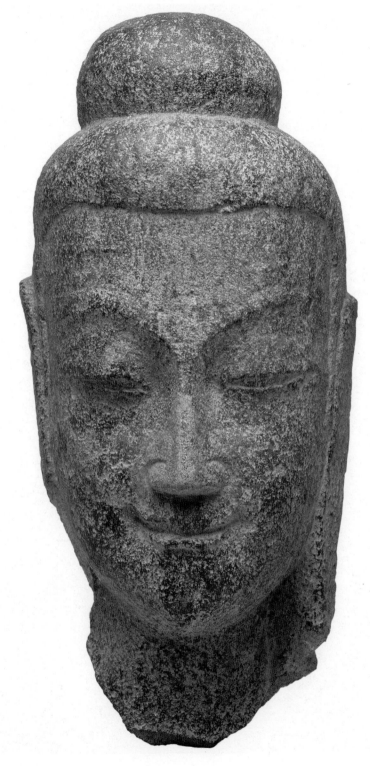

10. Asymmetric head of a Bodhisattva in coarse sandstone from Yungang, China, c.490 CE. Nelson-Atkins Museum, Kansas, USA (image courtesy Nelson-Atkins Museum).

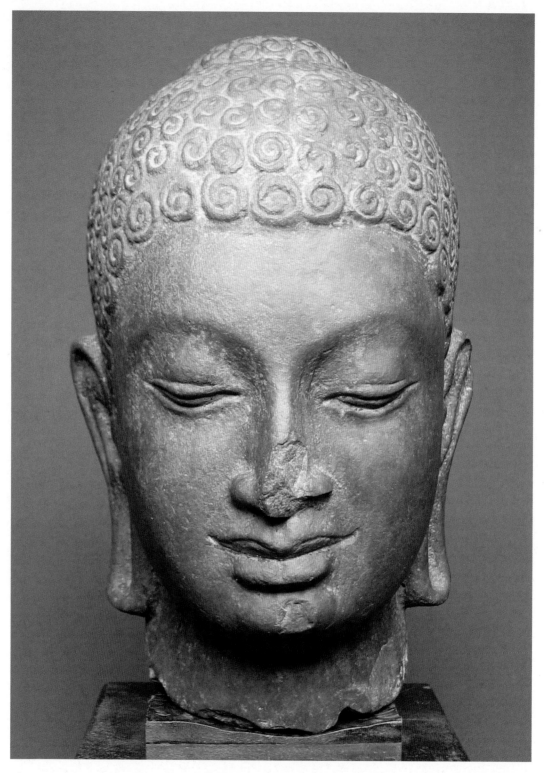

11. Sandstone head of a Buddha image, Pre-Angkor Period (Phnom Da style), 6th century CE. National Museum of Cambodia, Phnom Penh (image courtesy Cambodian Ministry of Culture).

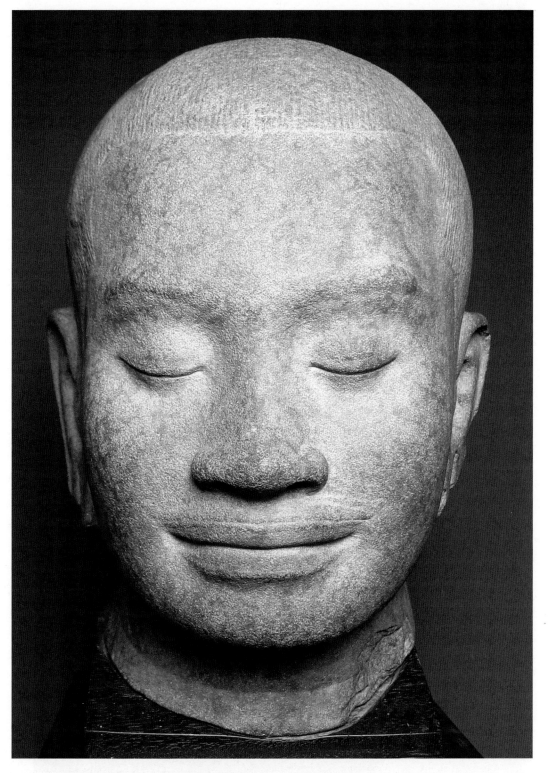

12. Sandstone head of Jayavarman VII as the Bodhisattva Avalokitesvara from Angkor Thom, Cambodia, late 12th–early 13th century CE. National Museum of Cambodia, Phnom Penh (image courtesy Cambodian Ministry of Culture).

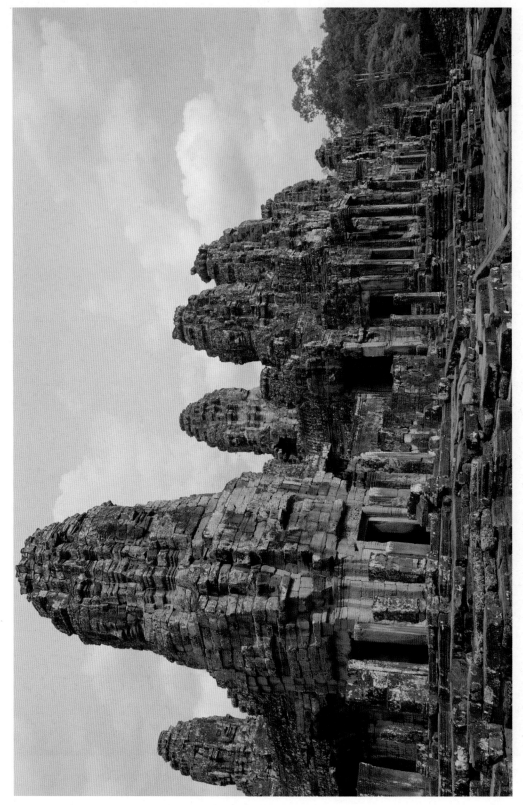

13. Prasat Bayon, Angkor Thom, Siem Reep Province, Cambodia, built late 12th–early 13th century CE (editor's photograph).

15. Neak Pean, Preah Khan, Siem Reap Province, Cambodia, built late 12th–early 13th century CE (editor's photograph).

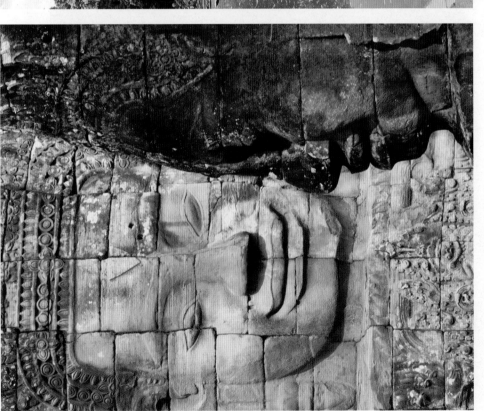

14. Asymmetric heads of the Bodhisattva Avalokitesvara in sandstone at Prasat Bayon, Cambodia, late 12th–early 13th century CE (editor's photograph).

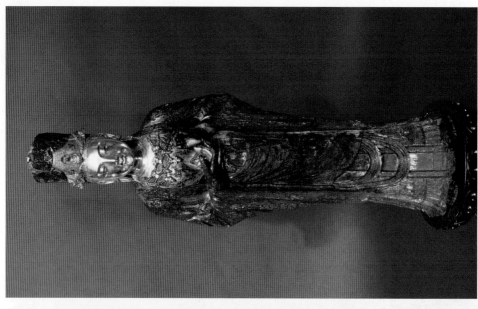

17. Image of the White-robed Guanyin in copper alloy from Manchuria, China, 10th century CE (Liao Dynasty). University of Pennsylvania Museum (image courtesy University of Pennsylvania Museum).

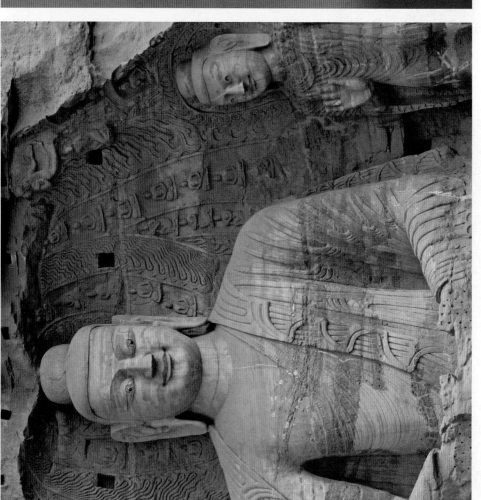

16. Colossal Buddha image in sandstone, 5th–6th century CE. Yungang, Shanxi Province, China (editor's photograph).

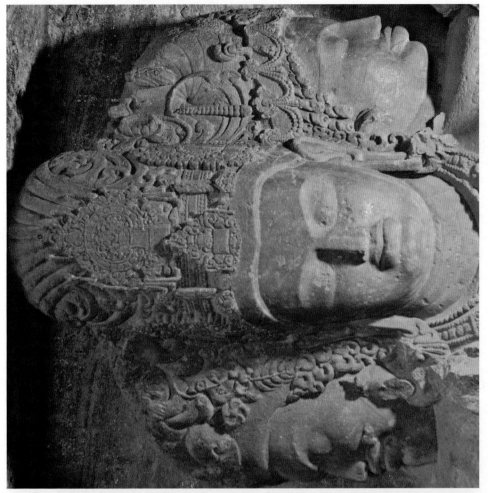

19. Sandstone Trimurti (head detail) from Cave 1 at Elephanta, Gharapuri Island, Maharastra, India, probably 5th–8th century CE (editor's photograph).

18. Red sandstone balustrade carved with a Buddha-image from Mathura, India, 1st–3rd century CE (Kushan). Musée Guimet, Paris (image copyright RMN Grand Palais (Hervé Lewandowski), Musée Guimet, Paris).

20. Photographic portrait of Winston Churchill by Yousuf Karsh, 1941 (courtesy Karsh estate/Camera Press).

21. *The actor Nakamura Utaemon III as Oboshi Yuranosuke* by Utagawa Kuniyoshi, woodblock print (*ohan tate-e*), mid-19th century CE (Edo Period). British Museum, London (image courtesy trustees of the British Museum).

23. Virgin and Child ('The Madonna of the Pillar') in carved wood, 1508. Chartres Cathedral, France (editor's photograph).

22. Bronze figure of Yamantaka Vajrabhairava in the Sino-Tibetan style from Beijing, China, 19th century CE. British Museum, London (image courtesy trustees of the British Museum).

24. The Dead Christ and the Virgin by a Neapolitan follower of Giotto (formerly attributed to Lorenzetti). Tempera and gold leaf on wood panel, probably 1330s–1340s, National Gallery, London (image courtesy National Gallery Picture Library).

25. William's Painting by William Empson. Oil on canvas, 1932–3. Collection of Mogador Empson, London.

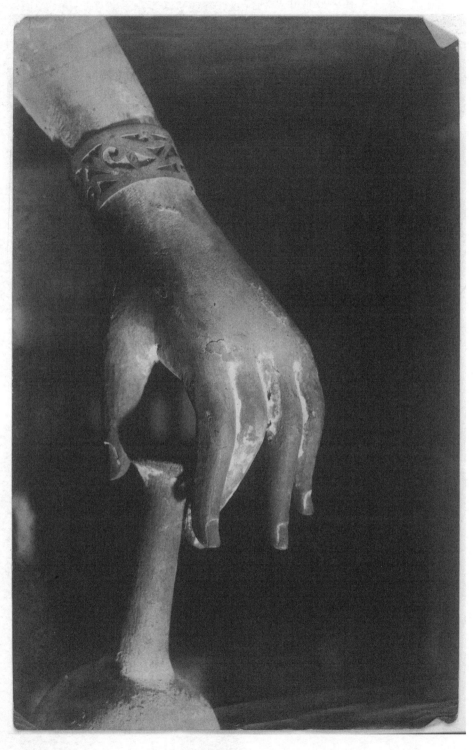

Fig. 43. Left hand of 39 [the Kudara Kannon]

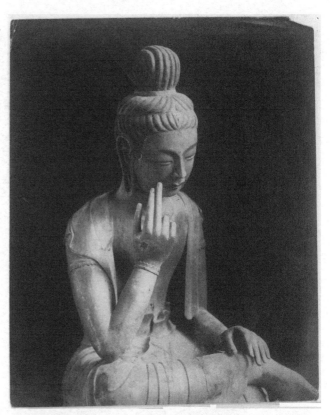

FIG. 44. Koryuji Maitreya [the Miroku Bosatsu of Koryu-ji Temple, Kyoto, Japan]

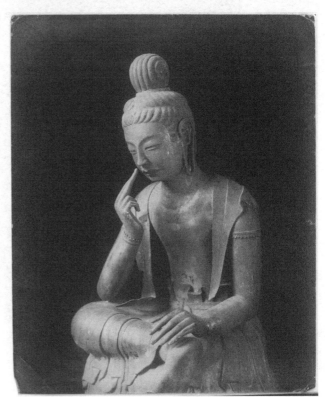

FIG. 45. Half Left of 44 [the Koryu-ji Maitreya]

FIG. 46. Full Left of 44 [the Koryu-ji Maitreya]

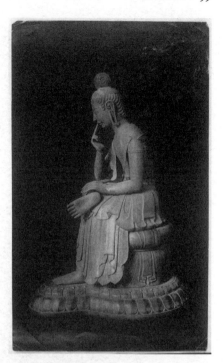

FIG. 47. Kwannon of
Yakushiji Toindo [i.e. the
East Hall of Yakushi-ji
Temple in Nara, Japan]

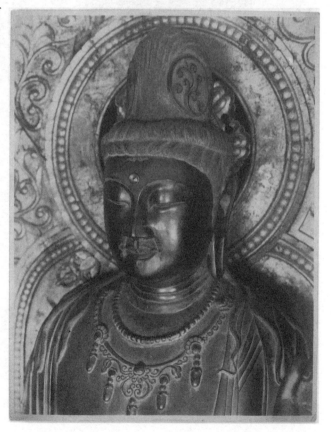

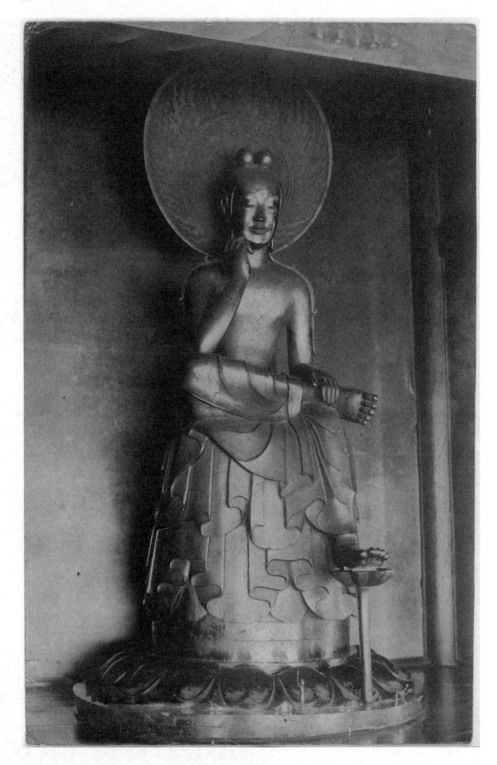

FIG. 48. Chuguji Maitreya [the Miroku Bosatsu of Chugu-ji Temple, Nara, Japan]

FIG. 49. Left view of 48
[the Chugu-ji Maitreya]

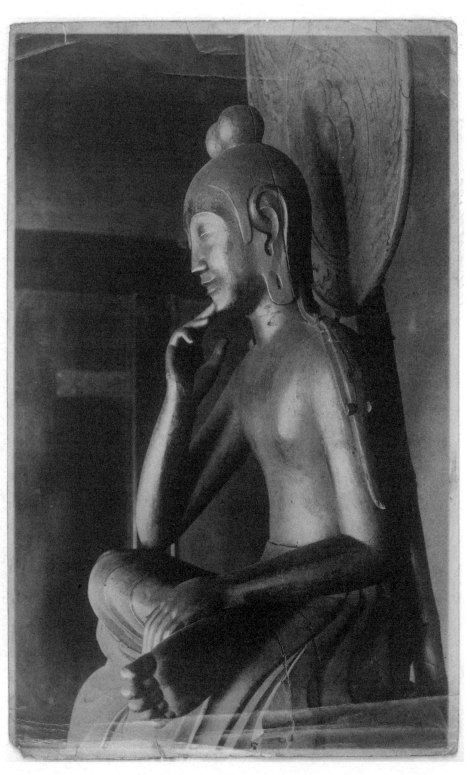

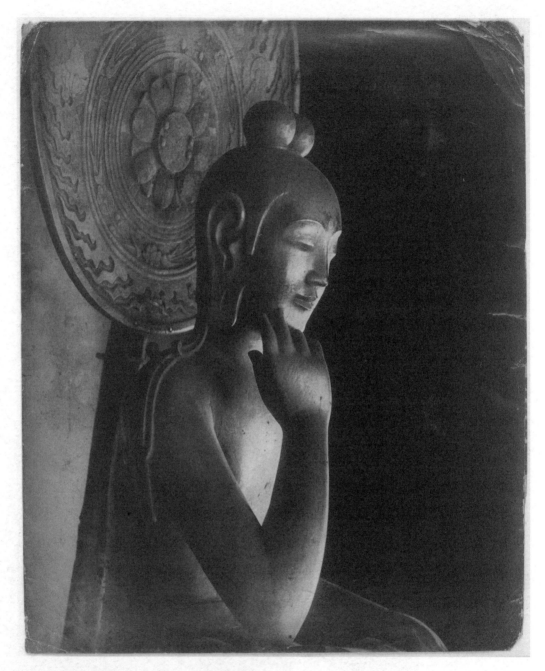

FIG. 50. Right view of 48 [the Chugu-ji Maitreya]

FIG. 51. Closer View [of the Buddhist frescoes at Horyu-ji Temple in Nara, Japan]

FIG. 52. Todaiji Bonten [i.e. Nikko Bosatsu (Bodhisattva Suryaprabha)]

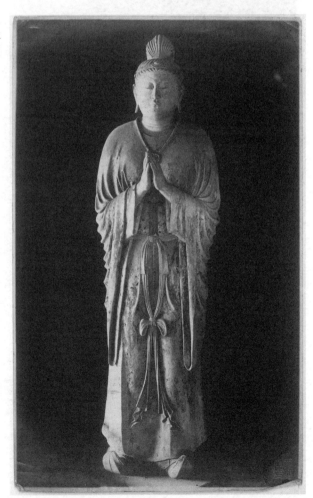

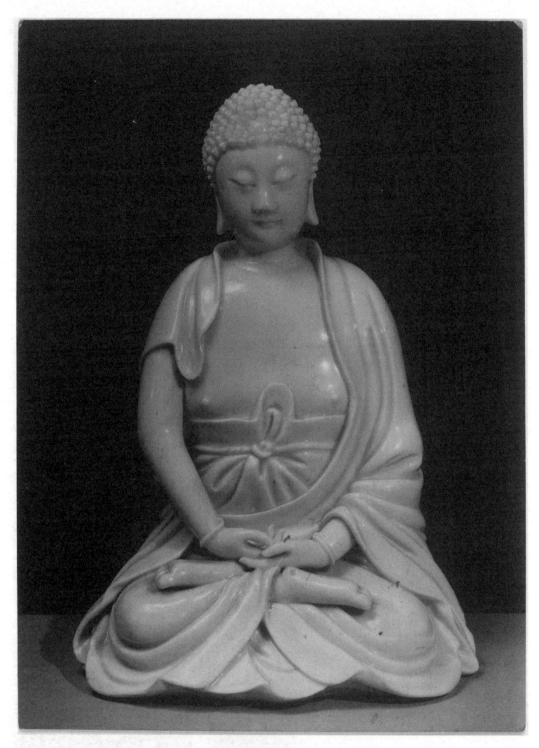

FIG. 53. Chinese Seventeenth Century Pottery Buddha (London [Royal Academy] Chinese Exhibition [1935])

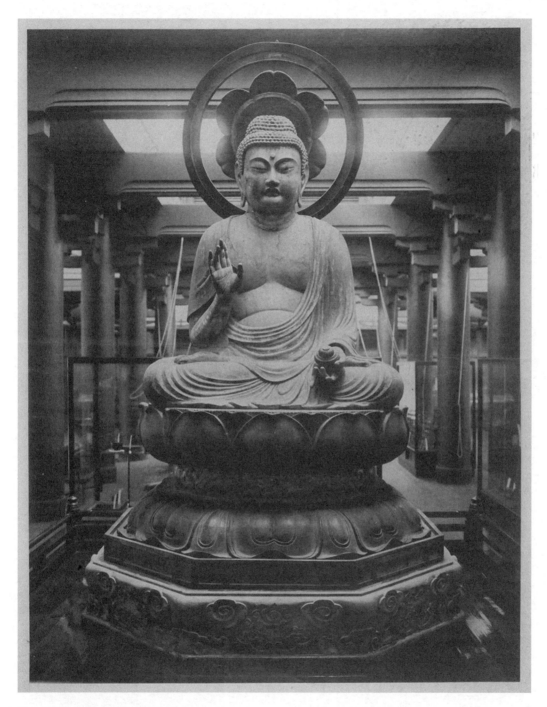

Fig. 54. Kamakura Period Buddha

Expression

I want here to put down some more general remarks about the Buddha faces, especially the eye, nose and mouth, and the way they work on the spectator. The whole subject of which this theme is an example, it seems to me, has been curiously neglected. The art of a given culture and period commonly has a favourite facial type, and if the later expert is content to have no idea *why* this face was found satisfying there is not much reason to suppose that his reaction to the work of art is even similar to what the artist intended. Indeed the human face itself is little known. I have never seen a study of how the occupational types (the typical lawyer's face, and so on) vary in different societies. The standard work on the machinery of the face, I understand, is still Darwin's *Expression of the Emotions in Man and Animals*, a very fine book, but said to be wrong in using the Principle of Opposites (that you express joy by doing everything the opposite way to sorrow, and so on).[66] The reason why present day art historians are shy of talk about faces seems to be that the Victorians made a number of bold shots at inordinate length, and it came to be felt that this method only led to nonsense. But timidity is not enough.

Many people have a vague impression that the Buddha's face is Chinese—that the type is a racial one. I tried to deal with this in the previous chapter, and said that the slit eye might conceivably have been suggested (in Gandhara) by the Mongolian type of face, but can only have been accepted, there or in India, because it was found expressive on non-racial grounds. There seems more to be said about what these grounds are; and in any case it is easy to feel that the Buddha type, whatever its origin, is really more suited to the Far Eastern outlook than to any other. Many Chinese and Japanese, it can be pointed out, have half-shut eyes like the Buddha, and some appear to squint because of the Mongol Fold,[67] a twist of skin at the inner end of the upper eyelid, like the Buddha's squint of concentration in the act of gazing at his navel. It so happens that some of the Indian Gupta Buddhas (and the seated Buddha here from Ceylon) get this squint from an entirely different eye-shape; their lower eye-lid curves up vertically at the inner end, sometimes with a final curl to make the end seem sharper. I am doubtful whether the Mongol Fold is ever represented on Chinese Buddhas,

and anyway this Indian eyeshape is an entirely unnaturalistic one; it was simply a way of making the statue look concentrated. The reader may feel that this did not need arguing; obviously the Mongol Fold has nothing to do with the question. But the position is rather the same about the Mongol eye. It seems that this is actually hard to open, and that some Chinese and Japanese have a similar eye-structure from Mongol ancestry. I am prepared to believe it; but certainly the eyes of most Chinese and Japanese are not hard to open. Europeans have often assumed that they were, but merely because there was a traditional practice of keeping them half closed. It goes with the idea that the scholarly high-class man resists the crude impact of outside impressions, and contrary-wise with the modesty of habitual politeness. It was not merely a convention of painters, evidently, because it lingers on in real life, but nowadays it is quite unusual. There was a student acquaintance of mine in Japan who struck me as exactly like one of the types in the paintings (most of them of course were entirely unlike any paintings) 'til one day he showed me a photograph of himself dressed in Shinto robes, for some ceremony, and there he looked like a European in fancy dress. The reason was he had his eyes open. One gets the same kind of shock in historical films, where the Hollywood beauty always seems absurdly out of character. It is not, probably, a matter of how she is holding her face at the moment but of how the muscles have grown from the way she has used them all her life. What the faces are expressing is a whole culture, though no doubt only in a partial and, as it were, accidental way. It may be indeed that the artists have always exaggerated the stock faces, and that historical characters looked more like Hollywood ones than we think; but the camera has been working long enough to show that the Victorians really did have faces which are now uncommon. In such a case the differences are clearly not racial ones, though they might easily seem to be.

As to the slant, as apart from the slit eye, the Japanese believe it to be unusual and praise it when found, as a mark of courage. A number of early Buddhist trinities in Japan give slant eyes only to the central figure, whose arms are at an angle, or sometimes only to the side figures. It seems clear that the slant eye here is only put in to improve the composition, and in general I think that symmetrical uses of it have no particular meaning in terms of character. The slit eye of course also occurs in European painting, and some years ago I wrote to Mr. Roger Hinks[68] to ask him where Giotto and Simone Martini got it from. After his customary disclaimer of any knowledge, he suggested that they

got it from the French art of the 13th century, where it is almost invariable. It does not appear in Greek or Roman art, or in Byzantine art, or anywhere nearer to the Mediterranean than Persia (where I had supposed it to be Mongol; it is not Achaemenid, Parthian or Sassanian). Why it was popular in northern Europe from the 13th to the 15th century I cannot say. The 13th was not a mystical century, rather the reverse, and in the 14th century, which was, the slit eye widens appreciably and begins to take notice of the outside world again.

I am including a Madonna by Lorenzetti in the National Gallery [London], who pokes her finger into one of the wounds of the Christ with a transcendent but monkeyish expression of triumph or agony; it is almost an obscene leer (Pl. 24).[69] The later use is for a calculating character, who is summing the situation up: Alexander Pope has an address to

> Coffee, that makes the politician wise,
> To see through all things with his half-shut eyes.

It is not merely that he is hiding his own expression; he is shading his eyes, embarrassed by the excess of light that comes to him, or isolating the case before him, as a painter might shade it with his hand. But there is a general idea of hiding too; the intelligence is awake but cautious of social consequences. The Buddha eye can be used to mean this; notably on the Japanese Konin period Jizos; but to move over the Buddha expression completely to this meaning is a corruption of it (Figs. 73 & 74). I suggested that the Hellenistic Gandhara sculptors may, in their earliest assignments, have adopted the eye because they found the religion esoteric, so that they intended some idea of secrecy. But it is clear that the standard Buddha eye (say in the Gupta period) means merely that the Buddha is in meditation and withdrawn from the world. However it was arrived at, this became the traditional basis on which other suggestions could be imposed. I have an impression that the sculptures of Yun-kang and those of Chartres make a real parallel in their use of the half-shut eye, or at any rate that the ladies in those two places do. They are not using it to be 'mystical' (in the sense of 'withdrawn from the world') not yet sly (in any way that would make them insincere); the point is that they are keeping a certain reserve of social force. They can remain conventional and yet act independently of the conventions; they remain modest though they are decisive. There seems to be a feeling that the last achievement of the mystic is something that a really well brought up girl knows already. It may seem very unlikely that Chinese monks should feel this, and yet China not long after was to take the mysterious step of turning Avalokitesvara, the Bodhisattva of Mercy, into an upper class woman (that the sculptors of Chartres had this sort of feeling about the Virgin is I suppose hardly in doubt) (Pl. 23). In other ways too I think one is haunted by parallels to the medievals in the early Buddhist work of the Far East. I do not want to put much weight on this, and in any case of course the parallel has nothing to do with the original invention of the Buddha slit eye or its development in India; it would be a separate use for the slit eye invented at Yun-kang. But the parallel seemed worth making, if only to suggest that even the subtle uses of the Buddha eye do not depend on a peculiarity of race.

The high arch of eyebrow in the Buddha suggests range of vision or sympathy (it would be a huge eye if it were not, perhaps, out of his mercy, kept closed), or if raised by a muscle there may be a suggestion of 'trying to see as much, take in as

much light, as possible' (with a shut eye the glance is inward) as well as the obvious one of surprise. It tends to make the face look childish in that the eye is not protected by the brow. Shrugging the shoulders—'it's no concern of mine'—is for some reason also done with raised eyebrows. Surprise I think is intended in some of the Semiune Yun-kang heads,[70] as a conscious piece of social charm; 'those in a position to learn what the world has to teach are already unworldly; fancy you not knowing (Pl. 9 & 10);' and the Horiuji [Kudara] Kwannon seems genuinely surprised at the failure of her prolonged efforts and the irresponsiveness of the world (Fig. 40).[71] But these are special uses of a convention which was not intended for them. When I first tried to theorise about the Buddha face (in Japan) it seemed to me that the slit eye was a necessary complement of the high brow, because to put round eyes under a round brow would give the coy surprise of George Robey.[72] Even after I had seen the Mathura Buddhas, it took me a long time to realise that this was just what they had done (Fig. 04). However, they are not coy, because they are bursting with energy; they have the arched brows of the Kruschen grandpa, if any of my readers remember that grisly figure.[73] The fundamental idea of the high brow, which is pre-Buddhist, is that the god is beaming out upon the world. And it seems clear that this idea was still intended to be present when the Gupta artists combined the high brow with the half-shut eye of meditation. Nor ought one to suggest that the Gupta artists did not know how to do anything else. The Buddha did once open his eyes fully in the Ajanta caves, when he took his last look at his wife; the picture has been destroyed by varnish, but the surviving photograph is impressive and clearly the face of a Buddha. In any case, Ajanta does not much exaggerate the high brow.

The suggestion of muscular effort in this eyebrow, and therefore of surprise, becomes more obvious if the curve down is emphasised on the outside. The Far East I think does this chiefly for Jizo and Vairocana. In a Vairocana it often echoes a doglike frisk of the long ears and uplifted forefinger, and conveys a sort of gay energy; which in its sophisticated way perhaps returns nearest to the Mathura originals. But at the same time, in the Keishu [Gyeongju] Vairocana, for example, the eyelids make sharp horizontal slits, a vehement contrast with the intense verticals of the *mudra* and the ears and the rushing bouncing water of the drapery (Fig. 55). In the later art both Kwannon and Maitreya have a version as a fat laughing sprawler, so a touch of comedy might be intended in the Vairocanas. The final version of the Japanese Jizo type, when he is a guardian of children, has actually semicircular brows that meet the nose without a break in the curve, and this makes him look especially innocent even if not particularly surprised (Figs. 73 & 74). It is perhaps worth analysing the George Robey eyebrow, whose essence is assumed surprise. He is coy from an exaggerated claim to innocence ('you *surprise* me,' implying lack of sexual experience) and contrariwise a claim to be the observer ('I know you'). The Buddha face is also intended to convey innocence,

FIG. 55. Vairocana [Biroja-nabul] from Bulguksa [near Seokguram], Korea. Eighth Century

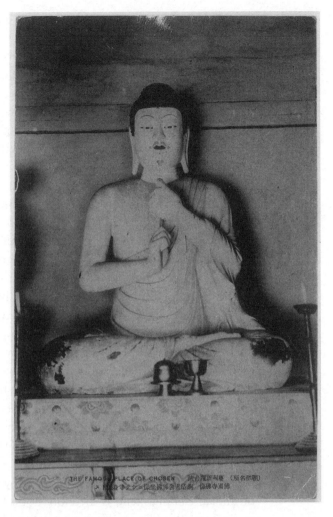

awareness, and a certain sexlessness, and the difference from the Keishu [Gyeongju] Vairocana lies merely I think in the absence of the round Robey eye, 'poking' fun at you. And indeed in the more subtle types of social surprise, for example, in the Yun-kang heads, it is a saving grace that the ironist seems ready to turn his joke against himself, as is inherent in the position of the comedian (Pl. 9 & 10). Whereas the round eyes and round brows on the more incompetent of the Mathura heads only do not look like Robey because they look like eager children. The *urna*, the mark above the nose, which seems to be lacking on most of the Mathura heads, is often an important means of quietening the high brow; it acts as a proof that the forehead has neither the horseshoe wrinkles of worry nor the horizontal ones of surprise. Then again, the Far East sometimes refuses to bring the eyebrow down at all on the outside, e.g. the main Yun-kang head here, and the Koriuji Maitreya (Figs. 44 & 61).

One would expect this to avoid surprise altogether, but it does not seem to do so in the Yun-kang example.

The nose admits of a good deal of variety in Buddhist sculpture as elsewhere; and perhaps it would be rather enlarging on the obvious to make any list of types. I want however to bring the subject up in order to insist on the extraordinary character of the nose of the Horiuji [Kudara] Kwannon. The types of actual nose can be classified unconsciously, so that we guess the whole perspective of a nose from one aspect, but this nose seems planned to deceive. In full front face, it looks a childish tough practical blob, and belongs to the rueful, puggy, puzzled effect of her absolute and hopeless generosity (Fig. 40). From half side face it is straight, intellectual, and rather conscious of a bad smell. From sheer side face (as if to echo the shock of the extended forearm) it is almost gross, with a sensuality admitted but renounced and a lust for power only half satisfied by bounty (Fig. 41). All the features of this wonderful statue are rather puzzling, but I think the nose is the one which makes you feel most certain that there is an intentional puzzle.

The lips of the Buddhas vary a great deal, but in the standard type so far as there is one, and certainly in the later formalised types, they are full, sensuous, and not distorted by muscular action. They stand for the paradox that a full and untrammelled emotional life has been attained by a system of renunciation. One can theorize about the shapes formed by habitual muscular drag on a lip, because the different muscles have specific uses, but I do not know any account of the different lip shapes formed by inherent growth of tissue. Also in sculpture you can get effects of great delicacy which I fancy are not at all naturalistic; especially in naked wood, where you can polish the surfaces of the face and leave the lips a mere raw edge which seems as sensitive as a wound.

The sensuous mouth, chiefly marked by a thick lower lip, is already found on Indian Buddhas, and is therefore not a Far Eastern addition; it is not found in the Greco-Buddhist work, is moderate and occasional at Mathura, and becomes normal in the Gupta period. For a really exaggerated lower lip one must go outside Buddhism to the great triple head at Elephanta (eighth century); the short pout of the upper lip presses against the long straight Indian nose and its spreading nostrils, and below this a vast curved slab of lower lip, with a sharp edge at the bottom, carries a weight of emotional life which would be brutal without the eye width and the high brow (Pl. 19). The Bodhisattvas in the Ajanta paintings sometimes give this mouth in action, the slug stretching itself; the upper lip is twisted as if with a sensitive distaste, and the soggy mass of the lower lip accumulated beneath it wells up with a portentous self pity. This very counter-Reformation piece of machinery is not used in the Far East.

Incidentally, this Elephanta head (the centre of the trinity) raises the question of how far such sculpture was meant to be painted, and how it could be done. There is no carved edge anywhere on the huge blank curve of the eyes; when you are in

front of it the creature looks through you and sees the hemisphere of infinity at one glance, but because of the shadow under the curve of the eyeball the eyes also seem closed in concentration. This grand and mysterious effect depends entirely upon putting no detail into the eye structure, and it may have developed its dreamy Titanism after its glory had departed.

The mouths of the early Chinese and Japanese Buddhas are very far from this sensuous placidity, and have been much affected by muscular action. The sleek effect is used early but there is a catch in it. For example, the Buddha of the chief Horiuji trinity is much more self-satisfied from the front than from the side (Fig. 56). This is partly because the light catches the polished bronze from the front so as to make the familiar pool of butter round the pout of the mouth; but from the side where this reflection is lost, you also find that the pout was if anything a sag.

The nose and chin stand out in judgment and the mouth is pulled back, with an intellectual or committee-working effect, as if careful not to impose itself too fiercely. Half-side-face there is an effect of humour and tenderness, very much the best version of this complex mouth, as if the intellectuality and the self-satisfaction needed both to be in view (Fig. 57). Such is the treatment of an unusually full early-Japanese mouth, of the school from south China; the north China influence, for example the Horiuji [Kudara] Kwannon, follow the Yun-kang heads in being definitely tightlipped, with something close to the 'Greek archaic smile' (Pl. 9 & 10, Fig. 40).[74]

This expression is not found on the Greco-Buddhist Gandhara work, and there is little excuse for thinking it was imported to China (Pl. 6). Fenollosa amusingly said, 'If there were any way of showing how archaic Greek art could have got into Central Asia, and then exerted influence a thousand years after it was dead in the West, we should eagerly invoke it to explain a thousand pseudo-parallels.'[5] In any case, the distinctive thing in an archaic Apollo is not simply the mouth but a peculiar half-baked look about the jowl (Fig. 58). Mr. Roger Hinks wrote to me:

The phenomenon seems to appear in the first half of the vi. century and to fade at the beginning of the v. It becomes extremely mannered and affected in the later *korai* from the Acropolis, and is rare after the time of the Aegina pediments ... I doubt whether the statistics about the date of its appearance, its regional distribution and functional reference have ever been collected and analysed ... Probably a sociologist could extract more meaning from the facts than archaeologists have succeeded in doing.[76]

As to the theory that it was due to incompetence, it is found on Greek statues otherwise copied with great competence from Egyptian ones: it is not invariable and not found on the earliest work; and it is used in drawings on pots where it has not the same technical convenience. I think it is relevant here, not as an 'influence', but as one of the fundamental types from which more complex expressions are derived.

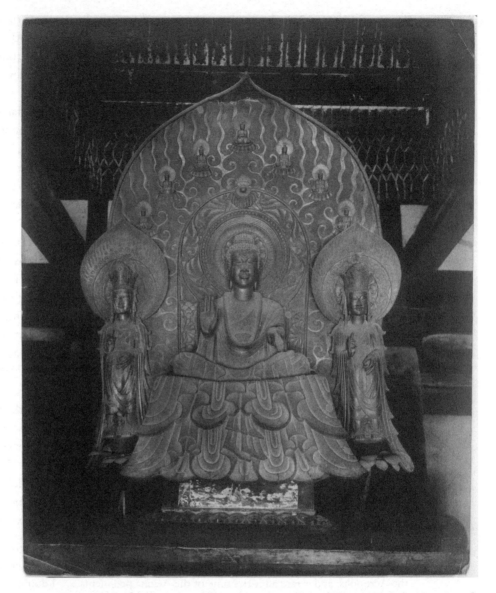

FIG. 56. Horiuji Trinity [the Seated Buddha and two Attendants of Horyu-ji Temple, Nara, Japan]

It is produced on a living face by a willful or hysterical pull on the main zygomatic muscle (lip-end to cheekbone) a uniform pressure from the others simply to keep the mouth shut. The effect is not a 'natural smile' because there is only one muscle smiling, and that the easiest to use willfully (though not the easiest to restrain). This use of it tells the spectator that a condition of nervous or mental strain is being faced with stoical irony. There is no bodily pain or fear in it, but there may be the lust due to nervous irritation; it is so mind-centred as to suggest the sensuality that despised itself. Socially it is the face of a man

FIG. 57. Side View of 56 [the Horyu-ji Trinity]

embarrassed, but holding to his first plan. Of course it need not occur alone; in the no-less-strained grin usual on the snapshotted flying ace the rest of the face is really smiling. The psycho-analyst Ranke argued that a strong 'mother-repression' was required for the intellectual achievements of the early Greeks, especially their escape from religious tradition; and one could fancy the smile to mean 'It is difficult to think straight, also embarrassing;' it involves a sort of asceticism, though I have come to it from an honest-sensual angle, to balance philosophy

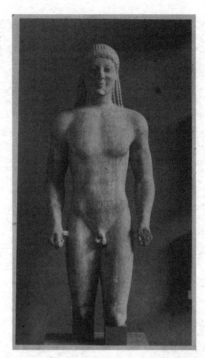

FIG. 58. Archaic Apollo [i.e. generic sixth-century Greek Kouros]

and religion.[77] James Joyce's phrase 'the Greek mouth that has never been twisted in prayer' becomes doubly false; it was twisted in the effort of not praying.

All this seems very far from the Buddha, who is generally conceived as a belly-centred creature, squinting at his navel and booming out 'Om' in a trance of self-satisfaction. It seems worth insisting on the contrast, if only to suggest that the characters of the early Buddhist heads have their own intellectual honesty, and that the object of their meditation is to enter a non-personal world of coolness and clear vision. I hope I have not implied that only one sort of smile is used. The Horiuji Buddha (Fig. 57) already described is not straining his mouth when depicted; the run of the mouth comes from a habitual use of muscles, rather suggesting the 'convulsive inclination to risibility' which Hazlitt said spoilt the classic features of Wordsworth, and might be guessed on the portraits of Milton.[78] Such a mouth perhaps sags inwards because the emotional life does not fill the space the intellect has prepared for it. On the other hand, on your extreme right as you enter the Yakushiji *toindo* [i.e. the east hall of Nara's Yakushi-ji Temple] near Horiuji, there is a wooden figure who is straining his mouth when depicted into a smile of thin-lipped sensual embarrassment; it makes him look constipated in his determination; the will to destroy will has so far failed to destroy itself, and he is sitting there trying. The more common feminine version of the strained mouth, as on the Yumedono Kwannon, which makes it end in dimples of the full comfort-able cheeks, is an equally temporary expression but an entirely out-looking one,

for receiving guests; it is the smile of the Mona Lisa, which roused Pater very much as a snub would have done (Fig. 37).[79] The Horiuji [Kudara] Kwannon's mouth is more complex; it seems to combine a slight willful smile with the expression of prudery, which works by showing you that it is willfully preventing a smile (or perhaps preventing the lips from having any sensual fullness) (Fig. 40). In her case, the combination is not self-conscious but mild, willing and frustrated. This may seem over-elaborate, but it is common knowledge that there is much room for complexity in human expressions. We often try to hide an expression by using muscles other than those involuntarily called into play, and then the combination itself becomes an intuitively recognised form which can be simulated as a whole. I do not mean to impute a monstrous ingenuity to the sculptor but to describe as he did a fairly common type of great-lady face.

The standard actor's or politician's mouth ought also to be mentioned; it builds up a mass of muscle somewhere beyond the ends of the lips, and then when stiffened by cross pulls from the cheek muscles this can be used as a fulcrum, as if it were a bone, to imitate expressions not otherwise under conscious control. It is recognised by a local swelling in the area, very different from a bulging jowl. I think this is sometimes used on the more administrative Buddhas, but have no example.

I shall end these remarks on Buddha mouths with a case which has nothing to do with the Buddha, but shows the human facial machinery in full play and the readiness of the Far East to make a formalised use of it. It is the heroic Ronin mouth of later Japanese painting and the Kabuki stage (Pl. 21).[80] This assumes a heavy strain on the depressor muscles, which run vertically from the mouth-ends to the chin. Babies pull them down well for howling; they form the 'long' face of depression and are at work in the rectangular mouth of agony. The voluntary use of them (a trick which can be acquired) seems to make determination; the Kabuki hero may be using them for this, or they may be the only mark of pain which he cannot control. He is counteracting them with a heavy strain on the zygomatic, either out of hysterical excitement or to mask the expression of pain. It does not make the tragic rectangular mouth because the local mouth muscles which are strongest in the centre, are straining to keep the mouth shut. The mouth therefore makes a spoon shape at the side, with the bulge below, and the hero mews out his sentiments through this hole with his face half turned away from you. It is perhaps the most fantastic distortion of facial muscles used anywhere as a settled convention, and I was pleased that it could be so neatly explained. The nineteenth-century Englishman's mouth, Huxley's rat-trap, comes from a habitual use of the same muscles, so we ought not to find the Ronin too foreign.[81]

An archaeological society called the *Gagaku Doshi Kyokai* was putting on performances of early dances when I was in Japan, and I thought these led me to recognise an important point about the sculpture, though in a roundabout

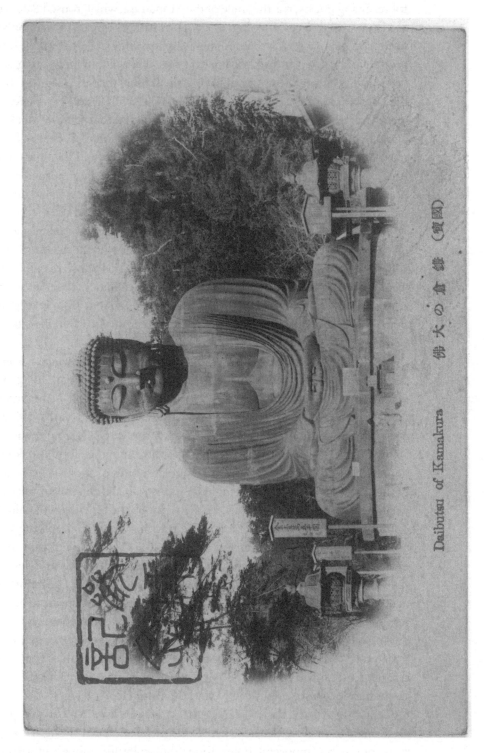

Fɪɢ. 59. Kamakura Buddha [i.e. the Daibutsu of Kotoku-in Temple, Kamakura, Japan]

way.[82] For example, in what is described as a flower-dance, after a handless Punch-like stretching apart of the big sleeves, the hands are slid together over the belly till the thumbs just touch, with the dancer's head peering down at them; his hands are all thumbs but he is moving his thumbs very carefully. This is similar to the Amida *mudra* of concentration: thumbs meeting on end with forefingers bent up to them. The *mudra* indeed is particularly effective, as in the colossal Kamakura Buddha (thirteenth century) when the circular lines of drapery round the arms to the shoulders seem to rise from it like a balloon from a small anchorage; concentration has brought release, and because of the almost fussy tightness of this one detail, the statue seems to touch earth only at one point and be already floating into the air (Fig. 59). Something in this seemed capable of being generalised. Then again one of the terrifying movements of the dragon dances, regularly repeated, is the same as our Music Hall policeman's 'easing the crutch,' which is itself apparently a mark of 'comically goodhumoured physical strength'. And indeed the basis of the charm of the military dances seems to be a clash or mutual comparison between pathetic puppyishness and heroic dignity; an odd fact brings this out, that they are equally successful, and give the same effect, when done by men of large build, easy strength, and a certain indifference, and when done by serious-minded boys. Whereas a dapper Japanese with toothbrush moustache may have learnt the movements better, but seems obviously out of place. The floppy, impossible great helmets seem to give the big man what he deserves but knows that life will not allow him to use, and for this reason is the same as their effect on the boy, where they seem the petals of a huge flower he can hardly carry. The dignity of the consciously cumbrous movements, at any rate, depends on some obscure infusion of pathos into their Titanism; just as the supreme expression of maturity in the Buddhas can come near to the face of a child.

It seems likely indeed that there is a limited number of contradictions on which the representation of a divine figure may be based, and that one of them is the bruiser and the flower. To my feeling this is the strength of the claim for an Indian as against a Greek origin of the Buddha type, though indeed the quality concerned belongs to most of the primary civilisations, and is plainer in the Pharaohs than in any Indian sculpture (Pl. 1). It belongs to a period of ethical simplicity or confusion when bodily strength is itself so much valued as to collect a sort of moral praise. The feeling is generally put into the torso; the powerful body of the Pharaoh is so handled as to seem delicate and vulnerable in the contrast of the rigid lines; he is doing his best at being a god, and the strong man is accepted as a touching emblem of nobility.[83] This carthorse quality is present in a standing male figure dug up at Harappa which Sir John Marshall accepted as belonging to the early Indus civilisation, which had contacts at any rate with Sumeria (these are what fix its date at about 2500 BC). Two thousand years are too long a gap; the point is not to trace a specific 'influence' but to show that this general line of

sentiment was expressed in India as well as Egypt in the time of the primary civilisations. The big *yakshas* at Mathura, dated a few centuries before the first Buddha images, have, in their clumsy way the same quality. Noble without fuss, masculine without assertion, divine without spirituality, these massive figures do indeed stand for a central pillar of the human structure, and one that the sophisticated Greek tradition could not have supplied. In Europe I think the quality appears again as one element in the Renaissance, and when people compare certain Far Eastern works to Michael Angelo [Michelangelo], it is really this carthorse sentiment which has struck them; it seems to be what is called his 'dynamism', but if so, this is an irrelevant term. The quality is very much lacking in later Indian work, and indeed seems to leave India with Buddhism.

Asymmetry

A good deal of the startling and compelling quality of the Far Eastern Buddha heads comes from their combining things that seem incompatible, especially a complete repose or detachment with an active power to help the worshipper. Now of course these qualities must somehow be diffused through the whole face, indeed the whole figure, or it will have no unity. But I believe there was a standard way of getting them in, one which put a strain on the unity; the two qualities were largely separated onto the two sides of the face. This technique, I suggest, was invented at Yun-kang [Yungang], and afterwards spread widely in the Far East, but became less obvious because it was absorbed into a fuller modelling of the face as a whole. It seems to me indeed that the chief novelty of the Far Eastern Buddhist sculpture, beyond what had already been done in India and central Asia, is the use of asymmetry to make the face more human. The Indians with their tendency to asceticism had increasingly emphasized the Buddha's withdrawal from the world; they did not want him human, whereas it is clear at Yun-kang, and anyway likely from the Chinese temperament, that the Chinese did want him human; and the easiest way to make a statue lively is to make the two sides of the head different (Pl. 9 & 10). It may seem absurd to suppose that the sculptors were using what is now a recent psychological theory about faces, but according to that theory, the knowledge is intuitive and often used in the drawings of children; it is not hard to suppose that the sculptors used it (indeed I think that is evident) but it is hard to be sure they were doing it on principle. I suggest that they drew on a system used by fortune tellers to read your character and your prospects in your face; such a system exists in China today, and treats the two sides of the head differently. I submit that the practice is likely to be old, and that a man who was developing a new art-form to portray character in a solid face (China has hardly any pre-Buddhist human sculpture other than reliefs) would be likely to take an interest in it. Nobody would want to say that the method was always used; the Yumedono Kwannon is perhaps the most beautiful of the few supreme early Japanese statues, and I will do well to admit, not to appear crazy over my facial theory, that it seemed to me completely symmetrical on the two occasions I saw it (Fig. 38).[84] But I think that the method was used often, and that it is a main source of the wonderful variety which the Far Eastern artists achieved within the formula

FIG. 60. Noh Mask [Ashikaga Period Chujo. See also Colour Plate 08 for a different mask that also shows subtle asymmetry]

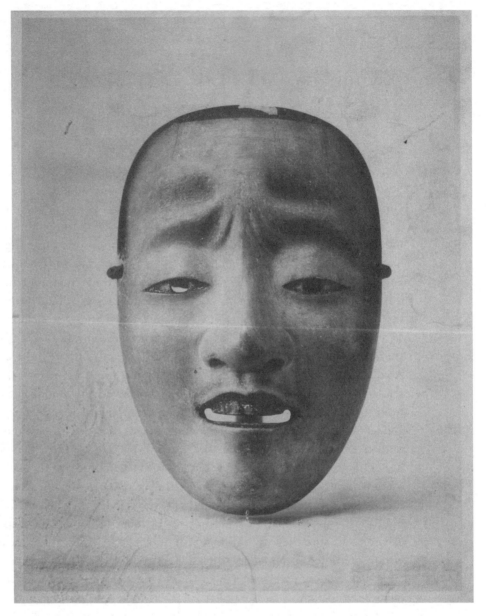

of the Buddha facial type. I have tried to summarise the theory fairly completely in this first paragraph, so that the reader can gauge the relevance of the items which follow. Perhaps the first thing to consider is whether such a technique would be suited to the general tradition of Far Eastern art.

I had the opportunity when in Japan to suggest this idea to the great Mr. Anesaki [i.e. Anesaki Masaharu], which I did very timidly, expecting him to treat it as a fad. He treated it as something obvious and well-known, and told me to compare the Buddhas with the masks of the Noh stage (Pl. 8 & Fig. 60). Here it

seems there is written evidence. The statues concerned come at an early stage in the development of Buddhist work in the Far East: I should put the last Japanese asymmetrical heads in the ninth century. The Noh masks are much later, and the craftsmen's tradition has I understand been preserved in writing. The maker was taught to construct them with two expressions for two positions of the actor's head. For example there is a young priest type, drawn and praying when the head is lifted, stoical when it is level; a girl type with a bunch of much thicker lip in the middle (the cherry lip of the later Geisha prints) which smiles when level yet gives the blank tragic mouth when bent downwards; and an old somewhat clownish male type with the mouth cut right back in something like the Greek archaic shape, so that it smiles when level and becomes the tragic pillar box slot mouth when looking up. The contrast is always vertical, not one of asymmetry; as indeed it should be, because the audience sits all round an apron-stage. I confess I could never see this effect in the course of a play, and doubt whether you can see it properly unless you are in the Emperor's box, which is kept empty in the front centre. But it is startlingly clear as you turn the thing in your hand; and at the same time it does not seem mere ingenuity; you have the same powerful piece of sculpture from any angle. The two moods are combined, just as the two moods of the character in the play are combined, into one person or one attitude to the world; just as the two halves of the Buddha head affect you as one live god in the room. The colossal Buddha at Kamakura has overhanging upper eyelids, with solid gold under the rim, so that the thing opens its eyes for you when you go up and pray under it (Fig. 59). It struck me that many life-size Buddhas, by an arrangement of the lips not the eyes, begin smiling in normal light, when you bob down and look at them from below. The asymmetrical method gets the more interesting results, but both make the same approach to the problem of making a fixed face appear subtle and alive.

Incidentally it is probably not true, as might be thought, that this method gives sculpture an advantage over painting. In a flat portrait taken from a not quite frontal position the spectator has to imagine a good deal of perspective to gauge the shape of the face, and he is liable to do it in different ways according as he stands to the left or right of the picture. Corpus [Christi] College Cambridge has a portrait of a judge, which is claimed to have different expressions according to where you stand, and I found myself quite ready to imagine them, but I do not know how far the method is commonly used.

The idea of dissolving different things into one art object seems to be more at home in the East than the West, though modern French painting has used it like so many other alien techniques. In the cause of realism we were always prepared to make portraits asymmetrical; there is the famous bust of Voltaire which sneers and laughs on the two sides; and at the other extreme we can produce those moral picture post cards in which old rakes' faces are constructed

out of young girls' bodies. But we do not take this seriously, whereas it is a regular exercise of the mystical Zen sect to try and see something 'in' something else—a tulip in a typewriter. You get temple decorations under the overhanging roof in Korea which build protective dragons out of lotuses, and pierced reliefs in Japan which are arranged to show a phoenix on one side and a religious incident on the other. All this, you might say, is decadent triviality. But the mysterious reliefs on the Chou [Zhou] period bronzes, at the beginning of Chinese art, are also using this method. The dragon is seen from several directions at once; its tails will also make birds; it is constructed out of formulae for thunderclouds. Maybe it is relevant to remember that the early European imagination has the chimaera, but that isn't dissolved when represented so that each part of it is magically several things at once. Early Chinese work doesn't play this trick on representations of people, only on the outer world of magic; but then one can almost say that representation of people begins with Buddhism; the faces on the Han Dynasty reliefs are hardly distinguished from one another. Of course I do not mean that the t'ao-t'ien [taotie] mask was a model for the Chinese Buddha, which it is very unlike, only that they show a similar fundamental tendency. About the date of the great statues you get superimposed pairs of heads in painting; the London Chinese Exhibition had a good example, a Kasyapa[85] dated 758 AD, where the masses of the painting made a meditative front face and the lines, when you came close, made a face of the same man become sly and leering and turned sideways. It is clear that the painter who did this would be prepared to make an asymmetrical statue head.

One might suppose that this technique was suited to India, and came from there. The Indian statues with many limbs, if viewed in a sufficiently trancelike state, might suggest that the god moves to suit his worshipper from one aspect to another. The conception of Hari-hara, for example, gives a clear enough theological precedent for the asymmetrical head: he is Shiva all down the right side and Vishnu all down the left.[86] But I know of no deliberately asymmetrical heads in Indian sculpture, and even the Cambodian Hari-haras are rigidly symmetrical in the face, though the contemporary (pre-Khmer) Cambodian Buddha heads are sometimes not (Pl. 11). The Hari-hara type would be done more carefully, perhaps, according to the proper Indian formula. The asymmetrical face demands a certain humanizing of the god, an attempt to get under his skin; and maybe this does not suit the absolutism of the Indian religious mind.

The technique might be arrived at merely in the course of trying to be realistic, or at any rate some recent psychologists have been saying so. The principle is broadly speaking that of the palmists, who say that the right hand shows what the person has accomplished, the left his congenital equipment or inheritance. Owing to right-handedness, such is the idea, the activities of the individual leave more marks on the right, while the left hand grows more according to the original plan. The muscles of the right side are controlled from the left half of the brain,

and vice versa, though I understand that some facial muscles have connections with both: this partial separation makes it more likely that there would be a recognizable difference. I do not know of any evidence to show that left-handed men's faces work the other way round. There is plenty of evidence that the two sides are often different, but there is much doubt whether the contrasts fit into any very tidy scheme. It should be explained before going any further that the right side of the face is always used to mean the right from the point of view of the man himself, not of the spectator, so that I shall talk about the right when meaning the reader to look at the left of a photograph of a statue.

There is a detailed formulation of the contrast by Dr. Werner Wolff in *Character and Personality* for December 1933, who says that the left embodies the wish-image of a person, how he sees himself, and the right represents his conventional face—how others see him.[87] Thus everybody recognises the left side in a photograph as his own but seldom the right, whereas they do the opposite in recognising side views of other people. Since we see ourselves reversed in mirrors (unless like Leonardo we use two mirrors placed at right angles) we see our wish-image on the side where we are accustomed to see others put their conventional face, and this helps to delude us about our own characters. This theory about the wish-image is clearly an addition to the simple view that the left is the hereditary side, unchanged by personal effort: Dr. Wolff uses the simple view (particularly for animals, in which he says that the right has the individual expression but the left the expression of the species), but he philosophizes it to make it cover the wish-image as well. He claims that the left hand cerebral hemisphere, which controls the right hand side of the body, has 'exclusive functional capacity,' so that the right hand hemisphere is left free for 'the collective functions of the unconscious.' We therefore find that 'the right has liveliness and vitality, the left remoteness from life. The right is sensual, active, smiling, frank, brutal, social etc. while the left shows a person in a state of rigor, dread, concentrated, reticent, passive, ethereal, demoniac, solitary.'[88] The same contrast, he claims, is very common in representations of the human face: 'The left hand side of the face shows, even in the earliest representations, as in primitive art and children's drawings, the more abstract, general and collective expression.'[89]

On the other hand M. Abraham, in two articles in the *Nouvelle Revue Francaise* for March and April 1934, declared that the left carries the marks of the contacts of the individual with the external world, and the right the traces of his interior monologue: 'à gauche la personnalité de contact, à droit la personnalité profonde.'[90] This, of course, is almost the opposite to Dr. Wolff's theory. The elegant left of George Sand's face was found to be that of an English lodging-house keeper (perpetually gossiping and with deranged imagination) while the massive right was that of an earth-goddess: the left of Baudelaire was Napoleon, the right soft, open, and in pain. Oddly enough he goes on to say that in personal contacts

George Sand put forward the earth-goddess, whereas the chattering of the lodging-house keeper appeared in her books: this seems a slight crack in the structure of his theory. The Baudelaire photograph is an impressive case (it is exactly the other way round from Winston Churchill, for example) but it is not hard to reply that Baudelaire was a naturally strong character (shown on the left) who acted with weakness and incurred suffering in his practical contacts with the world (shown on the right). There is a particularly interesting photograph of a Parisian actress in M. Abraham's collection, who completely breaks the rule of Dr. Wolff by being 'passive and ethereal' on the right, whereas the left-left photograph [i.e. a photograph manipulated to show the left side of the face joined to its mirror image] produced a practical sensual face which we are told reduced some of her admirers to tears.[91] M. Abraham says that this face shows us her contacts with the world in her practical professional struggles, whereas the right is the profound, the ideal being. But after all, the stage makes different demands on facial muscles from those of ordinary life. What the lady had been *trying* to do with her face throughout her career was to make it show an ideal and ethereal being, and she had been more successful on the right half of it. Certainly it is hard to agree with Dr. Wolff that her 'wish-image' is on the left, but this special case is not unintelligible. In the case of Baudelaire, one might say that he imagined himself as Napoleon, as well as that he had a strong character inherently (both shown on the left). In this kind of way, I think, one could drag round most of M. Abraham's own examples to support not only the simple view of the matter but also Dr. Wolff's elaboration of it. The disagreement does however, force one to notice how complicated the interpretation can become, and how easy it is to argue from the facts in either direction. (The disagreement of course is not complete: for example they agree that we recognize more easily the right in other people's faces, but the left of our own).

Indeed I think that both formulations are very slippery. The German version is the worse, because in general a man's 'wish-image' of himself is what he tries to make other people accept about him, and therefore his 'conventional face', so that the opposition collapses. The French version has the different fault of being a blank cheque, and this I think was why M. Abraham could make it work in what is (if anything) the wrong way round. We are to assume that each man has only one mask, and one real man just underneath it—a play by Eugene O'Neill made an 'expressionist' fuss using detachable masks to embody this conception.[92] It would be a truer image to say that we are made out of layers of masks like an onion, and that all the masks have got the living juice in them. M. Abraham's formulation could therefore be satisfied by almost any contrast that you found. Also both formulations apply more easily to artists than to other people, because an artist has to build up an 'inner' life which is protected from 'conventional' contacts and yet is meant to be externalised in another way, in his work. But consider a man who is actually working as an administrator, and whose daydream about himself is that he

is an efficient administrator. As a rule this type of work also requires a certain amount of play-acting towards other people, for the sake of morale: it is your business to seem more omniscient and more rapid in decision than you are. We can suppose that he is tolerably successful because he is keen and self-confident, but that his natural endowments are of a different sort. Both sets of opposites become abstruse here, if you try to fit this man with an asymmetrical face. The French version can only survive by arguing that the 'profound personality' is something quite different from the man's 'inner monologue,' and the German version can only survive by arguing that the 'wish-image' it refers to is a 'collective' one, dealing with unconscious wishes not with the man's actual fantasies, and indeed not really with this individual but with everybody.

In 1947, I wrote to Sir Cyril Burt and asked whether there had been any important further developments.[93] He kindly told me that American psychologists who had given systematic attention to the problem had become very skeptical about it, but that he did not himself entirely share the skepticism. The way that some nerve pathways cross over and others don't, he said, made the question very complicated; but then the evidence for that comes from diseases and wounds, and he doubted how far you argue directly from it to normal functioning. Asymmetry, he considered, seemed quite frequent in people who, for nervousness or other reasons, were apt to suffer from conflicting emotions, or conflicting impulses about the expression of their emotions. However, he pointed out, there can be other causes for asymmetry (apart from actual anomalies in the bone structure): 'people in whom vision is much more acute in one eye than in the other frequently develop a trick of slightly closing one eyelid and lowering the brow, usually on the short sighted side. Eventually one brow will be almost permanently fixed at a lower point than the other, and the horizontal creases in the forehead slope in conformity. Other habits may produce similar results. People who keep a pipe or cigarette hanging from one side of the mouth usually develop a facial asymmetry, not only around the lips, but also about the eyes (usually tending to close one eye to keep out the smoke).' When the method is used in art, he considered, the artist is more likely to have used a kind of symbolism than to have recognized intuitively some truth about the human face, because the truth whatever it may be is very complicated.

This is all I need for my argument, but it seems to me that the evidence of the photographs collected for the two opposite theories could take one a bit further. They fitted comfortably into what I called the simple view, that the right side is marked in a greater degree by the efforts of the individuals, whereas the left shows more of his inherent endowment; this of course involves guessing about his endowment, and it would be better to say that the right looks the more active, except that you want your formula to include unusual faces such as Baudelaire's. And I think that in most of the photographs the more passive or emotional part of the experience is shown on the left; this would follow naturally from the first,

because nobody supposes that the left of the face is left untouched, and what it tends to record would be the expressions which have not involved willful use of facial muscles. At any rate, the impressive photograph of Mr. Churchill follows this rule (Pl. 20). The administrator is on the right (I offer him as a possible solution of my little problem about the administrator) and on the left are the petulance, the rancour, the romanticism, the gloomy moral strength and the range of imaginative power. The bust by Epstein of him uses the same asymmetry.

However, the discussion of actual faces in these terms is to some extent otiose, because we might hesitate to say what was the 'wish-image' or inherent endowment of a Buddha after we had decided where to put them. But a statue of him to be worshipped has two functions; it has to convey his detachment from the world after achieving peace, and yet this figure is expected to help the worshipper. I suggest that the Far Eastern artists decided to make the statue more living or the paradox more vivid by putting the two functions on the two sides of the face and it would be obvious enough to put the power on the right, the side of the sword-arm. This has enough realism to satisfy the intuition of the artist (if I am right in my generalisation from the photographs of living people) because it makes the right show the marks of effort and the left show the marks of more passive experiences; and it is plausible enough as a fancy (whether true or not) to have occurred to the Chinese fortune-tellers, as it did to our palmists. The formula then is that in the Far East, for early Buddhist sculpture, the power to help the worshipper is on the right, and the calm, or in later examples, more generally, the inherent nature of the personage, is on the left.

I suggest that the trick was invented at Yun-kang, not merely because that was the chief centre for the earliest Chinese Buddhist sculpture, but because it was used there very regularly in a simple form. This assertion is easy to check; so many of the heads have been hacked off for private sale that there are plenty on view, nearly always with their stock expression of ironical and forceful politeness. If now you take a frontal photograph (Fig. 61), make another print of it in reverse (which requires a film not a plate negative) and cut them both in half to form a picture with the left taken twice over, you will find that this expression has almost entirely gone (Fig. 62). The eye and mouth are level and the face is calm and still. On the right the eye and mouth slant, and this gives the sardonic quality; in fact if you take the right twice over the thing approaches the standard European head of Satan (Fig. 63). It requires to be balanced by the left, which has the mystical and all but childish eternity of traditional Buddhism. In many of the heads, to be sure, the effect of irony is unimportant beside the archaic power and the missionary conviction; but even these use the stock method; the eye and mouth on the right elide up sideways, and on the left stay level. I am not clear whether the method is used on any heads believed to belong to the earliest period thirty years before the main one of 452–466. It seems to me (from what I remember of Yun-

FIG. 61. Head from
Yun-kang [i.e.
Empson's 'main' head
from Yungang, China]
(bought in Japan)

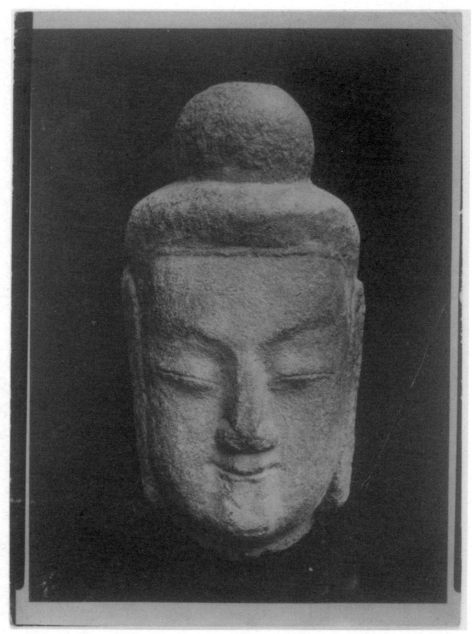

kang) that the hacked-off heads one sees in museums use the method more
frequently than the ones remaining on the site. This no doubt would be because
the dealers preferred them, very rightly; and indeed when I proffered my theory to
the great Boston Museum of Fine Arts, they said gaily that it had better be kept
dark, because it was how they spotted the fakes. The method in any case is not
used either on the colossal heads or on the small Buddhas repeated on the rock

FIG. 62. Left-left of 61
[i.e of Empson's 'main'
head from Yungang,
China]

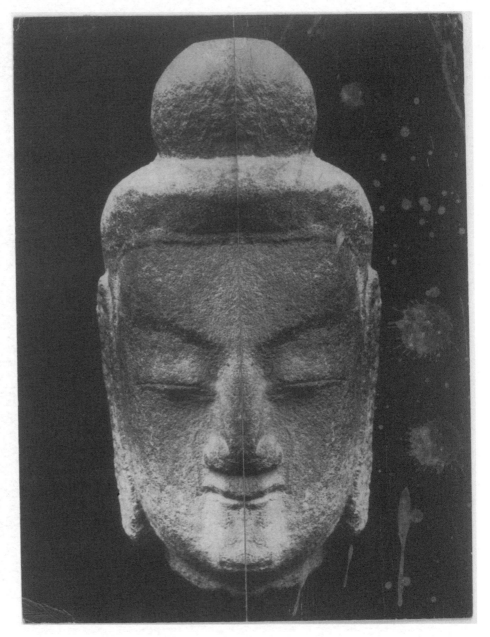

face like wallpaper patterns. But it appears on bronzes of the period (Northern Wei) where the face is merely sketched with two or three lines, and it seems to me that a man would not do this so willfully, when his main attention was given to the plastic of the work as a whole, unless he was doing it on formula. Confronted with one good head you might merely say that the artist had deep intuitive understanding, and on finding several rather like it, you could say that

FIG. 63. Right-right of
61 [i.e. of Empson's
'main' head from
Yungang, China]

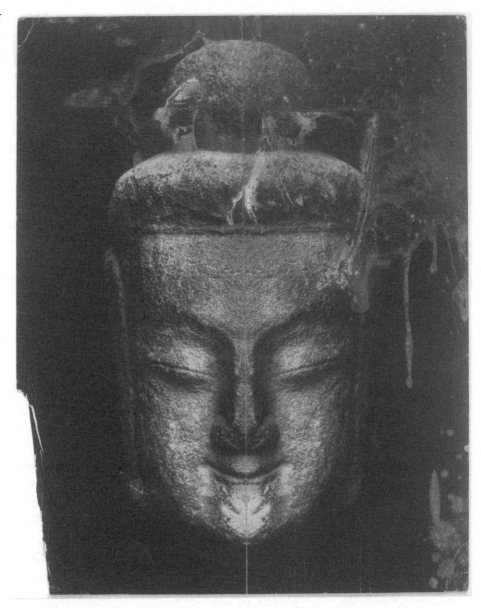

the general style had been copied. But when the trick is done perfunctorily it must have become a 'rule.'

I shall try to describe in detail the variations on my main example from Yunkang (Fig. 61). In the right hand face, as usual, the lines slant upwards from the centre; in the left hand face similar lines are horizontal or are made to seem so. This applies not only to the eye and mouth lines (in this example) but to the jowl and the line at the bottom of the nose. The inner eyebrow is perhaps actually steeper on the left, but it meets the nose at an angle; on the right there is a

continuous strong curve from nose to brow which makes the slant more impor-
tant. The left brow is slightly higher and has less hollow beneath it, which makes
the face more passive and less protected. The bulge below the eyeslit, suggesting
an eye, is nearer the nose in the left version, giving the squint of meditation; on the
right is longer and more pronounced, giving a forward-looking eye that seems to
wink. The bridge of the nose is more sharply defined for the more decided
character on the right. On the left the mouth is smaller and has a double curve,
smiling but turned down at the end, and the lower lip thickens away from the
willful compression at the centre; it is withdrawn, patient, childish and ascetic. On
the right the smile is strained, ironical and smug, a straightforward pull from the
zygomatic; the lower lip is short and thick in the middle, which seems more
sensual; and the downturn at the end is replaced by a satisfied dimple.

There may be doubt about details, but the broad case for asymmetry of this type
in the Yun-kang heads is, I think, too strong to be denied (Pl. 9 & 10). I have now
to maintain that the same simple rule was not forgotten in later periods, though it
underlay a far more highly modeled treatment of the face. This is harder to prove,
and needs more examples than I can give it. Also the examples use the distinction
between the two halves in various ways, and one can hardly suppose that this was
done on purpose unless the sculptors knew a general formula which could be said
in words (like the one I have given): it is no longer a matter of imitating a single
effect, though I suppose the single rule 'more slant on the right' would cover most
of the ground. In any case it is not extravagant to suppose that the Northern Wei
techniques were taken seriously and developed; the period is admittedly the
formative one for Chinese Buddhist sculpture.

My two examples here are the Five Dynasties (907–960) Kwan-yin and the great
pottery Lohan from the Pennsylvania Museum, which were in the London 1935
Exhibition (Pl. 7 & 17, Figs. 24; 64–5). The Lohan was there dated T'ang dynasty
but is now under suspicion of being Sung [Song]. In both of them the right eye
slants and the left eye is level. In the Kwan-yin the left has a gentle placid humanity
and the right the dignity of the aristocrat; you might argue that the right is the
more calm, in that it has the less expression, but her power to help is her
aristocracy—she is highly placed in the court of Heaven (Fig. 65). The Horiuji
[Kudara] Kwannon of Japan, for example, divides her face in the same way
(Fig. 40). It is perhaps not safe to argue from the odd shape of the eyes, which
look rather as if they used to have a thin lining of some precious material which has
been gouged out: but it is clear for instance that you always had the brow-line on
the right higher than on the left, and the inner point of the eye lower and nearer
the nose. The great pottery Lohan has an undamaged eye structure and it is clear
that the two eyes were planned differently (Fig. 24). You might say that both slant,
but it is only on the right that the middle of the lower lid slants, and this is what
catches the attention when you look straight at the eye. The right, it seems to me,

FIG. 64. Five Dynasties
Kwan-yin [Guanyin]
(London [Royal
Academy] Chinese
Exhibition [19]35)

has pride and suffering and looks out with a certain cunning; the left has a
stubborn and intelligent placidity. I do not know how to allot these qualities to
the shapes. He is not a god, but a man who has attained Nirvana; indeed the head
may be a portrait; but the perfection of the thing seems to imply a sense of
working on a theory. I have not seen any asymmetrical statue heads later than
Sung; no doubt they could be found in paintings, but none I should say in the
course of realism, not from a rule. In the T'ang period my general impression from
the museums is that the rule was used frequently.

I suspect that this idea reached Indochina and Siam (but not Java) though their
main techniques in Buddhist sculpture were entirely Indian. I have not been to
Siam, but noticed an asymmetry on a Siamese Buddha of the fifth to seventh
century at the 1939 World Fair in San Francisco (Fig. 66). Otherwise entirely under
Gupta influence, it makes the right eyebrow slightly higher than the left, and the
right eye slants upwards while the left remains level. The effect is not I think
impressive; it is merely curious to find the Chinese rule followed so tidily. Of
course one should remember that it is fairly hard to make a face symmetrical, and
an isolated example of the rule might be an accident. Cambodia, in what is called
pre-Khmer work, has a different technique. In the Phnom Penh Museum the
three or four heads which seemed to me the best, all had the eye on the left rather
lower than on the right. The photograph here of a fine specimen distorts a little by
being taken from below; the head is longer and harsher than it appears (Fig. 16 [cf.

FIG. 65.　Head of 64 [i.e.
of Empson's Royal
Academy Guanyin]

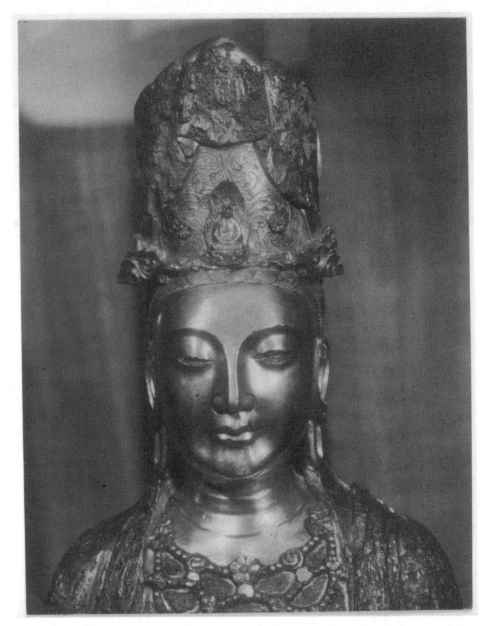

Pl. 11]). The left eye is more open than the right and its upper lid more level; the
whole left face seems a bit smaller. It is a steady, mild humanity that you get on the
left, and the right has the pride and the power of organisation. It seems to me that
this is sufficiently well thought out to be called intentional, but it is certainly not an
imitation of the Chinese sculptural technique. If I am right in thinking; that this
technique was derived from a fortune telling system, it is not hard to believe that
the system might travel; it would be sufficient if fragments of it were reported in

FIG. 66. Siamese Buddha, 5th–7th Cent. (San Francisco World's Fair, 1939)

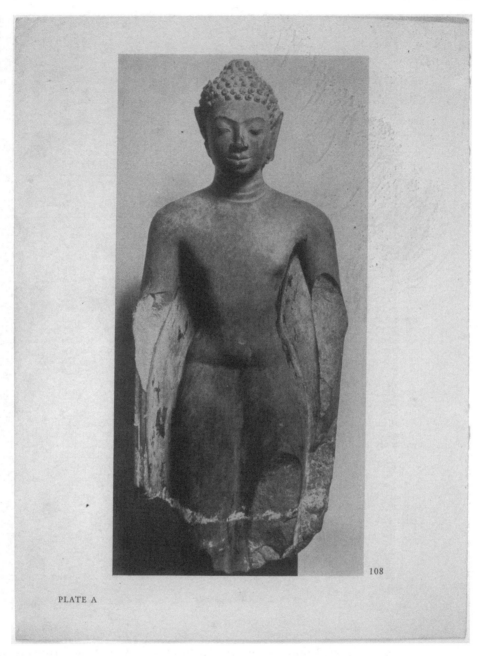

108

PLATE A

gossip. There was trading contact with China along the coast. In such a case the Cambodian sculptors might use the system independently and if so would work out a different sculptural technique from the Chinese. I feel that the whole Far Eastern area had a certain hankering for a more lively Buddha than the Indian ones they had as models, so that the Cambodians would be ready to pick the idea

FIG. 67. Right-right
Split of 44 [i.e. of the
head of the Koryu-ji
Maitreya]

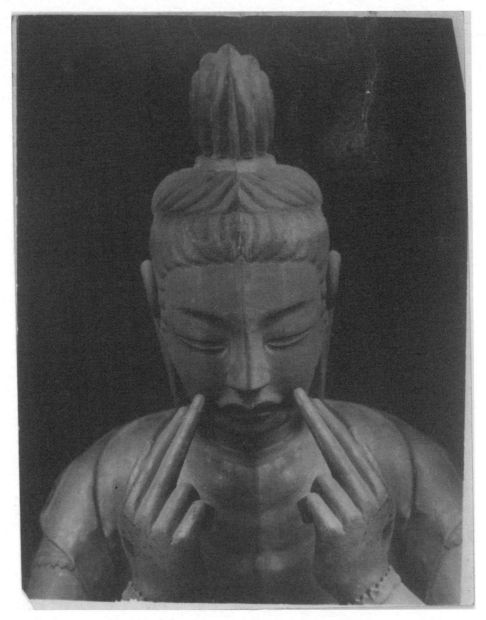

up. However, I do not want to put too much weight onto this suggestion; the Cambodian examples might be due only to the intuitive use of asymmetry which Dr. Wolff claims to find in primitive art.

The case is very different for Korea and Japan. If the asymmetrical technique was intentionally kept up in China, after being developed at Yun-kang, there is no reason to doubt that it would be exported to Korea and Japan with the rest of the Chinese sculptural tradition. It is known that both statues and sculptors were

FIG. 68. Left-left Split
44 [i.e. of the head of
the Koryu-ji Maitreya]

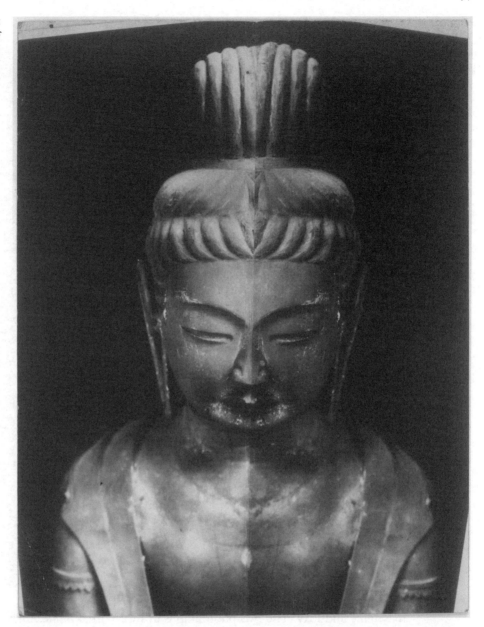

exported. The best Korean example is the Koriuji Maitreya, which was presented to the Japanese court from Korea in 604 (Figs. 44–6; 67 & 68). It is rather similar to the Keijo [i.e. Seoul] Museum Maitreya (Figs. 33–5), but more striking. The right eye is slightly the longer and steeper and the right mouth-end cannot give the same queer impression as the left one because it is hidden by the meditative finger (Figs. 44 & 67). From sheer left the mouth is plaintive and even ready to squall; from half left the face has a refined, coy distaste (Figs. 45 & 68). The right is

FIG. 69. Right-right of
Head [i.e. of the head
of the Chugu-ji
Maitreya (Figs. 48–50)]

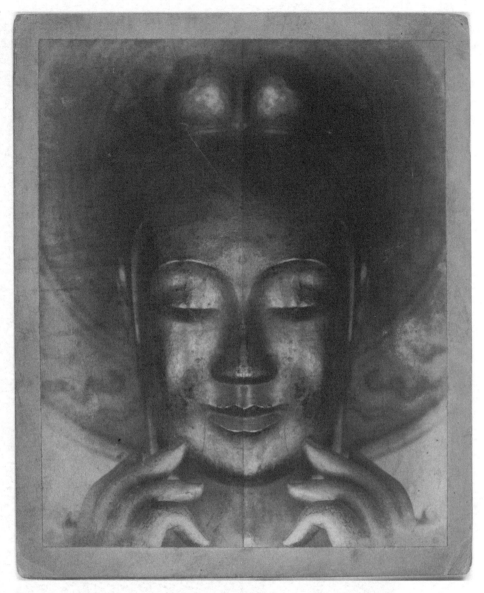

masculine and foxy. The two photographs in Karl With's *Buddhistiche Plastik in Japan*, taken almost from behind, bring out the same contrast without showing the features; the whole statue is a surprising mixture of qualities.[94] I take it that a childish charm is still present in the unborn Buddha but he is all the while plotting to appear in glory as a redeemer.

The Chuguji Maitreya (Figs. 48–50) does not take this active interest in politics. The right is still the more aquiline and active but the calm left is now the more mature. With different angles and lighting you can extract from the right a heavy maternal brooding, a Peter Pan daydream, or a solemn, judging child: the left is a normal Buddha in repose, though lighting can make it more or less young. Easily

FIG. 70. Left-left of Head [i.e. of the head of the Chugu-ji Maitreya]

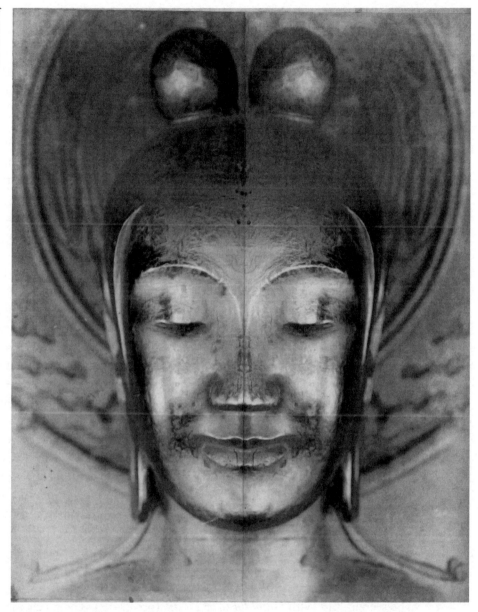

seeming dull in diffused light, the Chuguji Maitreya lends itself to the sympathetic photographer; and Japanese photography is so good that it is open to the same kind of objections as Coleridge on Hamlet. It makes With look as dull as Dr. Johnson. But even so, you couldn't play these tricks with any piece of sculpture you chose. I shall try to give what details I could see. The left brow is a fraction higher and curls down more on the outside, so that this face is the more ironical, rounded, and complete (Fig. 70). On the left the little ripple at the end of the eye ridge is more defined and the edge shorter. The firm horizontal of the right eye

ridge looks seriously down, and has a hollow below to take the heavy shadow of a massive emotional life if required (Fig. 69). The outer chin-line of the left is more rounded and the jowl behind on the right more heavy. However, both jowls look cumbrous in strong light; the delicacy of the face, like the Rossetti type of beauty, is liable to seem stuck on the end of a coarse lump. I suspect they are planned to make the apparent bone structure change with the light. Apparently it has never been moved from its present room, where the light is from the front and the left. The right half of the mouth is the more firmly closed, the more sensuous because of the defined fullness of the lower lip; it is the left-hand mouth which is held carelessly and vaguely, and will at any moment break into a smile. I think, too, on the left, at the level of the bulb of the nose, the fat of the cheek is nearer in, making the face more introvert but more settled; on the right it stretches out as a vague mass. All the contrasts are slight. The drapery carved as hanging from the figure is in conventional cloud forms, and next to the floor there is a tiny Buddha, to give the human scale, represented at the time when he pointed at earth and heaven, to include everything, as soon as he was born. Christian painting hardly ever makes a deity appear behind the skyline, though Botticelli does it once.[95] The effect is pantheistic; he becomes too big to be a person; so the method is more suited to Buddhist art, which often uses it. Here as in the Koriuji Maitreya, I take it, though by an almost opposite interpretation of the rule, there is a conscious effort to describe the unborn creature in the heavens with its Buddha nature not fully developed. It seems to me a marvellously subtle and tender work.

The Horiuji [Kudara] Kwannon (in Horiuji Temple near Nara) has a battered face, with remains of paint, and is very puzzling (Fig. 40). There is a copy in the British Museum, but it does not grapple with the problem of copying the face. I could only get a not quite frontal view to cut up, and this no doubt exaggerates the asymmetry (Figs. 71 & 72). However, I saw her several times, and once had the luck to find her being photographed in the open air, so am confident that I did not invent it. The right brow line is the steeper, with sharper curves; the right eye outline somehow the more fishlike—smooth and a bit slanting; and the right hand of the mouth the more beaklike or sharply pulled in (Fig. 71). The points may also be seen in Karl With's *Buddhistiche Plastik* (pp. 38–42). The puzzlement and the good humour of the face are all on the left, also the maternity and the rueful but amiable smile (Fig. 72). The right is the divinity; a birdlike innocence and wakefulness; unchanging in irony, unresting in good works; not interested in humanity or for that matter in itself; the Lady Almoner; more a mascot than a person.[96] Many small Kwannons of the period use this face on both sides. However, there is nothing simple about this noble and baffled creature, and what you make of the face depends in a high degree on the tall tired body (Fig. 40). On a dumpy body, it would be the White Queen; it needs for its interpretation the long sweep of the

flamelike draperies, stretching as far as the earth, and the jerk of the extended arm, exhausted but still offering.[97]

The central head of Horiuji's trinity sculpture is, I believe, also a case of asymmetry, but I have no photograph taken from the right (Figs. 56 & 57). My note taken on the spot says that the right is more aquiline, with harder lines, and that the complexity of the mouth, already discussed, is more prominent on the left, the side from which this photograph is taken. This use of the opposition is of course some distance from the formula that the calm is on the left; whether you take the left as looking worried or amused it is not impassive. But the power is on the right and the more personal or less public side of the face is on the left, as in the Horiuji [Kudara] Kwannon (Fig. 40).

So far, by one interpretation or another, we have had the more energetic side of the figure on the right. With the Jizos of the very interesting Konin or Jogwan period (ninth century) the right side is silence, because his power to help is his secrecy (Figs. 73 & 74). His function is to save you from Hell, and you must pay the priests for it. By this time Buddhism in Japan was highly organized, and there was capital in mystification. The statues are 'mystical' in the same sense as Leonardo's faces, and use the slit-eye for subtlety like some of Giotto's saints. 'You couldn't understand what I'm thinking even if I meant to tell,' also, 'It's going to take clever management to keep *you* out of Hell, but I'm an old hand at this.'[98] On the left the brow is slightly higher, so more ironical; the lower lid hangs a little open, to observe the worshipper, and the face is sleepy, sated, sly. On the right the huge eye-slit runs straight like a gash, and the face is blank. The Nara Museum has a row of these terrific creatures in big glass cases; it is like a snake-house; they seem to be sliding sideways along the slit of the right eye. This is the end; from the tenth century onward the Buddha face is conventional and symmetrical. The early work is so noble and free, seems to open such vast possibilities, and was achieved so rapidly, that it is at first sight baffling that Japan should descend to the family-joke art of her later styles. I think the Konin Jizos, awful and powerful as they are, do something to explain it.

I have been told that these effects of asymmetry must be imaginary or accidental, or anyway can have no meaning of any importance, because the statues were made to order by simple masons who often would not understand the religion at all. You can read things 'into' a Far Eastern painting because it was made by a cultivated gentleman, but not into a statue, because it was not. This makes me impatient; I do not understand why a man troubles to become an expert on these things if he thinks they were made by dolts. Sculptors were important enough to be specially imported. In Japan you get legends that Prince Shotoku made the best things himself, so it was not thought beneath his dignity. And the makers of Noh masks certainly planned complex faces, though they were not gentlemen. No doubt the low position of the sculptor does something to explain the degeneration

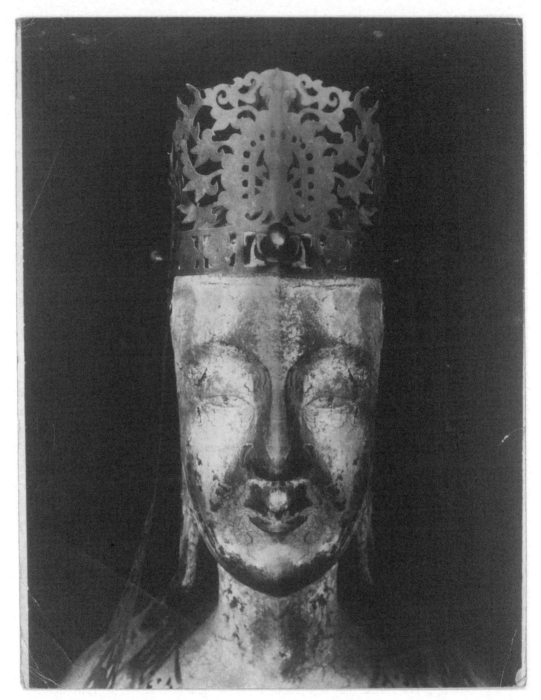

FIG. 71. Right-right of Head [i.e. of the head of the Kudara Kannon (Fig. 40)]

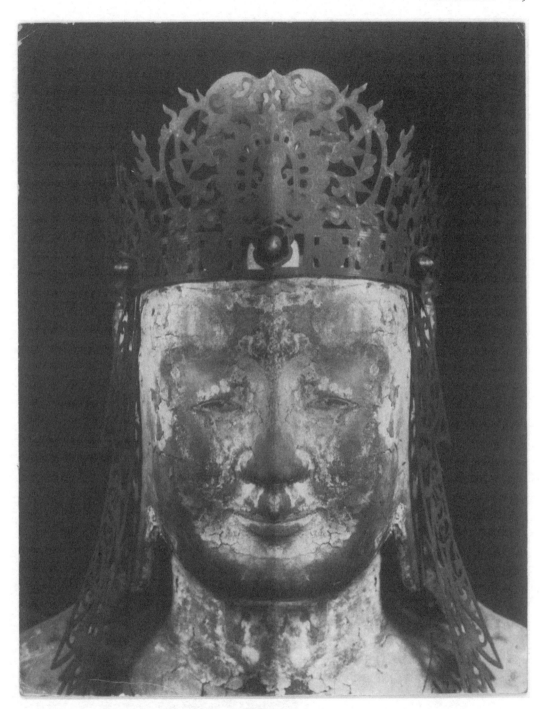

FIG. 72. Left-left of Head [i.e. of the head of the Kudara Kannon]

FIG. 73. Konin
Period Jizo
[i.e. Jizo
Bosatsu]

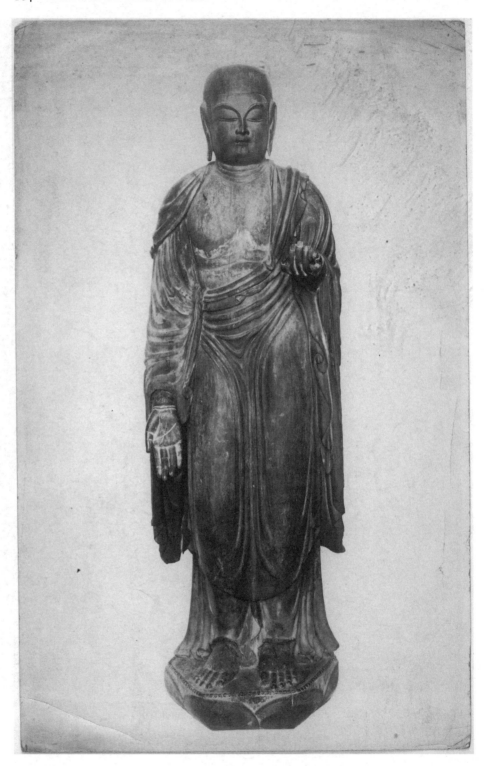

FIG. 74. Another [Jizo Bosatsu]

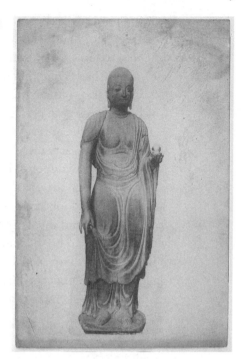

of the work in later periods, but we do not know enough about the early ones to argue from their ignorance.

The argument would be on a stronger footing if one could get evidence about fortunetellers of the Northern Wei period. Those who arrive at local fairs in China today generally have a large, scientific-looking poster, with a blank human face picked out by characters marking key points for telling your fortune, and these are different on the two sides. My learned Chinese colleagues believed that the earliest books on fortunetelling from the face date back only to the Sung [Song] dynasty, whereas what influenced the sculptors should be up to eight centuries older. There is perhaps some hope of further evidence from this quarter, and in any case I feel that the practice is inherently likely to be an old one. I hope I may smack together two prejudices by pointing out that the more the sculptors were low class, the more likely they were to believe a fortunetelling theory about faces.

However, though the existence of such a popular theory about faces seems to me necessary to explain the development of the sculpture, I do not want to talk as if it were a sufficient explanation. Any treatment of the heads in terms of a theory about facial expressions ought also to consider the philosophy which was being expressed. I have been treating the statues as people, and trying to describe their personalities. But Buddhism does not believe in a personality. What the Buddha or his earliest interpreters took as the crucial doctrine is that man is a muddle with no

unifying principle, a thing that needs tidying away; in the words of Drummond of Hawthornden, that 'death is the thaw of all those vanities which the frost of life fasteneth together; man were an intolerable thing, were he not mortal.'⁹⁹ To be sure, as Sir Charles Eliot pointed out, there is a mystery in the system as to whether this applies also to the nature of the saint. But it is precisely the mystery, I think, which is expressed so perfectly by the complex head. The salvationism of Maha-yana Buddhism went very far towards denying the *anatta* (the 'no-soul') doctrine, though it never actually did so. Hinayana Buddhism, which took it seriously, never uses the asymmetrical technique. It might seem that this goes the wrong way around, but the two points of view exist together within the Mahayana synthesis. If you look at a Bodhisattva from a Hinayana point of view, it has failed to tread to the end the narrow paths of escape; it can reasonably be given a head which proves it to be still a mixed bundle, though a splendid one. It would be an odd, but not an unreasonable, thing if the profoundest studies of character in all sculptures have proceeded from a painstaking application in detail of the doctrine that there is no such thing as a character at all.

6

Theology

It would be trivial to enjoy these statues without trying to make some estimate of the religion that inspired them, and I will discuss in this chapter how far the common reproach is right in calling it gloomy, repressive, selfish and impersonal. It seems to me that only the last adjective has an obscure but important truth; and if we are to call Buddhist art impersonal we must make a further effort to reconcile the idea with the personal quality of Far Eastern sculpture.

I feel particularly ill equipped to enter the larger field, and cannot emulate the aplomb of that great scholar Sir Charles Eliot, who in his *Hinduism and Buddhism* moves among the founders of religions entirely as an equal, and sometimes knocks their heads together; but at least I can quote him. The reader should also be referred to Mr. Aldous Huxley in *Ends and Means* for an informed and up to date discussion of mysticism in general.[100] He makes clear that the eastern type, in its pure form, is not directed towards a divine person, and he decides that this is better justified by experience than the western love of God, because its adepts do not pass through the Dark Night of the Soul. The westerners, he concludes, have to endure this period of suffering because as their insight increases they come to realize, however obscurely, that the prop of the personal approach must be abandoned. Huxley's praise of Buddhism is based on very wide reading, in psychology as well as history, and so far as I can see it is largely true. At the same time one can understand a reader feeling a general dissatisfaction with Huxley and his praise, not so much because the world view he presents is a gloomy one as because it seems sure not to produce good results in the world.

Indeed the typical left-wing attitude towards mysticism nowadays is one of moral disapproval. Dr. Joseph Needham, for example, in *History is on our Side*, a recent collection of essays, considers that there is a great gulf between this-worldly and other-worldly religions, and that only the this-worldly ones have had good effects. He takes the view that the Hebrew prophets, Jesus, and the primitive Christians aimed at bringing the Kingdom of Heaven on earth, and that later Christianity, by picking up transcendentalism from Plato, to whom it came originally from India, was playing into the hands of tyrants. Some, says Dr. Needham,

like the ancient Indians, worn out by excessive effort, exhausted by the struggle for existence, those for whom the fight against the jungle with primitive techniques was

almost hopeless, felt an insufficiency in all human action, an impossibility in all human dreams and demands; and they proclaimed that only in complete renunciation, only as he emancipates himself from the wheel of things, only as he relinquishes all reliance upon, and hope for the world, can he attain lasting satisfaction.[101]

Whereas the Chinese, goes on Dr. Needham,

remained faithful through the long history of their philosophy to the belief that man is not to be distinguished from social man, nor social man separated from nature, and that the very foundations of nature contain something congruent with, and favorable to, human social order.

The antithesis of this-worldly and other-worldly religion gives a neat account of the relations of Christianity and Buddhism;

We know of Buddhist missionaries in the near east from Asoka Maurya's time onwards, and they may have helped to divert Christian thought from its primitive intention to redeem this world into its later ascetic despair and hieratic resignation. So also the transition from Hinayana to Mahayana Buddhism, in which a world-denying philosophy is superseded or overlaid by a system of devotion to a personal savior, may have been assisted by the example of the great neighbouring religion of the west.

All this is part of an argument addressed to Christians to convince them that they ought to become socialists or communists, and the simplicity of the picture is required by the polemical intention.[102] Mysticism has been found satisfying to some people for a long time and in a variety of cultures; it is too large and sturdy to be dismissed as a mistake; what the mystics would say about the advanced thinkers deserves also to be considered. But I could not deny that the left-wingers appear the more reasonable and humane; indeed Mrs. Rhys Davids, in a series of learned works praising and expounding primitive Buddhism, has gone to what must be remarkable lengths even for theological exegesis in proving that the Buddha meant the opposite of what he is recorded as saying.[103] She maintains that what he wanted was not annihilation but more abundant life, and she is a striking witness because after being conquered and penetrated by the religion she is driven to these fascinating linguistic arguments as if to keep it at bay. Her thesis very nearly amounts to saying that, though the Buddha was right, all the Buddhists have been wrong since the first Great Council.

One feels that the religion must have been founded on at least a great paradox, not a misunderstanding. Certainly the Buddha cannot have meant to fabricate an ideal of death-wishes when he said, for example, after illumination, 'I go to Benares to set moving the wheels of righteousness; I go to beat the drum of immortality in the darkness of the world.'[104] He was indignant when called an unbeliever who thought that after death the saints are annihilated. But those who describe the state of a saint after death as a fuller and deeper mode of life are

infected with *aruparago*, or desire for life in a formless world, which is the seventh of the ten fetters.[105] The doctrine was never supposed to be easy; the Buddha at first despaired of teaching others the truth.

On the view that Indian religion is gloomy because of the debilitating climate of that country, Sir Charles Eliot has written some magisterial passages, and I think they ought to be quoted here because this fine writer is too little known except by specialists. It cannot he maintained, he is saying,

that in practice Buddhism destroys the joy and vigour of life. The Burmese are the most cheerful people in the world and the Japanese among the most vigorous, and the latter are at least as much Buddhists as Europeans are Christians. It might be plausibly maintained that Europeans' love of activity is mainly due to the intolerable climate and uncomfortable institutions of their continent, which involve a continual struggle with the weather and continual discussion forbidding any calm and comprehensive view of things. The Indian being less troubled by these evils is able to judge what is the value of life in itself as an experience for the individual, not as part of a universal struggle, which is the common view of seriously minded Europeans, though as to this struggle they have but hazy ideas of the antagonists, the cause and the result [...] Those Europeans who share with Asiatics some feeling of dissatisfaction with the impermanent try to escape it by an unselfish morality and by holding that life, which is unsatisfactory if regarded as a pursuit of happiness, acquires a new and real value if lived for others. And from this point of view the European is apt to criticize the Buddhist truths of suffering and the release from suffering as selfish. But Buddhism is as full or fuller than Christianity of love, selfsacrifice and thought for others. It says that it is a fine thing to be a man and to have the power of helping others; that the best life is that which is entirely unselfish and a continual sacrifice. But, looking at existence as a whole, and accepting the theory that the happiest and best life is a life of self sacrifice, it declines to consider as satisfactory the world in which this principle holds good [...] Life involves unhappiness; that is a fact, a cardinal truth. That this unhappiness may be ordered for disciplinary or other mysterious motives by what is vaguely called One above, that it would disappear or be explained if we could contemplate our world as forming part of a larger universe, that there is 'some far-off divine event', some unexpected solution in the fifth act of this complicated tragedy which could justify the creator of this dukkhakkandha, this mass of unhappiness—for all such ideas the Blessed One has nothing but silence, the courteous and charitable silence which will not speak contemptuously.[106]

All this, however, does not so much refute the argument from climate as claim that doctrines due to the Indian climate may well be true ones. He takes a rather similar position on arguments from race: 'All religious doctrines, especially theories about the soul, are matters of temperament. A race with more power of will and more delight in life might have held that the soul can stand firm and unshaken amidst the flux of circumstance. The intelligent but passive Hindu sees clearly that whatever illusions the soul may have it really passes on like everything else.'[107]

It seems natural to retort that Hindus believed in the *atta* doctrine of the absoluteness of the soul, which the Buddha denied. Elsewhere Sir Charles Eliot includes the Far East in this picture, saying that the sense of individuality is perhaps weaker in eastern Asia than in western Asia and Europe, so that pantheism and quietism, with their doctrines of the vanity of the world and the bliss of absorption, arouse less opposition from robust lovers of life. This, he says, may be due to political despotism, want of military spirit, or on the other hand a tendency to regard the family, the clan, or the state as the unit.

But while putting forward arguments to explain or justify the pessimism of the religion he also regularly denies that it has any. 'In Gotama's [i.e. Gautama Buddha's] esteem the great merit of the doctrine (of *anatta*) seems to have been moral and practical. The Brahmins and Jaina held the self or soul to be something permanent and unchangeable, but fettered and hampered by the body. They therefore strove to liberate and isolate it by mortifying the flesh. But the essence of the Buddha's doctrine is that self or soul can be altered and improved.' One of his principal objections to the doctrine of the permanent self was that, if it were true, emancipation and sanctity would be impossible because human nature could not be changed. 'And yet' Sir Charles Eliot goes on, the complete causal analysis of ordinary experience given by the Buddha makes it hard to fit in the saint at all. 'When the eight-fold path has been followed to the end new powers arise in the mind, new lights stream into it. Yet if there is no self or soul, whence do they arise, into what do they stream?' The real puzzle of Buddhism is not about the nature of Nirvana considered as a state after death. 'Even in this life the nature of a saint passes understanding, because he is neither all the *skandhas* nor yet one or none of them. Yet it seems that an ordinary human being is an aggregate of the *skandhas* and nothing more.'[108] The booming voice of the Buddha must close the discussion. 'The saint who is released from what is styled form is deep, immeasurable, hard to fathom, like the great ocean. It does not fit the case to say either that he is reborn, or not reborn, or both reborn and not reborn, or neither reborn nor not reborn. The saint who is released from what is styled sensation . . .' and so on with full repetitions substituting 'perception,' 'consciousness,' and further technical terms.[109]

On the fundamental issues I have nothing more profound to say than that it takes all sorts to make a world. But it is true I think that a desire and competence to do practical good must somehow be felt in the religion whenever the art which it inspires is deeply enjoyed. It may be some failure to insist on this aspect of its doctrine that made Buddhism fall so regularly into weakness and partial corruption, so that in each country only the first centuries of the art are very good. But after all the good periods of Christian are not enormously long by eastern standards. The generosity and intellectual breadth, even the simple effect of cleanness, about the Buddhist work make it immensely refreshing in India compared to

the later arts of Hinduism; and there seems no reason to doubt that the religion was doing practical good during the periods when the art feels as if it was doing so. Thibet and the Khmers, it might be plausibly argued, were producing *fleurs du mal*, but the main body of Buddhist work is very far from raising any moral puzzle.

There is also in Dr. Needham's account a suggestion that a 'world-denying philosophy' is the opposite to 'a system of devotion to a personal saviour', and it is important I think to see that this opposition does not cover all the ground.[110] Indeed the two things might be combined. The antithesis between the Yogi and the Commissar is not the same as that between God and the Absolute, and I quoted Dr. Needham's remarks about China in the same passage partly to show that he would not seriously treat them as if they were. The chief difference between East and West, it seems to me, one from which the others may almost be deduced, is that in the West the supreme God is a person and in the East he is not; Brahman the ultimate Hindu Godhead is a neuter noun. The Moslems in this antithesis count as part of 'the West', but in effect their extreme refusal to humanise God makes them act as a borderline case. The Chinese, whether by an accident or not, fit in neatly beside the Hindus as part of 'the East'.

Here again, as in discussing 'pessimism', there is a puzzle as to how far the difference of theological tradition is a question of racial temperament. As before it is an important consideration that the Chinese and the Indians (let alone the Aryans, if the Buddha was an Aryan) are different peoples with very different temperaments. The belief in metempsychosis (transmigration of the soul after death) appears to have come from India both to Europe and China; at least there is no record of it independently of influence from India. But the Chinese rejection of the personal supreme God seems to be independent of the Indian one, and may have been reached by a different route; though I think it has similar effects, not merely in sculpture but in music, ballet and the theatre. Confucius, it appears, was not interested in deities but in the proper behaviour among men; he used the impersonal *T'ien* [*Tian*] for 'heaven', rather than *Shang Ti* [*Shangdi*], perhaps as a cool tone towards the gods rather than as a philosophical assumption that behind them lies an impersonal first cause. But the character for *T'ien* itself involves a man: a process of impersonalising the conception had therefore already occurred. And the more metaphysical system of Taoism, from its beginning, is concerned with the idea of an impersonal indwelling world-nature; also as Dr. Needham pointed out, with the mutual accommodation of this and the nature of man.[111] Long before Buddhism got to China there had been no fundamental theism for it to oppose. And it is clear that the Chinese rejection of the personal supreme God did not involve a 'world-denying philosophy'; the world was fitted to the nature of man.

The relations of Europe with this type of doctrine have been confused, but the confusions have occurred at important points. It is radically opposed to a main

element of European thought, the emphasis on the individual; for the personal God is a sort of image of him which guarantees his importance. There is a series of Christian beliefs which emphasise the individual, and which are normally denied in the East. Each individual is immortal, and his fate is to be decided in this one life; the sense in which he can be called 'free' is therefore a subject for endless controversy, he is born in sin and must struggle, so that his position is a dramatic one; it was shared by God himself in the incarnation. Most of these ideas were prominent in Europe and the Mediterranean before Christianity; Frazer's 'sacrificial hero as dying god' belongs mainly to that area, whereas his 'sincere man as one with nature' belongs mainly to the East.[112] Tragedy itself, which is apparently derived from the sacrificial hero, and anyway is a main means of emphasising the individual, is practically unknown in the East except for the inverted tragedy of the Japanese Noh plays (where the ghost cannot forget his loyalties and therefore cannot die enough). But this very striking opposition between the areas is not a result of lack of contact. Pythagoras, at what may be called the dawn of European thought, seems to have been directly influenced by India and certainly held Indian doctrines. Bruno, at what may be called the dawn of scientific thought, was apparently a pantheist. The medievals were aware that such a heresy was possible; it is curious that when William of Rubruck in the thirteenth century was arguing with Moslems and Lamaist Buddhists at a World Religious Conference, held by one of the Tartar Khans in central Asia, he knew quite well that the Lamaists were pantheists, whereas in the eighteenth century a man like Edward Gibbon seems to have had no idea of it.[113] However, the idea came back again for the Romantic Revival; I am not clear how important it was to Wordsworth and Shelley, but they knew it was the latest thing. And yet in spite of this fertilising influence from the great rival world-picture, at so many key points of our development, it has never been widely accepted or in a sense even experienced; if we want to know what it feels like in practice we must go to the Eastern artists who have been brought up with it as an assumption and have it in their bones.

The relations of Hitler with Buddhism, though more innocent of thought, deserve attention; whatever the swastika may have meant originally, its only regular use when he adopted it was as a Buddhist symbol. He then assured the Japanese that they were 'honorary Aryans', and this can hardly have surprised the Japanese, who like all Buddhists were accustomed to being exhorted to follow the Aryan Path. Most of our own moral words, for example, 'noble,' 'generous,' and 'frank,' were originally terms of class or race, and it would be hard to say just what the Buddha felt 'Aryan' to mean after his rejection of caste; but at any rate it was he, not Hitler or even Max Müller, who first made it a term of general praise. The Germans however, in the eighteenth and nineteenth centuries certainly took the lead in expounding and philosophising upon the sacred books of India, which were becoming available in Latin translations made by missionaries.

Schopenhauer gave them a great advertisement, and a more fundamental use of them was made by Hegel. The Absolute and the doctrine that All is One are directly derived from India, and Marx said that he had only to turn Hegel upside down. We can expect therefore to find in a quite literal sense that the Absolute is fitted to the nature of the Commissar, and there is no need for Dr. Needham to reject it as a Yogi-doctrine in favour of devotion to a personal saviour. It might indeed be argued that a belief that the Absolute is 'congruent with' the social order, as Dr. Needham put it, gives too much power to the rulers of that order; it is liable to be debased into worship of the state. But we have already been told that the Yogi-doctrine and Pauline Christianity were also used to give too much power to rulers, in their different way, and if both types of religion can suffer this corruption the argument gives no preference to either.

Mahayana Buddhism, it is not to be denied, does very largely consist of devotion to personal saviours, and perhaps this is hard to reconcile with the doctrine that the supreme God is not a person. It seems enough to say that all religious programmes have to work on a rich tradition, and are carried out only in part. The Bodhisattva, even in accepting worship, continued to regret that he had had to renounce becoming impersonal; and from the point of view of the worshipper, the belief in reincarnation itself is enough to take most of the sting out of the individual soul. The fragment that can be reborn into a new network of confusion is identical with the previous life in hardly more than the sense that it is affected by its deeds; and the rejection of the permanent soul carried as a sort of mirror-image the rejection of the personal God. At all events it seems to me true to say (as is commonly said) that Buddhist art remains impersonal, in some sense in which most of the culture of the East is also impersonal, but in which Christianity and the arts of Europe are not. This, if true, seems an important generalisation, and I want finally to try to make it more definite by looking at the secular arts in the East, such as music and the theatre.

As to the ancient music of China, Confucius regretted the loss of Chou [Zhou] Dynasty music; the music of his day was lost in the Han Dynasty, and that of Han again in the T'ang. It is perhaps rather ridiculous when one considers that music was supposed to teach the art of government, but then the loss is not likely to have been so complete as the writers said. Some T'ang music is preserved by the Japanese, and I have heard one or two performances. Music of essentially the same character is used regularly in the Japanese Noh plays. It is extremely hypnotic, and you are likely to stay through the long performances even if you say you are bored.[114] It is based on eight slow beats, taken separately by different percussive instruments. We feel differently about rhythm according as it goes quicker or slower than a heartbeat, and nearly all European music goes quicker. Our limit of slowness is the Dead March, which goes about the pace of the heart.[115] This music goes slower, and that is why it cannot be imitated on

European instruments. Our music is meant to go bouncing along frankly like a well-intentioned dog; theirs sits still and strengthens itself like a cat. There are long squalling noises that hold you up during the wait for the next beat, and the beat comes with a snap as if you had stretched a piece of elastic till it broke. The connection with the art of government is clear enough, I think; the ruler remains in dignity on his official seat and tries hard but remains passive. The folk-music of the Far East has none of this complete strangeness for us; it is rather like Russian folk-music. But the operatic music of China, with its strained dragging falsetto male voice, is clearly a direct descendent of this tradition. A rhythm quicker than a heartbeat is one that seems controlled by some person, and the apparently vast field of European music is always, within this range, the individual speaking up. Music based on rhythms slower than a heartbeat can carry a great weight of emotion and even of introspection, and of course incidental runs will go quick, but it remains in some sense impersonal. I think that European music is a much larger creature; it is the fresh air. On the other hand it seems to me obvious that Eastern music is much better for ballet. In dancing of serious power, the dancer can stand still for several minutes and make you watch for the imperceptible movements of his breathing like a cat watching a mouse. Now western music cannot stand still; it is not built to give a dancer these opportunities. Sensible people who love the European ballet will tell you that the great thing about it is its eternal youth. This is quite true, but childishness is not all you want. I am not clear how far my account of Far Eastern music has any relevance to Indian music, but that gives the same kind of opportunity to a ballet-dancer.

As to the Far Eastern theatre, which is next door to opera and ballet, the first point to make is that the movements are modeled on those of puppets. The notion of personality is a complex thing, and I hope I am not dragging along with me some irrelevant idea; I only mean in the most obvious sense that this makes the art impersonal. It might be better to say that it is generalised. Then, the ordinary performance both in China and Japan, which takes many hours, is made up of single scenes from enormous plays that everybody knows already. This implies a different attitude to the stage from our own. It would be amusing to make up an evening from bits of *Hamlet, The Dynasts, The School for Scandal, Oedipus* in Greek, and *Charley's Aunt*; but we would not find it moving.[116] We would want to go on sympathising with the characters; we would want to hear the end of the story. The characters in a Far Eastern play are hardly even what we call 'types', let alone individuals. It is the situation which is typical. The situation often happens in real life, and a play about it is therefore real, and may be very moving. It is quite in order to have the whole audience in floods of tears. But in real life the situation ends in all sorts of ways, and you are not much interested in the way this one ended; why should you be, when the people who are in it are not the important thing? If you put in a definite ending it would be unrealistic; it would

look as if the thing always ended in that way. Of course many people will know the traditional ending to that particular story, but they do not need to see it, as we would do.

I hope that these comparatively superficial points will do something to clear up what is meant by a culture which is not based on belief in a personal supreme God and therefore not on the unique value of the individual. It is a slippery generalisation, but I think that one has to use it in trying to describe Buddhist art to European readers. At any rate no-one will suppose that the examples from the theatre imply asceticism or rejection of the world. But after the shift from theology to the individual the reader is likely to have called up strong feelings of resistance. Democracy or humanitarianism is based on the soul, it is frequently said, or for that matter the high ideals of aristocracy are based on the soul. The antlike qualities of the Japanese are due to their lack of respect for the individual, a heathen trait. I do not think any of this is true. The Chinese are recklessly individualistic and have the same fundamental philosophy as the Japanese. The Buddha frequently expresses awe at the mere state of being a man, from a sort of evolutionary argument, because you have to be born as an animal so often first; 'hard, hard is it to be born as a man; hard to be a man in the world.'[117] The conception that all men are brothers no doubt does not get enough acted on in a society where overpopulation is both cause and effect of a low standard of life; but it follows as well from our common nature and our share in the worldsoul, or the *dharma* of the Buddha, as from our being children of God. I do not see, in short, that any other major belief necessarily follows from the belief that the supreme god is not a person; but I am sure that the belief crops up in many details and in some way colours the whole of a society which accepts it.

Since, however, the belief is held both in China and India (or so I am assuming) it cannot be used to explain any contrast between their types of Buddhist sculpture; and there I think that Dr. Needham's formula is the relevant one. One can believe that the supreme god is not a person without believing that he is a thing which individual men should struggle to imitate; one can believe that 'man is not to be distinguished from social man, nor social man separated from nature, and that the very foundations of nature contain something congruent with, and favourable to, human social order.'[118] I suggested earlier, in an effort to show how the ideas interact, that to make a Bodhisattva with a complex head might be regarded as a criticism, from Hinayana point of view, of the whole idea of a Bodhisattva; it is proved not to have attained peace. And indeed I think there are sometimes traces of this line of feeling. But after all, the Yun-kang Buddhas also have asymmetrical faces, though they are not suspected of excessive renunciation (Pl. 9 & 10, Figs. 23; 61–3). I think the Buddha at the centre of the Horiuji Trinity has a trace of asymmetry too, though the method is generally kept for Bodhisattvas in the later periods (Figs. 56 & 57). The formative period, at any rate,

could apply the idea to a Buddha even when making him ascetic and stern. It may
be relevant that for later Chinese fancy (in *Monkey* [i.e. Wu Cheng'en's *Journey to
the West*], for example) Heaven is conceived as a court, with the head of it merely
as one of the functionaries; the whole governmental system, not the saint, is what
is reverenced and transferred bodily to the sky. In India the idea that the saint
should merge himself into the Absolute, as his last triumph, remains prominent
even though the Buddha himself regarded it as only one of a group of formula-
tions which were all inadequate. But in China the Absolute is congruent with the
social order rather than with the individual who has fully renounced selfhood; and
the Buddha after attaining peace is still imagined as a social being. Of course one
must not make these things too clear-cut; the Indians had to humanise the
Buddha in some degree (as Mahayana developed) before they could make statues
of him at all; but I think this contrast was the basis for the much greater degree of
humanisation required in the Chinese development of the complex Buddha face.

'BUDDHAS WITH DOUBLE FACES'

by WILLIAM EMPSON

People tend to think of 'a Buddha' as a standard object, to think of the heads as all alike and practically without expression. This is roughly true about the work of later periods in all countries which adopted Buddhism, but the earlier ones vary a great deal. I want in this article to describe an asymmetrical technique, a rule for making the two sides of the faces different, which I think was used in the Far East from about the fifth to the tenth centuries AD. However, before enlarging on the variety of these heads one should of course recognise that there is a Buddha type, in its way a rigid one, and that the different heads are keeping the rules.

It is perhaps the simplest expression of high divinity that the human race has devised. In a way, Europe has agreed on the face of Christ, but you have to be a trained artist to draw it. The Lotus Sutra, written probably in the first century AD, says that even boys in their play who draw the Blessed One with their fingernails are acquiring merit and becoming pitiful in heart. The boys would really be able to draw a Buddha with their fingernails; even the crudest use of the formula gives him his effect of eternity. It is done by the high eyebrow, soaring outwards; by the long slit eye, almost shut in meditation, which would be a frighteningly large eye if opened; and by a suggestion of the calm of childhood in the smooth lines of the mature face—a certain puppy quality in the long ear often helps to bring this out. If you get these they carry the main thought of the religion; for one thing the face is at once blind and all-seeing ('He knows no more than a Buddha' they say of a deceived husband in the Far East) so at once sufficient to itself and of universal charity.

Representations of the Buddha himself seem to have been forbidden in India till the first century AD, and the earliest ones were probably made by foreign converts in Gandhara, part of the modern Afghanistan, along the trade route to Europe and China. These draw on Greek conventions for the face and drapery, but give the Buddha his distinctively Indian marks such as the spot between the brows (over the pineal gland; perhaps originally a caste-mark) and the cross-legged position with the soles of both feet lying upwards. He has already the nob on the top of his head, which may have been the formalisation of a hairdressing fashion, but is listed early as a sacred deformity. He has wavy but not tightly curled hair, and a half-closed eye, but the early examples have not got the high eyebrow.

At almost the same date, statues of the Buddha appear at Mathura in India, drawing not on the Greek tradition but on an Indian tradition for local pagan deities (the first statues of the main Hindu deities seem to have been made about the same time. These give him much more of the vigour of an evangelist; he has a wide open eye and a high eyebrow, as if beaming out his radiance to the world. As a rule only the hairline is marked on an apparently bald head (monks shaved their heads) but he sometimes has a sort of twisted cap. The earth-god tradition gives him a strong physique and a swelling chest. In fact, the 'mysticism of the East' as shown by the slim body and the halfshut eyes, seems to have been put in by the Greek artisans not by the Indians.

Then by the Gupta period in India, from the fourth century, these two traditions have been fully combined, and the Buddha has the high eyebrow and the slit eye. They combine so perfectly that it is hard to believe they developed apart. All the details are now firmly stylised; for instance the ear has become longer. The idea that the Buddha when a prince wore very grand jewels in his ears which dragged down the lobe, but since his renunciation there is only the long ear to show it. In the same way the Greek wavy hair has become tight curls which look like snail-shells and are actually said to be snailshells. As a monk he should have shaved his hair, but he was partly thought of as a prince; it was settled therefore that the shade of the sacred Bo-tree moved away from him while he was plunged in meditation, and a crowd of devout snails came clustering onto his head to keep him from sunstroke. The Gupta Buddhas are magnificent creatures but withdrawn from the world to the point of deadness, except for some youthful ones which are touching but rather feminine.

It was this convention which was exported to central Asia, South-east Asia and the Far East. In China most of the earliest surviving work is from the Yun-kang [Yungang] caves, northwest of Peking, and was done during the fifth century. The cliff of the caves is dominated by a dull but extremely ruthless colossal Buddha, and many of the smaller statues are very devoted and concentrated. But the novelty about the first Buddhas in China is that they have already a suggestion of ironical politeness and refined superiority. Delicious conversation pieces are found in progress between these reserved but winking figures, withdrawn (like the classical Chinese poets) from the vulgarity of active life rather than from the world. The later Chinese work, I think, tends to lose this freshness even while keeping considerably religious power; and the Kwan-yin [Guanyin], the Bodhisattva of Mercy, who changes sex in China and becomes a woman, is often hardly more than a sort of fashionplate of the court lady. It is only fair to add that even in its complacent forms the work has great moral strength; the Buddha has freed himself from the world and may well look superior to it, but he is telling you that you can do the same; and the idea of a Bodhisattva is in its way sacrificial (it

was formed in the same age as Christianity) because a Bodhisattva has renounced the peace of nirvana till he has helped all mankind to get there first.

Buddhism gets to Japan somewhat later, and has got there to fit in with a high civilisation already formed; indeed the need to read Buddhist texts was the chief reason for learning to read and write at all. There is an extraordinary flowering of Japanese Buddhist sculpture in the seventh and eighth centuries, one might say during the process of first becoming civilised. Much of the work may have been done by imported foreign craftsmen, but in any case it is unique. The Yun-kang tradition, filtered through Korea, seems to be its chief source.

It seems to me that the chief novelty of this Far Eastern Buddhist sculpture, beyond what had already been done in India and central Asia, is the use of asymmetry to make the faces more human. The Indians with their tendency to asceticism had put the emphasis on the Buddha's complete withdrawal from the world; they did not want him human. Whereas it is clear at Yun-kang, and anyway likely from the Chinese temperament that the Chinese did want him human; and the easiest way to make a statue lively is to make the two sides of the face different. I suspect too that they drew on a system used by fortunetellers to read your character and your prospects in your face; one can find booths at fairs in China still doing this, and using different rules for the two sides. The surviving texts on this branch of learning date back far enough, but it seems reasonable to think that the practice is old, and that a sculptor who was developing a new art form (China has hardly any pre-Buddhist human sculpture in the round) would take an interest in it. The point is important, I think, because the faces all seem to be asymmetrical in the same way, as if the artists were working on a theory; and what is more, I believe that their main idea was true.

During the last twenty years the psychologists have been developing a theory about asymmetry in the human face, and illustrating it by 'split' photographs; that is, the left taken twice over and the right taken twice on another picture. (You need a film, not a plate negative, because you have to print it backwards). I have tried this method on the Far Eastern Buddhas, and it seems to me to work very nicely. The theory about actual faces is still not on a solid footing; the contrasts between the sides are hard to interpret consistently, and the paths of the facial nerves to the brain, which one would expect to explain the contrasts, are complicated because though most of them cross over to the other side, some of them don't. However, it seems to be true that the marks of a person's active experience tend to be stronger on the right, so that the left shows more of his inherent endowment or of the more passive experiences which have not involved willful use of facial muscles. All that is assumed here is that the muscles on the right generally respond more readily to the will and that the effects of old experiences pile up. The photograph of Mr. Churchill will be enough to show that there is sometimes a

contrast of this sort, though it seems that in Baudelaire, who led a very different kind of life, the contrast was just the other way round. In Mr. Churchill the administrator is on the right, and on the left (by which of course I mean the left of the person or statue, which is on your right as you look) are the petulance, the romanticism, the gloomy moral strength and the range of imaginative power.

We might hesitate to say what the experiences or the inherent nature of a Buddha may be. But a statue of him to be worshipped has two very different functions; it has to convey his detachment from the world after achieving peace, and yet this figure is expected to help the worshipper. The formula I propose for the Buddha head, in the Far East, up to the tenth century or so, is that the calm is on the left and the power to help the worshipper on the right. This has enough realism to be satisfying, because it puts the more active or outgoing part in the usual place.

The trick may well have been invented at Yun-kang, where it is used very regularly. Large numbers of the heads have been hacked off (very wickedly) for private sale, and there are plenty of them on view, nearly always with their expression of ironical and forceful politeness. But if you make a picture with the left side of the head twice over it has hardly any of this expression. The eye and the mouth are level and the face is calm and still. On the right the eye and mouth slant, and this gives the sardonic quality; in fact, if you take it twice over the thing approaches the standard European face of the Devil. One finds this trick with eye and mouth even on small statues of the period, where the face is a mere sketch of two or three lines, and this is what makes me believe it was done on a theory. In the good heads it might be enough to say that the artist had deep intuitive understanding, but when the trick is used carelessly it must have become a 'rule'. Of course I don't say it is invariable; where you get a sheer wall in the caves of thousands of tiny statues they don't do it.

The convention seems to spread, and last for some time, but it is absorbed into a more fully modeled treatment of the whole face. The life-size pottery Lohan (saint) which was in the London Chinese Exhibition of 1935 is a good example; it is only on the right that the middle of the lower lid slants, and this gives you an impression that the whole eye is more slanted than the one on the left. The right of the face, it seems to me, has pride and suffering and looks out with a certain cunning; the left has a stubborn and intelligent placidity. Of course it may be a realistic portrait, but it follows the rule. It is now thought to be probably Sung [Song] (960–1280) rather than T'ang (808–907) which would make it a late example.[119]

I want to take two of the supreme early statues of Japan; both are seventh or early eighth century. For the Horiuji [Kudara] Kwannon (an image of the Bodhisattva of Mercy) I could not get a quite frontal view to cut up, but it is clear that mouth, eye and eyebrow are a bit steeper on the right. The good humour and

maternity of the face, rueful but amiable, belong to the left; on the right is the divinity, a birdlike unchanging wakefulness. It is quite a different contrast from the previous ones but still fits the psychological theory. Of course what you make of the face depends on the whole statue, the long sweep of the flamelike draperies, stretching as far as earth, and the jerk of the extended arm, exhausted but still offering. The Chuguji Maitreya is the coming Buddha, not yet born, but waiting in the heavens. The calm left is a normal Buddha face; from the right you can extract various sorts of child according to the lighting. It is a wonderfully subtle and tender work.

The Yumedono Kwannon (another Bodhisattva of Mercy) is perhaps the most beautiful of these early Japanese statues, and I had best end with it, not to appear crazy over the split-face theory; because the face seemed to me completely symmetrical on the two occasions that I saw it. It was used often, and that is a main source of the wonderful variety which the Far Eastern artists obtained within the strict formula of the Buddha facial type.

NOTES

1 The Irish author and journalist Lafcadio Hearn (1850–1904) lived in Japan for fourteen years and became famous for his ghost stories and more general writings on Japanese culture. See particularly *Glimpses of Unfamiliar Japan* (Boston: Houghton, 1894).

G. K. Chesterton (1874–1936) regularly attacked Buddhist principles in his writings, believing them to represent a negative antithesis to those of Christianity. His only substantial observations on Buddhist art, however, tend to impute less a sneering expression than one of solipsistic inactivity. 'The Buddhist saint always has his eyes shut,' Chesterton writes in *Orthodoxy* (John Lane, 1909, 196–201); 'while the Christian saint always has them very wide open [...] The Buddhist is looking with a peculiar intentness inwards. The Christian is staring with a frantic intentness outwards [...] By insisting specially on the immanence of God we get introspection, self-isolation, quietism, social indifference—Tibet.' It is probable that Empson has here conflated Chesterton's remarks on Buddha images with the author's attacks on Friedrich Nietzsche (regularly characterized by Chesterton as 'sneering'), whose philosophy is said finally to share the same *telos* as that of Buddhism. 'Nietzsche scales staggering mountains,' Chesterton offers; 'but he turns up ultimately in Tibet. He sits down beside Tolstoy in the land of nothing and Nirvana' (*Orthodoxy*, 67).

2 Empson is referring to the Bodhisattva Avalokitesvara, who became known as Guanyin (Empson's Kwan-yin), Gwan-eum, and Kannon (Empson's Kwannon) in China, Korea, and Japan respectively. Indian artists originally visualized Avalokitesvara as male or as androgynous, but East Asian artists tended increasingly to emphasize the Bodhisattva's female characteristics, eventually arriving at an unequivocally female depiction dressed in the flowing robes of an aristocrat.

3 A reference to the Vyaghri Jataka, a story of one of Gautama Buddha's previous incarnations in which he sees a tigress starving along with her cubs, and throws himself from a cliff in order for his physical body to provide a meal for them. It is intended to offer an example of selfless generosity that is unmotivated by reward or recognition.

4 Probably Nathan Söderblom and George Grimm. Söderblom: 'While I am living thus, after having felt the extreme sensations, my mind does not look for sensual pleasures' (*The Living God: Basal Forms of Personal Religion* (Oxford: Oxford University Press, 1933, 91)). Grimm: 'Without the stimulus of *sensation*, there is no desire. When every sensation has vanished completely and forever, then all willing, all thirst, of every kind, also is gone forever' (*The Doctrine of the Buddha* (Leipzig: Drugulin, 1926, 204)).

5 The Lotus Sutra is one of the most important early documents of Mahayana Buddhism. Compiled between 100 BCE and 200 CE, it is mainly important because it suggests that laypeople may reach enlightenment by various methods other than entering monastic life. See particularly H. Kern's 1884 translation *The Saddharma-Pundarika, or the Lotus of the True Law*, which may have been Empson's source. As Charles Eliot remarks in his *Hinduism and Buddhism*, easily the work that had the greatest influence on Empson's thinking about Asian religions, 'the Lotus is unfortunately accessible to English readers only in a most unpoetic translation by the late Professor Kern' (*Hinduism and Buddhism: An Historical Sketch*, vol. 1 (London: Routledge & Kegan Paul, 1921, 53)).

6 Gautama was the historical Buddha's family name, with the given name Siddhartha meaning 'all wishes fulfilled'. The honorific 'Sakyamuni' [Shakyamuni] means 'Sage of the Shakyas'—the Shakyas being the wider clan to which the family belonged.

7 Empson's manuscript has '(Paryauta)' here, but this will almost certainly have been a mistranscription from his handwritten notes. *Paryanka* is a Sanskrit term that can mean 'seat' or 'sitting'; it has sometimes used to signify the *padmasana*, or 'lotus seat' position, in which Gautama Buddha is said to have attained enlightenment, and which is by far the most common arrangement for the figure's legs in Buddhist sculpture. In contemporary yoga the term *paryankasana* usually refers to a posture in which the back lies flat on the floor with the lower legs bent back and the soles of the feet pointing up, but this has never been applied to Buddha images.

8 The Kushans were a group, now thought by many scholars to have been Indo-European in origin, that dominated present-day Afghanistan, Tajikistan, and northern India during the golden age of Gandhara-tradition Buddhist sculpture (i.e. between the 1st and 2nd centuries CE).

9 The theory that the pineal gland might function as a higher sense organ had been popularized by Theosophist authors such as Helena Blavatsky and C. W. Leadbeater. See particularly Blavatsky's *The Secret Doctrine*, vol. 2 (London, 1888), 298; and Lead-beater's *The Chakras: A Monograph* (Adyar (India), 1927), 73.

10 There are several well-known Kannon sculptures at Nara's Horyu-ji temple, but from Empson's description here, there can be no doubt at all that he is referring to the 7th-century image generally known as the Kudara Kannon. This figure holds a *kundika* (a bottle-shaped container used for sprinkling water in Buddhist rituals) in its hand.

11 i.e. a Buddha figure showing the *dhyana* position of the hands.

12 Amida is the Japanese name of Amitabha (meaning 'measureless light'), a figure believed in some Mahayana sects to have attained Buddhahood aeons before Gautama Buddha, and in a different part of the universe. In so-called 'Pure Land' sects, devotees are encouraged to seek rebirth in Amitabha's 'Buddha-realm', where conditions are considered more conducive to the attainment of enlightenment than they are on Earth.

13 The name Avalokitesvara actually translates most closely into English as 'the one who looks down'. However, the earliest form of the Bodhisattva's name was Avalokit*a*svara —literally, 'the one who looks down at sound'—which matches the sense of the Chinese name Guanyin (or Kwan-yin, as Empson transliterates it) perfectly. Empson here derives his own English translation of the name from a slight variant on the Chinese version—Guan*shi*yin. This can be translated as meaning 'the one who per-ceives the laments of the world', and was used by a small number of historical translators including the 4th-century Indo-Chinese monk Kumarajiva, who was tradi-tionally credited with having rendered the Lotus Sutra and other significant Buddhist texts into Chinese.

14 Empson's manuscript has 'seventh' here, but this was probably a simple error based on the repetition of the word 'seven' later in the sentence. Gautama, the historical Buddha, is described in some of the earliest documents of the Pali Canon as the fourth Buddha of the current *kalpa* (aeon), to which three Buddhas from previous *kalpas* are regularly added to make seven. Maitreya, the 'Future Buddha', will therefore be the fifth (or the eighth). In some later Pali texts, the number of Buddhas is increased to twenty-four.

15 Yijing (635–713 CE) was one of the great Chinese Buddhist pilgrims. He travelled from Tang China via South-East Asia to India in order to reach the great Buddhist university of Nalanda (the ruins of which are in today's state of Bihar), where he studied for eleven years. He is remembered particularly for his diaries, which contain unique descriptions of contemporary Asian civilizations, and for his translations of significant Buddhist documents from Sanskrit into Chinese.

16 See Charles Eliot, *Hinduism and Buddhism: An Historical Sketch*, vol. 3 (London: Routledge & Kegan Paul, 1921), 220; and George Sansom, *Japan: A Short Cultural History* (London: Cresset, 1931), 243.

17 Empson's statement here is misleading, as the goal of entering Amitabha's Buddha realm would still be to attempt to attain nirvana, albeit under far more favourable conditions than on Earth.

18 A reference to the Brahmajala Sutra of Mahayana Buddhism, which in Empson's time was thought to have been translated by Kumarajiva in the late 4th century, but is not now considered to have appeared in Chinese until the middle of the 5th.

19 Empson's text has 'possible dates for his death, in his eightieth year, are 554 and 437' but there is clearly an accidental omission here. Contemporary scholars tend to prefer 563–483 BCE for the life of Gautama Buddha.

20 Empson's dates are for Ashoka's reign.

21 '20 AD' may have been a mistranscription by Empson from his handwritten notes. Most scholars prefer 70 CE as an end date for the Sunga Empire.

22 A reference to the *vinaya* (monastic regulatory code) of the Sarvastivada sect of early Buddhism in northern India, which later became the most common *vinaya* in early forms of Chinese Buddhism.

23 See Charles Eliot, *Hinduism and Buddhism: An Historical Sketch*, vol. 1 (London: Routledge & Kegan Paul, 1921), p. xxxi.

24 Empson is forgetting about early Pali texts such as the *Milinda Paha*—the famous *Questions of Milinda*—a Plato-style dialogue on Buddhist principles between the Graeco-Bactrian monarch Menander I and the arhat (enlightened being) Nagasena. There are also references to the Indo-Greek cultures of the north-west in the Pali *Mahavamsa*, or *Great Chronicle*, another important early Buddhist text.

25 Eliot, *Hinduism and Buddhism*, vol. 1, 219 and 451.

26 See Alfred Foucher, *L'Art Gréco-bouddhique du Gandhara* (Paris, 1905).

27 Ananda Kentish Coomaraswamy was technically Anglo-Ceylonese.

28 Yakshas are a generic class of nature spirit common to Hinduism, Buddhism, and Jainism. The male versions are usually depicted as portly dwarfs, while depictions of female versions tend instead to emphasize voluptuousness and heightened sexuality.

29 Nagas are beings who traditionally appear in the form of a snake, most often that of the Asiatic King Cobra (*Ophiophagus hannah*). Probably derived originally from pre-Buddhist village deities, they feature often in the mythologies of Buddhism, Hinduism, and Jainism.

30 Mabel Lucie Attwell (1879–1964) was a popular illustrator famous for her cuddly and sentimental depictions of round-faced babies and children.

31 The dates for the Gupta Empire are now more commonly thought to have been 320–550 CE.

32 This folk tale relating to Buddhist mythology is popular in Japan, where Empson probably heard it. There is a reference in English to it in William Eliot Griffis, *Fairy Tales of Old Japan* (London: Harrap, 1911), 147–8.

33 The general consensus today is that the reliquary was probably created somewhat later—around 50 CE.

34 Vincent A. Smith, *The Oxford History of India from the Earliest Times to the End of 1911* (Oxford: Clarendon Press, 1919), 155.

35 The former British Museum curator Arthur Waley (1889–1966) is still the best-known translator into English of sections of *Journey to the West*, a classic Chinese novel by the Ming Dynasty author Wu Cheng'en. It describes the efforts of the historical Chinese Buddhist pilgrim Xuanzang to reach India, helped along by a set of disciples that include the unruly Sun Wukong, otherwise known as The Monkey King. See Wu Cheng'en, *Monkey (A Fairy Tale)*, trans. Arthur Waley (London: Allen & Unwin, 1942). Empson had always been a fan of Waley's translations, having enthusiastically reviewed his rendering of the Japanese novelist Murasaki Shikibu's *Genji Monogatari* while still an undergraduate at Cambridge. He also must have known Waley's translations of Chinese poetry, as he quotes two lines from the 1918 'New Corn by T'ao Ch'ien (365–427)' in *Seven Types of Ambiguity* (London: Chatto & Windus, 1930), 30. See Waley's *One Hundred and Seventy Chinese Poems* (London: Constable, 1918).

36 Probably a reference to the Vessantara Jataka, an illustration of which covers one entire wall in Cave 17 at Ajanta. Another story about one of Gautama Buddha's previous incarnations, it describes the decision of a monarch to give up all his privileges and possessions, and is usually seen as a parable of generosity and of the futility of accruing material wealth.

37 Coomaraswamy, *History of Indian and Indonesian Art*, 115.

38 Empson is here using the traditional Chinese designations for the Mekong delta and the area roughly corresponding to present-day Cambodia. They tended specifically to refer to the cultures that existed prior to the foundation of the Khmer Empire, but the term Chenla was also used by many historical Chinese geographers to refer to the Khmer civilization itself.

39 Empson here closely anticipates the findings of later research in the transmission of material culture factors such as chair design. See especially John Kieschnick, *The Impact of Buddhism on Chinese Material Culture* (Princeton: Princeton University Press, 2003).

40 The only aesthetically comparable colossal heads might be those of the Mesoamerican Olmec civilization. Dated to around 900 BCE, these are found on the Gulf coast of Mexico, but do not seem to have been incorporated into an overall architectural scheme like those of the Bayon.

41 Eliot, *Hinduism and Buddhism*, vol. 1, 115–16.

42 'Giustizia mosse il mio alto fattore: | fecemi la divina podestate, | la somma sapienza e 'l primo amore. || Dinanzi | a me non fuor cose create | se non etterne, e io etterno duro. | Lasciate ogne speranza, voi ch'intrate' (Dante, *Inferno* III, 5–6); 'Justice it was that moved my great creator; | Divine omnipotence created me, | And highest wisdom joined with primal love. || Before me nothing but eternal things | were made, and I shall last eternally. | Abandon every hope, all you who enter' (Dante, *The Divine Comedy Volume 1: Inferno*, trans. Mark Musa (New York: Indiana University Press, 1971), 89).

43 'The question of drugs is particularly pertinent as far as Angkor is concerned, for I am morally certain that the Khmer were an opium-soaked community. I question whether this alone would account for their complete defeat, though combined with the illness and change of climate that I have supposed the resulting inertia would undoubtedly have contributed. Opium is, however, absolutely necessary for the comprehension of their art. Khmer art has always seemed strange and alien to European commentators; and this strangeness in analysis is caused by the fact that Khmer art is extremely sensual and completely sexless' (Geoffrey Gorer, *Bali and Angkor* (London: Michael Joseph, 1936), 178–9).

44 'There is no reason to suppose that the Khmers have made use [of opium].'

45 Empson most likely worked from Chou Ta Kuan [Zhou Daguan], *Memoire sur les coutumes du Cambodge*, trans. P. Pelliot (Hanoi: École Française d'Extrême-Orient, 1902).

46 Eliot, *Hinduism and Buddhism*, vol. 3, 135.

47 Cf. Empson's remarks on the Cheshire Cat from Lewis Carroll's *Alice in Wonderland*: 'all cats are detached, and since this one grins it is the amused observer. It can disappear because it can abstract itself from its surroundings into a more interesting inner world; it appears only as a grin because it is almost a disembodied intelligence, and only as a grin because it can impose an atmosphere without being present [...] it is unbeheadable because its soul cannot be killed; and its influence brings about a short amnesty in the divided nature of the Queen and Duchess' (*Some Versions of Pastoral* (Chatto & Windus, 1935), 218).

48 A reference to the marriage of the Tibetan king Songtsan Gampo both to the Nepalese princess Bhrikuti and the Chinese princess Wencheng (a niece of the Tang Emperor Taizong). Songtsan Gampo also had three Tibetan wives.

49 Dunhuang is actually located in Gansu, just on the other side of the provincial boundary of Xinjiang.

50 The paintings are now in the collection of the Sichuan University Museum in Chengdu.

51 It is unclear whether Empson here intends two *years* BCE, or the second *century* BCE. Both would be considered too early by most contemporary Sinologists. It is now accepted by most scholars that, whether it arrived by sea from the south or by land from the north, Buddhism probably did not begin to be adopted in China much before the latter half of the 1st century CE.

52 Eliot, *Hinduism and Buddhism*, vol. 3, 250.

53 Wu Zetian is now more commonly reckoned to have reigned 690–705 CE.

54 Contemporary scholars prefer 742–74 CE for the construction of Seokguram.

55 Sansom, *Japan: A Short Cultural History*, 65.

56 Empress Suiko's dates are now thought to have been 690–705; Prince Shotoku is now thought to have died in 622 CE.

57 Ernest Fenollosa, *Epochs of Chinese and Japanese Art*, vol. 1 (London: Heinemann, 1912), 50 and 57–64.

58 Ibid. 59–60.

59 See Andreas Eckardt, *A History of Korean Art*, trans. J. M. Kindersley (London: Edward Goldston, 1929), 108; and Sansom, *Japan: A Short Cultural History*, 147.

60 The name of the village where Horyu-ji and Chugu-ji Temples are located is actually Ikaruga.

61 Fenollosa, *Epochs of Chinese and Japanese Art*, vol. 1, 51.

62 Charles Eliot, *Japanese Buddhism* (London: Edward Arnold, 1935).

63 See Eckardt, *A History of Korean Art*.

64 Sansom, *Japan: A Short Cultural History*, 154.

65 Empson's use of the word 'period' in this context is misleading. Konin and Jogwan are *nengo*—spaces of time that were established and named according to fairly random historical factors until the mid-nineteenth century, when they became fixed to the duration and nomenclature of imperial reigns. The usual convention is to use the English equivalent 'era', while 'period' is reserved for bookending more obviously epochal historical developments. The recognized dates for Konin and Jogwan are actually 810–24 CE and 859–77 CE respectively.

66 Charles Darwin, *The Expression of the Emotions in Man and Animals* (London: John Murray, 1872).

67 The correct anatomical term would be 'epicanthic fold'.

68 Roger Hinks (1903–63), art historian, assistant keeper of Greek and Roman Antiquities, British Museum, 1926–39.

69 The Lorenzetti was later reattributed to a Neopolitan follower of Giotto (Pl. 24). I am grateful to Matthew Power at London's National Gallery for pointing this out.

70 It is highly unclear what Empson means here by 'Semiune', especially as the word has been capitalized. It seems possible, however, that he intends 'semilune'—i.e. that he is comparing the eyebrows of the sculptures to halves of a crescent moon.

71 Cf. Empson's remarks about the character of Alice from Lewis Carroll's *Alice in Wonderland*: 'the theme here is that it is possible for a well-meaning and innocent girl to be worldly, because she, like the world, should know the value of her condition. "When we were girls we were brought up to know nothing, and very interesting it was"; "mamma, whose ideas on education are remarkably strict, has brought me up to be extremely short-sighted; so do you mind me looking at you through my glasses?"' (*Some Versions of Pastoral*, 224).

72 The comedian and singer George Robey was one of the most successful and famous music hall performers of the first half of the twentieth century. His comic performances made extensive use of the double entendre, usually accompanied by a denial of any covert salacious content and an expression of mock shock that anyone would suspect such a thing.

73 Kruschen Salts, maker of a popular laxative, ran during the interwar years a newspaper advertising campaign stressing that users of the product would benefit from enhanced levels of physical energy. These often featured a drawing of an elderly man performing improbable sporting or athletic feats wearing an expression intended to show that he was 'bursting with energy', as Empson implies here. The expression consisted of a somewhat manic-looking smile and raised eyebrows above wide-open eyes. One version of the advertisement notes, 'The old boy is as pleased with himself as a puppy-dog with two tails!'

74 The so-called 'archaic smile' is an aesthetic feature of pre- and early-Classical Greek sculpture, particularly of the mid 6th century BCE, in which the corners of a closed

mouth are turned up in what often seems a rather fixed or unnatural expression. It is taken by some art historians as an attempt by the sculptor to make the artwork engage emotively with the viewer, and by others as an expression of religious beatitude.

75 Fenollosa, *Epochs of Chinese and Japanese Art*, vol. 1, 74.

76 Empson's manuscript has 'Koral' here, but this is evidently a typo. *Korai*—Greek for 'young women'—refers specifically to pre- and early-Classical sculptures of female figures, later examples of which often featured an exaggerated version of the archaic smile.

77 Rank suggests that 'chthonian dependency' on the Earth Mother was a defining characteristic of 'primitive' art, but that this was transcended by the Greeks in the development of Classical sculpture. However, 'mother-repression' is not a phrase that he appears ever to have used (I am grateful to Jake Empson for pointing this out). See Otto Rank, *Art and Artist: Creative Urge and Personality Development* (London: Knopf, 1932).

78 Hazlitt's actual phrase is 'convulsive inclination to laughter about the mouth' (William Hazlitt, 'My First Acquaintance with Poets', *The Liberal*, April 1823, in P. P. Howe (ed.), *The Complete Works of William Hazlitt* (London: J. M. Dent and Sons, 1930–4), vol. 16, 118).

79 See Walter Pater, *The Renaissance* (London: Macmillan, 1893), 124.

80 Ronin were Samurai warriors who had fallen into disgrace as a result of having failed to commit ritual suicide after the slaying of their master. Most of the Kabuki performances and paintings featuring them that Empson saw in Japan would have been based on the story of the Forty-Seven Ronin, a historical revenge tale that engendered an entire body of popular fictionalized versions known as the *Chushingura*.

81 Empson had been thinking about the use of facial muscles to produce ambiguous expressions since at least 1930. In *Seven Types of Ambiguity*, he notes that 'there are fewer verbal devices, as there are fewer ways of moving facial muscles, than there are sorts of feeling to convey by them; and in that the opportunities for ambiguity arising from this can be exploited in so many ways' (p. 39).

82 *Gagaku*, or 'Elegant Music', refers to several styles of musical performance associated with the Japanese imperial court. Developed between the 6th and 8th centuries, it settled into orthodox instrumental and stylistic divisions during the Kamakura Period (1185–1333). *Gagaku Doshi Kokai* has a meaning similar to 'Music and Dance Ensemble'.

83 Empson expands on these observations in *Some Versions of Pastoral*: 'the striking thing about Ancient Egypt when you come there from the East is that it is so European and the noble great head of Amenemhat in the British Museum (good dog—the Prince of Wales always does his best) would be at home on a War Memorial. Such faces belong only to one period, but the feeling was regularly put into the torso, a powerful body so handled as to seem delicate, vulnerable, and touching, in the contrast of the rigid lines. The same clash of the bruiser and the flower (now mainly used in representations of cart horses) seems at work in one of the statues of the Indus civilization and is clear in the earliest statues of Buddha at Mathura, based on a clumsier tradition for big earth gods; then a new idea of spirituality comes in, whether partly Greek or not, and this theme can only dimly be fancied in the normal Buddha. It seems clear in the more satisfying

Pharaohs at any rate, that this conception of the divine king, devoted and unintellectual, doing his best at the work of being a deity, especially in its firm acceptance of the strong man as a touching emblem of nobility, has a double feeling of the same kind as is invoked for pastoral.' The Egyptian sculpture he is discussing is the British Museum's colossal granite head of Amenemhat III (12th Dynasty, *c.*1800 BCE) from Bubastis in the Nile delta, which was acquired in 1889 (see Pl. 1).

84 Empson had been theorizing over the use of symmetry in the production of aesthetic beauty since *Seven Types of Ambiguity*, where he talks about Sumerian carvings that put 'two beasts in exactly symmetrical attitudes of violence, as in supporting a coat-of-arms, so that whatever tendencies to action are aroused in the alarmed spectator, however he imagines the victim or the huntsman to have been placed, there is just the same claim on his exclusive attention, with a reassuring impossibility, being made on either side, and he is drawn taut between the two similar impulses into the stasis of appreciation' (p. 242).

85 This may refer to Kasyapa [Kassapa] Buddha, or to a disciple of Gautama Buddha's of the same name. Kasyapa [Kassapa] Buddha is the sixth in the Pali Canon's succession of Buddhas, positioned immediately before Gautama. Kasyapa [Mahakassapa] was one of Gautama Buddha's two chief disciples (the other being Ananda)—he is often depicted in Chinese Buddhist art, as he is considered to have paved the way for the foundation of the Chan (Zen) sect of the religion.

86 Harihara sculptures tend to emphasize the underlying unity of Shiva and Vishnu while simultaneously displaying the independent attributes of each. This accounts for the carefully symmetrical presentation of the standard facial features on each side, while the clothing, jewellery, and non-standard features (such as Shiva's third eye) are strictly differentiated. A very fine 10th-century Harihara from the famous temple complex of Khajuraho had been on display in the British Museum since 1872, and Empson's observations are likely to have been based, at least partly, on this.

87 Werner Wolff, 'The Experimental Study of Forms of Expression', *Character and Personality*, 11 (December 1933), 168–76.

88 Cf. Empson's 'Marvell's Garden' discussion in *Some Versions of Pastoral*, where the lines under analysis are 'Annihilating all that's made | To a green thought in a green shade'. Empson writes: 'Either "reducing the whole material world to nothing material, i.e. to a green thought", or "considering the material world as of no value compared to a green thought"; either contemplating everything or shutting everything out. This combines the idea of the conscious mind, including everything because understanding it, and that of the unconscious animal nature, including everything because in harmony with it. Evidently the object of such a fundamental contradiction (seen in the etymology: turning all *ad nihil*, to nothing, and *to* a thought) is to deny its reality. The point is not that these two are essentially different but that they must cease to be different so far as either is to be known. So far as he has achieved his state of ecstasy he combines them, he is "neither conscious nor not conscious", like the seventh Buddhist state of enlightenment.'

89 See also Empson's remarks on 'the primitive mind' in *The Structure of Complex Words* (London: Chatto & Windus, 1951), 379.

90 'On the left, the social personality; on the right, the deep personality' (Pierre Abraham, 'Une figure, deux visages', *La Nouvelle Revue Française*, XLII (Spring 1934), 428.

91 Empson forgets here that he has not yet introduced the concept of left-left and right-right photographs; he does this a few pages further on.

92 Probably *The Great God Brown* (1926).

93 Sir Cyril Burt (1883–1971) was a professor at University College London and a renowned educational psychologist.

94 Karl With, *Buddhistische Plastik in Japan* (Vienna: Anton Schroll, 1922).

95 Probably *Trinity with Saints* (1491–4), now in the collection of London's Courtauld Institute (acquired in 1947).

96 During the late 19th century, free hospitals began to employ Almoners—usually female—whose responsibility was to assess the needs of those accessing their services, and to decide whether or not such patients were able to contribute financially to their own treatment by means of donations. Empson evidently intends to imply that the expression he is describing implies a caring attitude combined with professional detachment.

97 See Lewis Carroll, *Through the Looking Glass* (London: Macmillan, 1871). Empson is probably referring to the engraving of the White Queen by Carroll's illustrator John Tenniel, which gives her a symmetrical face with a grandmotherly, if somewhat aloof, expression. More detailed observations on Tenniel's illustrations for the Alice books may be found in *Some Versions of Pastoral*, 226.

98 Cf. Empson's discussion of Alice's dealings with the pig in Lewis Carroll's *Alice in Wonderland*: '"I will do my best even for you; of course one will suffer, because you are not worth the efforts spent on you; but I have no temptation to be uncharitable to you because I am too far above you to need to put you in your place"—this is what her tone would develop into; a genuine readiness for self-sacrifice and a more genuine sense of power' (*Some Versions of Pastoral*, 226).

99 'Againe, how can death be euill, sith it is the Thaw of all these vanities which the Frost of Life bindeth together? If there bee a Sacietie in Life, then must there not bee a Sweetnesse in Death? Man were an intollerable thing, were hee not mortall' (Drummond of Hawthornden, 'A Cypress Grove', 436–40, in W. B. Turnbull (ed.), *The Poetical Works of William Drummond of Hawthornden* (London: Reeves & Turner, 1856), 81).

100 Aldous Huxley *Ends and Means: An Enquiry into the Nature of Ideals* (London: Chatto & Windus, 1937).

101 Joseph Needham, *History is on Our Side: A Contribution to Political Religion and Scientific Faith* (London: Allen and Unwin, 1946), 8.

102 See also Empson's *Milton's God* (London: Chatto & Windus, 1961), 10. 'Thus young people often join a church because they think it is the only way to avoid becoming a Communist, without realizing that a Renaissance Christian State was itself usually thorough-going police terror.'

103 Caroline Augusta Foley Rhys Davids, erstwhile president of the Pali Text Society and lecturer in the History of Buddhism at London's School of Oriental and African

Studies, was the author not only of many English translations of original Buddhist documents, but also of a large number of books aiming to explain Buddhism to the educated layperson. She suggests in some of these that *anatta*—the belief that that the concept of 'self' is an illusion—did not initially feature as a part of Buddhist doctrine.

104 Quoted from Eliot, *Hinduism and Buddhism*, vol. 1, 140.

105 Pali documents such as the *Sutta Pitaka* (which Empson would have known via C. A. F. Rhys Davids' translations) list ten 'fetters'—modes of behaviour or thought that are liable to increase attachment to various kinds of existence, thus perpetuating the cycle of rebirth and the continuation of suffering.

106 Eliot, *Hinduism and Buddhism*, vol. 1, 202–5.

107 Ibid. 43.

108 Ibid. 218–19. The *skandhas* can roughly be defined as the five qualities of a living being that might, according to Buddhist doctrine, encourage the illusion that a 'self' exists. Empson actually lists two of the *skandhas*—'perception' and 'consciousness'—at the end of his paragraph; the other three are usually transliterated as 'matter', 'sensation', and 'mental formations'.

109 Quoted ibid. 231.

110 'So also the transition from Hinayana to Mahayana Buddhism, in which a world-denying philosophy is superseded or overlaid by a system of devotion to a personal saviour, may have been assisted by the example of the great neighbouring religion of the west' (Needham, *History is on Our Side*, 9).

111 Ibid. 217.

112 James G. Frazer, *The Golden Bough* (London: Macmillan, 2 vols., 1890; 3 vols., 1900; 12 vols., 1906–15). See also Empson's *Some Versions of Pastoral*, 21.

113 William of Rubruck, a.k.a. Willem van Ruysbroeck (1220–93), a Franciscan monk, was sent by Louis IX of France on a mission to convert Central Asia to Christianity. The interfaith debate Empson describes was ordered by Mongke, the fourth of the Mongol Great Khans, and took place in Karakorum in the summer of 1254.

114 Interestingly, the great ethnomusicologist Laurence Picken proposes that both the music of the Tang and of the early Japanese courts had originally been derived via the Silk Roads from the Sogdian civilization of Central Asia, but that the music had slowed down very significantly in tempo on its journey east (*Music from the Tang Court* (Cambridge: Cambridge University Press, 1988)).

115 See also Empson's *Seven Types of Ambiguity*, 40: '... in particular, a rhythmic beat taken faster than the pulse seems controllable, exhilarating, and not to demand intimate sympathy; a rhythmic beat almost synchronous with the pulse seems sincere and to demand intimate sympathy; while a rhythmic beat slower than the pulse, like a funeral bell, seems portentous and uncontrollable.'

116 *The Dynasts* is a 1904–8 verse drama by Thomas Hardy famous for its length and complexity (it has more than 130 scenes). Sheridan's *The School for Scandal* is a comedy about society gossip from the 1870s. *Charley's Aunt* was a popular farce of the 1890s by Brandon Thomas. Empson's intention here is to provide an equivalent for the mixture of genres presented at many theatrical performances in China and Japan, and to show how incongruous such a mixture would seem in the West.

117 See Eliot, *Hinduism and Buddhism*, vol. 1, 203: '"Hard is it to be born as a man, hard to come to hear the true law" and when the chance comes, the being who has attained to human form and the critical issues which depend on his using it rightly are dwelt upon with an earnestness not surpassed in Christian homiletics.'

118 Needham, *History is on Our Side*, 8.

119 Contemporary scholars prefer 960–1279 CE and 618–907 CE for the Song and the Tang Dynasties respectively.

ORIGINAL NUMBERING OF WILLIAM EMPSON'S BLACK-AND-WHITE ILLUSTRATIONS

What follows is an accurate transcript of William Empson's original list of black-and-white illustrations for *The Face of the Buddha*, with an additional column added to describe the eventual figure or colour plate number of each illustration as it appears in this book.

As mentioned in my 'Note on the Illustrations' (see p. lv), some of Empson's original black-and-white images have been replaced by colour plates either because the supplied images had been lost, or because copyright issues had surfaced with respect to reproduction of a historical photograph of the object illustrated. In cases where black-and-white photographs were found to be damaged, or were of a visual quality that seemed inadequate, the original image has been reproduced at a small size on the page, and then supplemented with a larger contemporary version in the colour plate section.

Late during the preparation of the final layout of this book, I made the decision to replace the image of Michelangelo's Delphic sibyl, that had originally stood as the last of the contemporary images in the colour plate section, with a reproduction of William Empson's own painting of a Japanese figure walking beneath trees (Pl. 25). I did this because the Michelangelo work is mentioned only very briefly and in passing in the text, but moreover because I felt it would be not only more valuable, but also more interesting, to supply the reader instead with a recently-discovered example of an artistic experiment by the author himself that is closely related to the themes explored throughout *The Face of the Buddha*.

In the above case, and in the small number of other cases where an illustration called for or included by Empson has not been reproduced in this book, I have indicated this within the list via the abbreviation N/S (for 'not supplied'), and have given the reason for its non-inclusion in square brackets after each entry.

Rupert Arrowsmith

Fig. 01	Fig. 03	Parkham Yaksha (Coomaraswamy, *History of Indian and Indonesian Art*. Plate III no. 9)
Fig. 02	Fig. 04	Mathura Buddha (Op. cit. Pl. XXIII no. 87)
Fig. 03	Fig. 10	Mathura Buddha 'Ai' (Op. cit. pl. XXIII no. 84)
Fig. 04	Pl. 18	Small Mathura Buddha (Musee Guimet)
Fig. 05	Fig. 09	Early Gandhara Buddha (Op. cit. [reference not given by Empson]
Fig. 06	Pl. 06	Later Gandhara Buddha (Musee Guimet)
Fig. 07	Fig. 13	Gupta Period Buddha from Mathura (Calcutta Museum)
Fig. 08	Fig. 14	Gupta Period Buddha from Sarnath (Calcutta Museum)
Fig. 09	Fig. 15	Ajanta Bodhisattva (bought there)
Fig. 10	Pl. 19	Elephanta Head (Op. cit. LVI. no. 195)
Fig. 11	Fig. 11	Ceylon: Anuradhapura Standing Buddha (Op. cit. pl. XXCVII. no. 293)
Fig. 12	Fig. 12	Anuradhapura Seated Buddha (Op. cit. pl. XXCVII. no. 295)

Fig. 13	Pl. 11/ Fig. 16	Sixth Century Head from Indochina (Phnom Penh Museum)
Fig. 14	Fig. 17	Seventh-eighth Century (as above)
Fig. 15	Fig. 18	Another (as above)
Fig. 16	Fig. 21	Angkor Thom (postcard bought there)
Fig. 17	Fig. 19	Fourteenth Century Cambodian Head of a Divinity (acknowledgments to Museum of Fine Arts, Boston)
Fig. 18	Fig. 20	Side view of Fig. 17
Fig. 19	Fig. 66	Siamese Buddha, 5th–7th Cent. (San Francisco World's Fair 1939)
Fig. 20	Fig. 22	Group from Yun-kang (bought in Japan)
Fig. 21	Fig. 61	Head from Yun-kang (negative included. Bought in Japan)
Fig. 22	Fig. 62	Left-left of 21
Fig. 23	Fig. 63	Right-right of 21
Fig. 24	Fig. 23	Second Yun-kang head (courtesy of Kansas City Museum, permission given, negative included. Would make splits)
Fig. 25	Pl. 17/ Fig. 64	Five Dynasties Kwan-yin (London Chinese Exhibition 35)
Fig. 26	Fig. 65	Head of 25
Fig. 27	Fig. 24	Head of Sung Pottery Lohan (Pennsylvania Museum) (Two copies included. Would make splits)
Fig. 28	Pl. 07	Chinese Seventeenth Century Pottery Buddha (London Chinese Exhibition)
Fig. 29	Fig. 25	Korean Primitive Head (bought at Keishu Museum, Korea)
Fig. 30	Fig. 28	Early Yakushi (as 29)
Fig. 31	Fig. 26	Buddha Buried beside Tomb (as 29)
Fig. 32	Fig. 27	Yakushi in Earth-Touching Position (as 29)
Fig. 33	Fig. 32	Korean Buddhas
Fig. 34	Fig. 33	Maitreya in Keijo Museum, c. 6th Cent
Fig. 35	Fig. 34	Head of 34
Fig. 36	Fig. 35	Side view of 34
Fig. 37	Fig. 29	Entrance to Sokkulam Cave (bought in Korea)
Fig. 38	Fig. 31	Figure from Wall of Inner Room (as above)
Fig. 39	Fig. 30	Figure from Dome of Inner Room (as above)
Fig. 40	Fig. 55	Vairocana from Bulguksa, Korea. Eighth Century.
Fig. 41	Fig. 44	Koriuji Maitreya (bought in Japan, as are all the following till further notice)
Fig. 42	Fig. 45	Half left of 41
Fig. 43	Fig. 46	Full left of 41
Fig. 44	Fig. 67	Right-right split of 41
Fig. 45	Fig. 68	Left-left split of 41
Fig. 46	Fig. 56	Horiuji Trinity
Fig. 47	Fig. 57	Side view of 46
Fig. 48	Fig. 36	Yumedono Kwannon
Fig. 49	Fig. 37	Half length of 48
Fig. 50	Fig. 38	Front view of 48

Fig. 51	Fig. 39	Horiuji Kwannon
Fig. 52	Fig. 40	Head of 51
Fig. 53	Fig. 71	Right-right of head
Fig. 54	Fig. 72	Left-left of head
Fig. 55	Fig. 41	Left view of head
Fig. 56	Fig. 43	Left hand of 51
Fig. 57	Fig. 42	Right hand of 51
Fig. 58	Fig. 48	Chuguji maitreya
Fig. 59	Fig. 49	Left view of 58
Fig. 60	Fig. 50	Right view of 58
Fig. 61	N/S	Front view of head [Empson's original photograph lost]
Fig. 62	Fig. 69	Right-right of head
Fig. 63	Fig. 70	Left-left of head
Fig. 64	N/S	Horiuji frescoes [Empson's original photograph lost]
Fig. 65	Fig. 51	Closer view
Fig. 66	Fig. 47	Kwannon of Yakushiji Toindo
Fig. 67	Fig. 52	Todaiji Bonten
Fig. 68	Fig. 73	Konin Period Jizo
Fig. 69	Fig. 74	another
Fig. 70	Fig. 59	Kamakura Buddha
Fig. 71	Fig. 54	Kamakura period Buddha
Fig. 72	Fig. 60	Noh Mask
Fig. 73	Pl. 21	Kabuki Ronin Actor [not supplied by Empson]
Fig. 74	Fig. 58	Archaic Apollo
Fig. 75	Pl. 24	Lorenzetti pieta (National Gallery)
Fig. 76	N/S	Michael Angelo Delphic sibyl [not supplied by Empson, and see note above]
Fig. 77	Pl. 23	Suitable Chartres Virgin [not supplied by Empson]
Fig. 78	Pl. 01	Suitable Pharaoh [not supplied by Empson]
Fig. 79	Pl. 20	Mr. Churchill (would make splits) [Empson's original photograph lost]

RECONSTRUCTED BIBLIOGRAPHY OF EMPSON'S *THE FACE OF THE BUDDHA*

ABRAHAM, PIERRE, 'Une figure, deux visages', *La Nouvelle Revue Francaise*, XLII (Spring 1934).

CHESTERTON, G. K., *Orthodoxy* (Oxford: Clarendon Press, 1908).

CHOU TA KUAN [ZHOU DAGUAN], *Memoire sur les coutumes du Cambodge*, trans. P. Pelliot (Hanoi: École Française d'Extrême-Orient, 1902).

COOMARASWAMY, ANANDA K., *History of Indian and Indonesian Art* (London: Edward Goldston, 1927).

DARWIN, CHARLES, *Expression of the Emotions in Man and Animals* (London: John Murray, 1872).

ECKARDT, ANDREAS, *A History of Korean Art*, trans. J. M. Kindersley (London: Edward Goldston, 1929).

ELIOT, CHARLES, *Hinduism and Buddhism: An Historical Sketch*, 3 vols. (London: Routledge & Kegan Paul, 1921).

ELIOT, CHARLES, *Japanese Buddhism* (London: Edward Arnold, 1935).

FENOLLOSA, ERNEST, *Epochs of Chinese and Japanese Art*, 2 vols. (London: Heinemann, 1912).

FOUCHER, ALFRED, *L'Art Gréco-bouddhique du Gandhara* (Paris: Leroux, 1905).

FRAZER, JAMES G., *The Golden Bough*, 12 vols. (London: Macmillan, 1906–15).

GORER, GEOFFREY, *Bali and Angkor* (London: Michael Joseph, 1936).

GRIMM, GEORGE, *The Doctrine of the Buddha* (Leipzig: Drugulin, 1926).

HAZLITT, WILLIAM, 'My First Acquaintance with Poets', *The Liberal* (April 1823), in Geoffrey Keynes (ed.), *Selected Essays of William Hazlitt 1778–1830* (London: Nonesuch, 1939).

HUXLEY, ALDOUS, *Ends and Means: An Enquiry into the Nature of Ideals* (London: Chatto & Windus, 1937).

NEEDHAM, JOSEPH, *History is on our Side: A Contribution to Political Religion and Scientific Faith* (London: Allen & Unwin, 1946).

PATER, WALTER, *The Renaissance* (London: Macmillan, 1893).

RANK, OTTO, *Art and Artist: Creative Urge and Personality Development* (London: Knopf, 1932).

RHYS DAVIDS, CAROLINE A. F., *Buddhism: A Study of the Buddhist Norm* (London: Williams & Norgate, 1912).

RHYS DAVIDS, CAROLINE A. F., *Outlines of Buddhism: A Historical Sketch* (London: Methuen, 1934).

SANSOM, GEORGE, *Japan: A Short Cultural History* (London: Cresset, 1931).

SMITH, VINCENT A., *The Oxford History of India from the Earliest Times to the End of 1911* (Oxford: Clarendon Press, 1919).

SÖDERBLOM, NATHAN, *The Living God: Basal Forms of Personal Religion* (Oxford: Oxford University Press, 1933).

WALEY, ARTHUR, *One Hundred and Seventy Chinese Poems* (London: Constable, 1918).

WITH, KARL, *Buddhistische Plastik in Japan* (Vienna: Anton Schroll, 1922).

WOLFF, WERNER, 'The Experimental Study of Forms of Expression', *Character and Personality*, 11 (December 1933), 168–76.

WU CHENG'EN, *Monkey (A Fairy Tale)*, trans. Arthur Waley (London: Allen & Unwin, 1942).

ADDITIONAL WORKS CITED IN THE INTRODUCTION

ARLINGTON, L. C., and LEWISOHN, WILLIAM, *In Search of Old Peking* (Peking: Henri Vetch, 1935).

ARROWSMITH, RUPERT R., *Modernism and the Museum: Asian, African, and Pacific Art and the London Avant Garde* (Oxford: Oxford University Press 2011).

ARROWSMITH, RUPERT R., '"An Indian Renascence" and the Rise of Global Modernism: William Rothenstein in India, 1910–11', *The Burlington Magazine*, 152/1285 (April 2010).

BREDON, JULIET, *Peking: A Historical and Intimate Description of its Chief Places of Interest* (Shanghai: Kelly & Walsh, 1931).

BURGESS, JAMES, *The Bauddha Rock-Temples of Ajanta* (Bombay: Archaeological Survey of Western India, 1879).

CANDEE, HELEN CHURCHILL, *Angkor the Magnificent* (London: Witherby, 1925).

CASWELL, JAMES O., *Written and Unwritten: A New History of the Buddhist Caves at Yungang* (Vancouver: University of British Columbia Press, 1988).

DEY, MUKUL, *My Pilgrimages to Ajanta and Bagh* (London: Thornton Butterworth, 1925).

EDWARDS, PENNY, 'Womanizing Indochina: Fiction, Narrative and Cohabitation in Colonial Cambodia, 1890–1930', in Julia Ann Clancy-Smith and Frances Gouda (eds.), *Domesticating the Empire: Race, Gender, and Family Life in French and Dutch Colonialism* (Charlottesville: University of Virginia Press, 1998).

EMPSON, WILLIAM, *Seven Types of Ambiguity* (London: Chatto & Windus, 1930).

EMPSON, WILLIAM, *Some Versions of Pastoral* (London: Chatto & Windus, 1935).

EMPSON, WILLIAM, *The Gathering Storm* (London: Faber & Faber, 1940).

EMPSON, WILLIAM, *The Structure of Complex Words* (London: Chatto & Windus, 1951).

EMPSON, WILLIAM, *Collected Poems* (London: Chatto & Windus, 1955).

EMPSON, WILLIAM, *Milton's God* (London: Chatto & Windus, 1961).

EMPSON, WILLIAM, and GRIFFITHS, ERIC (ed.), *Empson in Granta* (London: Foundling, 1993).

EMPSON, WILLIAM, and HAFFENDEN, JOHN (ed.), *Selected Letters of William Empson* (Oxford: Oxford University Press, 2009).

FUKUHARA, RINTARO, 'Mr William Empson in Japan', in Roma Gill (ed.), *William Empson: The Man and his Work* (London: Routledge & Kegan Paul, 1974).

GROSLIER, GEORGE, 'Les arts indigènes au Cambodge', *L'Indochine française: Recueil de notices rédigées à l'occasion du Xe Congrès de la Far-Eastern Association of Tropical Medicine* (Hanoi: Far-Eastern Association of Tropical Medicine, 1938).

HAFFENDEN, JOHN, *William Empson Among the Mandarins* (Oxford: Oxford University Press, 2005).

HAFFENDEN, JOHN, *William Empson Against the Christians* (Oxford: Oxford University Press, 2006).

HATCHER, JOHN, *Laurence Binyon: Poet, Scholar of East and West* (Oxford: Clarendon Press, 1991).

HEARN, LAFCADIO, *Glimpses of Unfamiliar Japan* (Boston: Houghton, 1894).

HERVEY, HARRY, *King Cobra: An Autobiography of Travel in French Indo-China* (New York: Cosmopolitan, 1927).

JEANNERAT DE BEERSKI, PIERRE, *Angkor: Ruins in Cambodia* (London: Grant Richards, 1923).

JONES-BATEMAN, DOROTHY, *An Illustrated Guide to the Buried Cities of Ceylon* (London: Kandy Hotels, 1932).

KEITH, ELIZABETH, *Eastern Windows: An Artist's Notes of Travel in Japan, Hokkaido, Korea, China and the Philippines* (London: Hutchinson, 1928).

MARCHAL, HENRI, *Guide to Angkor* (Saigon: Société des éditions d'êxtreme-asie, 1931).

MULLIKIN, MARY AUGUSTA, and HOTCHKIS, ANNA M., *Buddhist Sculpture at the Yun Kang Caves* (Henri Vetch: Peiping [Peking], 1935).

MUTSU, ISO, *Kamakura: Fact and Legend*, 2nd edition (Tokyo: Times, 1930).

OKAKURA, KAKUZO, *The Ideals of the East* (London: John Murray, 1903).

PANT, BALASAHEB, *Ajanta: A Handbook of the Ajanta Caves descriptive of the Paintings and Sculpture therein* (Bombay: D. B. Taraporevala, 1932).

PATEL, DIVIA, 'Copying Ajanta: A Rediscovery of Some Nineteenth-Century Paintings', *South Asian Studies*, 23 (2006).

PURCELL, VICTOR, *Chinese Evergreen* (London: Michael Joseph, 1938).

QUENNELL, PETER, *A Superficial Journey through Tokyo and Peking* (London: Faber and Faber, 1932).

RAINE, KATHLEEN, 'Extracts from Unpublished Memoirs', in Roma Gill (ed.), *William Empson: The Man and his Work* (London: Routledge & Kegan Paul, 1974).

SANSOM, KATHARINE, *Living in Tokyo* (London: Chatto & Windus, 1936).

SANSOM, KATHARINE, *Sir George Sansom and Japan* (Tallahassee: Diplomatic Press, 1972).

SATO, NOBUO, 'Emupuson-san no omoide' (Reminiscences of Empson), *Eibungaku fūkei*, (*English Literature Landscape*), 2/1 (January 1935).

SMITH, JANET A., 'A is B at 4000 Feet', in Roma Gill (ed.), *William Empson: The Man and his Work* (London: Routledge & Kegan Paul, 1974).

SMITHIES, RICHARD, 'A Luohan from Yizhou in the University of Pennsylvania Museum', *Orientations*, 32/2 (February 2001).

STEUBER, JASON, 'The Exhibition of Chinese Art at Burlington House, London, 1935–36', *The Burlington Magazine*, 1241/148 (August 2006).

TERRY, T. PHILIP, *Terry's Guide to the Japanese Empire including Korea and Formosa* (Boston & New York: Houghton Mifflin, 1927).

UDAKA, MICHISHIGE, *The Secrests of Noh Masks* (Tokyo: Kodansha, 2010).

ACKNOWLEDGEMENTS

The most heartfelt of my thanks must go to Mogador and Jake, the sons of William Empson, and to his granddaughter Rebecca, all three of whom supported my work on this book unstintingly, and with trust and friendship. I am grateful to them also for their patience during what turned out to be a longer voyage than any of us had anticipated when we first shook hands on an icy London morning in January of 2011.

I owe similar debts of gratitude to Anna Davis, the Empsons' literary agent; to Jacqueline Baker at OUP; and to my esteemed mentor at Christ Church, Christopher Butler. It was Anna who hosted that first meeting with the Empsons, and she has kept a firm hand on the tiller ever since. If there was ever a possibility that this project might founder, it was because of Anna's clear-eyed leadership that it did not. My sincerest thanks to Jacqueline for following through her hunch that I, though a generalist and something of a maverick, might be able to do something interesting with William Empson's only unpublished manuscript, and also to Christopher, who I know encouraged her in that belief, though it is his time-honoured custom to deny everything.

At University College London I would like to thank Henry Woudhuysen for inviting me to become an associate of the Department of English, and to John Mullan for continuing the arrangement, which has allowed me to make use of the school's facilities while working on this book. Also Stephen Cadywold and the wonderful Anita Garfoot for helping me renew my credentials when necessary. At the London School of Advanced Study I would like to thank another revered mentor, Warwick Gould, for allowing me similar privileges under the fellowship that I held there for a period. I also have not forgotten David G. Williams, who has been there from the beginning.

For their invaluable help with the parts of this book that concern Japan, I would like to thank my friends David Ewick and Isaka Riho. Among many other kindnesses, David managed to locate for me a rare copy of the Japanese language article by Sato Nobuo from which I have quoted in connection with Empson's visits to the temple town of Kamakura. Riho then very kindly took time out from her busy schedule to translate sections of the article for me over various cups of tea and plates of curry in London and Yangon, and over the years has given me numerous useful pieces of advice on Japanese philology.

For allowing me to publish his observations on the theory of asymmetry and Empson's remarks specifically on Chinese Buddhist sculpture, I would like to thank Victor Mair. Also Katherine Tsiang, Dorothy Wong, Lukas Nickel, and a certain antiques dealer in Macao for taking the time to respond to my queries on the same.

In connection with the images used in this book, I would like to thank Peter Coomaraswamy for being kind enough to allow OUP to reproduce images from his grandfather's book without charge, and Roger Lipsey for connecting me with him. My sincerest gratitude also to Kong Vireak, the Cambodian Minister for Culture, for supplying such outstanding images of Khmer sculpture, and for allowing OUP to use them gratis—if only all permissions holders could be as gracious, and as encouraging towards scholarly publications. Thanks also to Aida Satoko for much valuable assistance in locating items in Japanese museums, and to Matthew Power at the National Gallery for solving the puzzle of the missing Lorenzetti.

Finally, my gratitude to Partha Mitter for his stunning preface, to Norah Perkins at Curtis Brown literary agency for her good humour and her tenacity in pushing the project through its final stages, to the series editor Seamus Perry, and to our excellent production editor at OUP, Caroline Hawley, and Senior Assistant Commissioning Editor, Eleanor Collins.

Rupert Arrowsmith, November 2015

CREDITS FOR BLACK-AND-WHITE ILLUSTRATIONS

Figures 13 and 14: Gupta Period Buddha from Mathura; Gupta Period Buddha from Sarnath, courtesy of the Indian Museum, Kolkata. Figures 19 and 20: *Head of a Divinity,* Cambodian (Khmer), Bayon, 12th century. Object Place: Cambodia. Sandstone. 21.7 cm (8 9/16 in.) Museum of Fine Arts, Boston. Denman Waldo Ross Collection, 23.447. Photograph © 2016, Museum of Fine Arts, Boston. Plate 10: *Head of a Buddha,* Chinese, from Yungang, Shanxi Province, ca. 490 CE, Northern Wei Dynasty (386–534 CE). Coarse sandstone, 15 × 7 × 8 inches (38.1 × 17.8 × 20.3 cm). The Nelson-Atkins Museum of Art, Kansas City, Missouri. Purchase: William Rockhill Nelson Trust, 31–83. Photo: Robert Newcombe. Plate 7: Luohan statue. Courtesy of Penn Museum, image #152267. All images attributed by Empson to 'Phnom Penh Museum' are reproduced courtesy of the Ministry of Culture of the Government of Cambodia. All black-and-white photographs taken or purchased by William Empson in Japan and Korea that are reproduced in this book were created prior to 1946 under the jurisdiction of the Government of Japan, and are considered to exist in the public domain according to Article 23 of the Old Copyright Law of Japan and Article 2 of the Supplemental Provision to the Copyright Law of Japan. The locations of some of the artefacts in black-and-white images supplied with Empson's original manuscript are not currently known. These include that of his key Bodhisattva head from Yungang (Fig. 61), which appears to have originated in Japan, and the Noh mask that according to my research was part of the Japanese Imperial collection prior to

World War Two, but is no longer (Fig. 60). I am grateful to the DNP Art Communications image agency in Tokyo for their efforts in helping me attempt to track down these artworks. Other items whose current status remains obscure are the Thai Buddha-image that Empson photographed at the San Francisco World's Fair in 1939 (Fig. 66), and the two generic Buddha images, Chinese and Japanese, that he offers to the reader merely as examples of sculpture that is in his opinion uninteresting (Figs. 53 & 54). If informed, OUP will be pleased to rectify any errors or omissions related to the black-and-white illustrations at the first opportunity.

Please see the 'List of Colour Plates' (p. lxi) for credit information relating to the plate section.

Endpaper illustrations by Stentor Danielson, www.mapsburgh.com.

INDEX